THE COVARRUBIAS CIRCLE

HARRY RANSOM
HUMANITIES RESEARCH
CENTER

Harry Ransom
Humanities
Research Center
Imprint Series

Published from the collections of the HRC

Stuart Gilbert, *Reflections on James Joyce: Stuart Gilbert's Paris Journal,*
ed. Thomas F. Staley and Randolph Lewis. 1993

Ezra Pound, *The Letters of Ezra Pound to Alice Corbin Henderson,*
ed. Ira B. Nadel. 1993

Nikolay Punin, *Nikolay Punin: Diaries, 1904–1953,* ed. Sidney Monas
and Jennifer Greene Krupala, trans. Jennifer Greene Krupala. 1999

Aldous Huxley, *Now More Than Ever,* ed. David Bradshaw
and James Sexton. 2000

Stanley Burnshaw, *The Collected Poems and Selected Prose.* 2000

Laura Wilson, *Avedon at Work: In the American West.* 2003

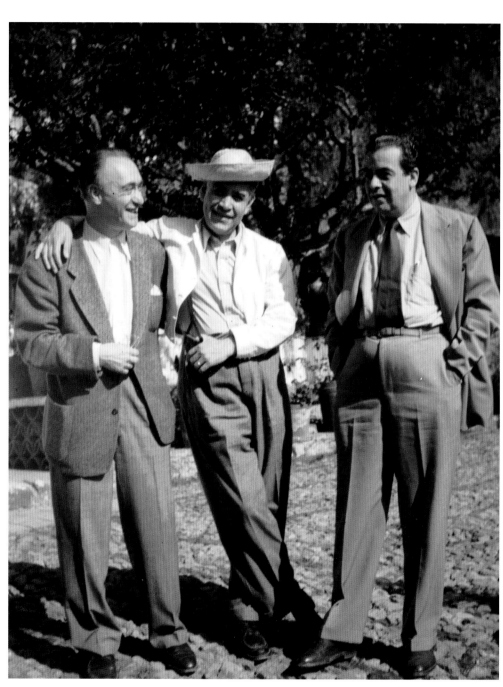

Photographer unknown, undated. Left to right: Nickolas Muray, Rufino Tamayo, and Miguel Covarrubias. Cibachrome reproduction. © Nickolas Muray Photo Archives, courtesy Mimi Muray.

NICKOLAS MURAY'S COLLECTION OF TWENTIETH-CENTURY MEXICAN ART

THE COVARRUBIAS CIRCLE

General Editor:

KURT HEINZELMAN

Curator of Art:

PETER MEARS

UNIVERSITY OF TEXAS PRESS, AUSTIN

First edition, 2004

Printed in China

Requests for permission to reproduce material from this work should be sent to Permissions, University of Texas Press, P.O. Box 7819, Austin, TX 78713-7819.

(∞) The paper used in this book meets the minimum requirements of ANSI/NISO Z39.48-1992 (R1997) (Permanence of Paper).

LIBRARY OF CONGRESS CATALOGING-IN-PUBLICATION DATA

The Covarrubias circle : Nickolas Muray's collection of twentieth-century Mexican art / general editor, Kurt Heinzelman ; art curator, Peter Mears.— 1st ed.

p. cm. — (Harry Ransom Humanities Research Center imprint series)

Published on the occasion of the exhibition Miguel Covarrubias: A Certain Clairvoyance, from the Ransom Center's collections.

ISBN 0-292-70588-3 (hardcover : alk. paper)

1. Covarrubias, Miguel, 1904–1957—Exhibitions. 2. Covarrubias, Miguel, 1904–1957—Friends and associates—Exhibitions. 3. Modernism (Art)—Mexico—Exhibitions. 4. Muray, Nickolas, 1892–1965—Art collections—Exhibitions. 5. Art—Private collections—Texas—Austin—Exhibitions. 6. Art—Texas—Austin—Exhibitions. 7. Harry Ransom Humanities Research Center—Exhibitions. I. Heinzelman, Kurt. II. Mears, Peter, 1945– III. Harry Ransom Humanities Research Center. IV. Series.

N6559.C68A4 2004

709'.2—dc22

2003027561

This book is dedicated to Mimi Muray Levitt and Nicholas C. Muray.

PUBLICATION OF THIS BOOK WAS MADE

POSSIBLE BY THE GENEROUS SUPPORT OF:

JANET AND JACK ROBERTS

RICHARD G. HARDIN

MIMI MURAY LEVITT

THE TEXAS COMMISSION FOR THE ARTS

THE GLADYS KRIEBLE DELMAS FOUNDATION

ACKNOWLEDGMENTS

At the Ransom Center, Leslie Wearb Hirsch, (past) Assistant Curator, for research and writing the Muray artists' biographical components and obtaining images and permissions; Rick Watson, Research Associate, for research and writing Covarrubias's theatrical caricature captions and obtaining images and permissions; Hilary Edwards, Research Assistant, for copyediting assistance on the preliminary manuscript; Erin Baudo, Plan II Intern, and Christopher Reece, Federal Work Study Student, for assistance in managing data and helping compile captions for the illustrations.

At the University of Texas Press, Mary LaMotte, for copyediting above and beyond the call of duty; Heidi Haeuser, for the beautiful design.

Mimi Muray Levitt and Bruce Proctor for their help in providing Muray family images.

Maria Elena Rico Covarrubias for granting permission to use her uncle's artwork throughout the book.

CONTENTS

THE COVARRUBIAS CIRCLE

Introduction THE COVARRUBIAS CIRCLE: NICKOLAS MURAY'S COLLECTION OF TWENTIETH-CENTURY MEXICAN ART

Kurt Heinzelman

Executive Curator for Academic Affairs,
Harry Ransom Humanities Research Center

This book contains color plates of virtually all the items in Nickolas Muray's collection of twentieth-century Mexican art.[1] It thus fulfills the purpose of the Harry Ransom Humanities Research Center Imprint Series, jointly sponsored by the Ransom Center and the University of Texas Press, to produce in print format unpublished work—both textual and visual—from the Ransom Center's collections. An essay by the Center's Associate Curator of Art, Peter Mears, describes the provenance of the Muray Collection, the importance of the individual works, the interest of the collection as such, and its relationship to other Latin American holdings at the University of Texas.

The occasion for the publication of this book is also the Ransom Center's exhibition of the artistic and cultural work of the Mexican artist Miguel Covarrubias, whose productions comprise 90 percent of the Muray Collection. Indeed, Miguel was the godfather of Muray's daughter, who was given the unusual (for a girl) name of Michael—nicknamed Mimi—and to whom the present volume is dedicated.

The motivation for the exhibition "Miguel Covarrubias: A Certain Clairvoyance" is, in turn, the centennial celebration of his birth on November 22, 1904. For most of the past century the dominant Mexican artists, in the eyes of both critics and the general public, have been Diego Rivera, José Clemente Orozco, and David Alfaro Siqueiros, artists who attained their earliest renown as muralists. These men have been belatedly joined by Frida Kahlo, whose current fame, especially as promulgated through a single iconic photograph by Nickolas Muray, is the subject of one of the essays below (all of which are original to this volume). The aim is not to shoehorn Covarrubias into this upper echelon, or even to install him in the next tier of artists, which includes, most notably, Rufino Tamayo and Roberto Montenegro, as well as Fernando Castillo, Guillermo Meza, Rafael Navarro,

and Juan Soriano, all of whom are represented in Muray's collection. Rather, we wish to reexamine, from the historical vantage of a new century, the pervasive cultural role of Covarrubias and his circle in their own time as well as explore their legacy for us today. A crucial member of that circle is the understudied yet equally important cultural impresario Nickolas Muray.

Covarrubias, in many ways, has been lost to official—meaning largely Anglo—cultural histories of the modernist era, but he has not been forgotten in Mexican, or even perhaps in Mexican American, cultural consciousness. The problem is that few who do remember Covarrubias recall his exact importance, although they may call up one or two famous incidents from his life and career—an "Impossible Interview" in *Vanity Fair*, say, or his work on Mexico's pre-Hispanic cultures. One question that both this book and the Ransom Center's exhibition wish to pose is how and why Covarrubias's specific accomplishments have passed from consciousness. Why don't we know more fully this successful and, in his time, extremely influential man of art and letters?

One answer is that Covarrubias worked in some of art's most ephemeral forms of representation. Caricature, the genre in which he gained his greatest critical recognition and public fame, has a long and important history as a specifically Mexican genre—witness the great practitioner of the revolutionary era, José Guadalupe Posada. But caricature's endurance usually depends as much on the caricatured subject's successful withstanding of the test of time as it does on the skill of the caricaturist in rendering that subject. Caricature is not considered the equivalent of large-scale murals or even oil portraiture (although Covarrubias also composed both murals and some very fine easel paintings in oil). Moreover, many of Covarrubias's other accomplishments in design, arts administration, book illustration, and as a collector are activities insufficiently grand to interest anyone but social historians. Even in the fields of museology and archaeology, the singular collection of Olmec artifacts that Covarrubias and his wife acquired has been dispersed among the holdings of Mexico City's National Museum of Anthropology in such a way as to lose the "collection" as a unique cultural icon, the mark of an inspired and particularly learned collector. While it is true that some of Covarrubias's designs for the public exhibitions he curated still exist (in the archives of the Universidad de las Américas at Puebla, for instance), these do not depict exhibitions of his own collections. At the Museum of Anthropology, "Covarrubias" is an honorific name for one wing of the building, not for a collection that can be publicly displayed or even archivally retrieved.

Covarrubias's own work has enjoyed, in this hemisphere, only five exhibitions since his death in 1957. The first, as Adriana Williams points out in her excellent 1994 biography of Covarrubias (also published by the University of Texas Press), was put together hurriedly in Mexico City shortly after his death; there would not be another public exhibition in Mexico until 1981, almost a quarter-century later. The first major showing of Covarrubias in the United States, in 1984, appeared under the auspices of the Smithsonian's National Portrait Gallery in Washington, D.C., and focused exclusively on the caricatures. A full retrospective then arrived in 1987 at the Centro Cultural Arte Contemporáneo in Mexico City, along with an accompanying catalogue addressing all areas of Covarrubias's interests

and achievements. This volume, *Miguel Covarrubias: Homenaje,* an amply illustrated series of essays by diverse hands, was at the time the best book-length treatment of Covarrubias's impact on twentieth-century Mexican art, to which one must now add *Miguel Covarrubias: Artista y explorador* (Mexico City: Editions ERA, 1993) by Sylvia Navarrete, who was one of the contributors to the earlier *Homenaje.* Finally, more than a decade later, in 2000, an exhibition at the Mexican Museum in San Francisco drew on Adriana Williams and her husband's personal repository of Covarrubias materials.

The Ransom Center's exhibition is not a true retrospective; still less is this book an exhibition catalogue. The concern here is to explore the idea of a cross-fertilization between modernist artists working in different media, from painting and photography to dance and ethnography. In further examining the media transgressions that defined modernism, wherein artists drew influences and developed techniques across the boundaries of discrete aesthetic genres, this book expands upon the Ransom Center's earlier book and exhibition, both titled *Make It New: The Rise of Modernism.* Indeed, "Covarrubias: A Certain Clairvoyance" opens almost a year to the day after the modernism exhibition. Because that earlier exhibition's version of modernism depended exclusively upon the Ransom Center's own holdings, the principal emphasis fell on what might be called the east-west axis of modernism—its British/French/American nexus. But that, of course, is only part of the story. As José E. Limón demonstrates in one of the essays below, modernism also had a south by southwest axis. On this axis, Covarrubias's apartment in Greenwich Village, his later studio on 45th Street, and his house at Tizapán outside Mexico City were essential coordinates.

Modernism may have begun in the 1890s, but it reached ascendancy in the period between the two world wars. Many critics have regarded 1922 as a high-water mark for the various aesthetic ideas and artistic techniques that reshaped the new century's understanding of creative practice and theory. One of the triumphs of modernism was surely the way it reassessed the cultural value of art itself, including for the first time lowbrow and commercial art as well as the various artifactual contributions of so-called primitive societies. *Reading 1922,* Michael North's important book, is less an investigation of the actual cultural events of 1922 than it is a cross section of attitudes, including both implicit cultural presumptions and explicit socioeconomic mores, that remained largely unexamined by contemporary commentators—the "ideology" of 1922, so to speak. It is therefore worth reviewing what actually did happen in that totemic year.

It was the year of T. S. Eliot's *The Waste Land,* of course, and of James Joyce's *Ulysses*—two of the four or five seminal works of the century. But there was also Virginia Woolf's *Jacob's Room,* Sinclair Lewis's *Babbitt,* F. Scott Fitzgerald's *Tales of the Jazz Age,* Rilke's *Sonnets to Orpheus,* Paul Valéry's *Charmes,* and Edith Sitwell's *Façade.* E. A. Robinson's *Collected Poems* won the Pulitzer that year and A. E. Housman's *Last Poems* was published on the other side of the Atlantic, but these were anti-avant-garde examples of what modernism was not. Modernism was better represented by the appearance of Bronislaw Malinowski's *Argonauts of the Western Pacific,* which redefined the nature of anthropological inquiry, a subject vital to Covarrubias's imagination; the English transla-

tion of Wittgenstein's *Tractatus,* a breakthrough work in the philosophy of meaning; Marcel Duchamp's *Large Glass* and Joan Miró's *The Farm,* both cornerstones for new kinds of pictorial representation; Louis Armstrong's arrival from New Orleans to join King Oliver in Chicago, a vital melding of different jazz idioms, ideas of virtuosity, and ensemble playing—subjects that Covarrubias would brilliantly document in his Harlem sketches; and finally the construction of a new concrete tennis stadium on Church Road at Wimbledon, where Helen Wills, later the subject of one of Covarrubias's most famous caricatures, would shortly introduce the modern baseline power game she had learned playing against men on the West Coast. In 1922 Covarrubias, only eighteen years old, still living in postrevolutionary Mexico, was helping to curate two major exhibitions, one on Mexican arts and crafts, the other on folk arts.

The next year, 1923, he arrived in New York City.

By all accounts, he took the city by storm. Within the year he was publishing in *Vogue, Vanity Fair,* and the *New Yorker.* One should remember that New York City of the 1920s and 1930s was not simply a spawning ground for American-born artists waiting to decamp for Europe. It was itself a thriving expatriate community, a rival of London and Paris, that attracted many artists from Europe, Latin America, and elsewhere (including some, like Hart Crane and Langston Hughes, from the American hinterlands of Ohio and Kansas). They came for many of the same reasons that Europe attracted Americans.

Nickolas Muray was such an expatriate, having arrived in 1913, as was his friend Winold Reiss, the Austrian-born painter and decorator who was to create the bulk of the illustrations for Alain Locke's revolutionary collection *The New Negro* in 1925. So were the poet Moyshe-Leyb Halpern, the young Galician immigrant who in 1919 published his first book in New York in Yiddish; the Swiss-born, French-speaking Frédéric Sauser, who wrote under the pseudonym Blaise Cendrars; and the Spanish visitors Juan Ramón Jiménez in 1916, Leon Felipe in the mid-twenties, and Frederico García Lorca in 1929.

Not all of these visitors were true expatriates who intended to stay in the States or were fleeing persecution. Many, like Covarrubias, were simply curious, adventurous, or just looking for an economic break. They were absorbing; they were observing; they were not necessarily rooting themselves. Covarrubias, who came, saw, and conquered the city, returned to Mexico frequently, even when he "lived" in New York.

Nickolas Muray, on the other hand, never intended to return to his native Hungary, where he faced conscription into the Austro-Hungarian army, among other things. An innovative photographer doing pioneering work in the color carbro process, Muray was also, like Covarrubias, immensely successful as a commercial artist. Perhaps this is one reason he has not been studied by either art or cultural historians. Although now overshadowed by photographers like Edward Weston, Edward Steichen, and Margaret Bourke-White, Muray may fit in with the next group of important photographers, also undervalued—people like Anton Bruehl, Lejaren a Hiller, Adolf De Meyer, and Paul Outerbridge. There is no biography of Muray like Williams's of Covarrubias, only biographical sketches in various encyclopedias or collection catalogues, and there is virtually no sustained piece of secondary critical study. The essay below by Mary Panzer, the former Curator of Photog-

raphy at the National Portrait Gallery in Washington, is the first publication of its kind; that is, an essay of significant length which analyzes the oscillations of Muray's own critical and popular reputation as a photographer, while also unveiling new characteristics of his personal life—the qualities that made him both a financial success and a beloved friend of artists.

The point is that Covarrubias and Muray, overlooked though they now may be, were both major players in New York City's particular urban version of transnational modernism. For Muray, who was himself well-networked, Covarrubias was the center and source of all connections Mexican or Latino. It was through Covarrubias that Muray met Frida Kahlo, with whom he would have a lengthy love affair. We do not know how Muray came to acquire all of his artworks (presumably his Kahlos are directly from the artist herself; they may even refer to him). It is significant, though, that Muray owned at least one piece by most of the notable Mexican artists of the century, and that invariably his one example is a major work by that artist. One presumes that his oarsman here was Covarrubias. This is not to suggest that Muray did not have a fine eye of his own, only that Muray's collection does not exhibit the intensity of focus or thematic connoisseurship of collectors such as Jacques and Natasha Gelman, for example.[2]

In an essay below, the scholar José E. Limón, Director of the Center for Mexican American Studies at the University of Texas, identifies what he calls a "Greater Mexico" in twentieth-century art and letters and a concomitant Mexicanophile discourse. In another essay, Wendy Wick Reaves, Curator of Prints and Drawings at the National Portrait Gallery and author of *Celebrity Caricatures in America* (Yale University Press, 1998), the most comprehensive study of the subject, identifies a "vogue for all things Mexican" in the twenties and thirties. Turning to Covarrubias in particular, one is tempted to speak of this period immediately following the Agrarian Revolution in Mexico as the "Mexican Decades." Certainly Covarrubias participated in and even presided over the cultural scene in that thirty-year span from the mid-twenties to the mid-fifties as few others did, whether Mexican or not.

There is a graphic illustration in the 1987 *Homenaje* volume that depicts a genealogical tree of Covarrubias's accomplishments (Figure 1): anthropologist and archaeologist; author of many books; scholar in traditional or folk art, primitive art, the art of masks, and the social sciences; ethnographer, cartographer, cosmogonist, and museologist; professor; dance and museum administrator; art collector; magazine designer and book illustrator; sculptor and caricaturist. The only thing missing from this list is set and costume designer, one example of which is represented in Muray's collection. I think it could be argued, in respect to the Mexican Decades, that Covarrubias was a modernist impresario par excellence, at least as important in his sphere of influence as Pound or Eliot, Apollinaire or Cocteau, Kandinsky or Stanislavsky were in theirs.

What made Covarrubias different, though, was that he was highly successful in commercial terms. As with Muray, in fact, one wonders if Covarrubias's early and intense popular successes partly explain his subsequent decline in critical reputation in the last half of the twentieth century. Although we now know better than ever how even the most dif-

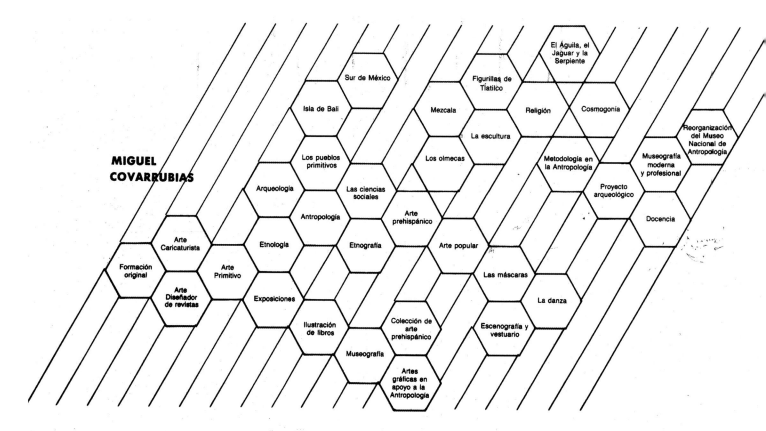

Figure 1. A genealogical tree of Covarrubias's accomplishments. From *Miguel Covarrubias: Homenaje* (Mexico City: CCAC, 1987).

ficult artworks of the modernist era were skillfully packaged and marketed, Covarrubias—who was not a "difficult" artist but who was more avant-garde in his techniques than he is usually given credit for being—was a master marketer. Approached by the Container Corporation of America in the late 1930s to do a series of advertising images, Covarrubias not only executed that contract but managed to extend it through 1947.[3] A similarly grand commission was to paint six huge cartographic murals for the San Francisco World's Fair in 1939.

But nothing compares to the skill with which the so-called Bali craze was created, which lasted into the early war years and perhaps was still informing such works as James Michener's *Tales of the South Pacific* even after World War II. To put it benignly, the "craze" resulted from how Covarrubias made his Balinese anthropological work available to the public. He did so in carefully constructed increments—"glimpses," his biographer calls them—of text and image, published here and there in small and large venues alike, in both print media and exhibition spaces. Thus began, his biographer concludes, a kind of fashion frenzy: his Balinese cover adorned the last issue of *Vanity Fair* in February 1936, his cover for *Vogue* in July 1937 was awarded "Best Magazine Cover of the Year," *Life* magazine did a full spread on what they called his "Dutch Bali" book, and the Franklin Simon department store feted Covarrubias in a show called "Bali Comes to Franklin Simon." And all this before his book *Island of Bali* appeared in mid-November 1937.

Another of Covarrubias's most popular and critical successes, which appeared in the pages of *Vanity Fair*, was the so-called "Impossible Interview," illustrated by him and

scripted by his collaborator Corey Ford, in which two people who could not possibly meet are forced to converse. One of the most notorious was between John D. Rockefeller and Joseph Stalin. And yet, the concept of "impossibility" in terms of Covarrubias's own circles of friendship and influence is a malleable one. Covarrubias and his friends, like many artists of the time, were Communist sympathizers; the original collection of Muray's art offered at auction after his death was titled by the auction house "Covarrubias and His Distinguished Comrades." One comrade, Diego Rivera, knew and admired Trotsky, who spent his last years in Mexico, part of the time with Rivera and Kahlo. When Rivera wanted to include the figure of Lenin in his commissioned mural for the Rockefeller Center in New York, the Rockefellers objected. When Rivera refused to remove the likeness of Lenin, the mural was dismantled. Yet Nelson Rockefeller, John D.'s son (and portrayed in the movie *Frida* as the one who executes the dismantling), was a good friend of the Covarrubiases. In one photo, he is seated at Tizapán between Rosa Covarrubias and Frida Kahlo where Trotsky, if not Stalin, could easily have been seated as well.

Thanks in large part to the friendship of people like Muray and Weston, the Covarrubias circle is well documented in photographs, so often we can literally see who is who (Figure 2). An imaginary photograph of the implausibly, almost impossibly large circle of Covarrubias's friends would include—in addition to the scion of one of America's greatest capitalist families as well as the founder of the Bolshevik revolution in Russia—such literary figures as D. H. Lawrence and his New Mexican *compadres*, plus Langston Hughes and Zora Neale Hurston; theater and movie people such as Fredric March, Orson Welles, Claudette Colbert, John Huston, Dolores del Rio, and Eugene O'Neill's Provincetown Playhouse coterie; musicians such as W. C. Handy and Ethel Waters; and of course photographers and writers (such as Carl Van Vechten), artists and dancers (such as Georgia O'Keefe and George Balanchine), and people from the publishing and museum worlds (such as W. A. Barr, the first director, in 1929, of the new Museum of Modern Art; Frank Crowninshield, editor of *Vanity Fair,* and George Macy, founder of the Limited Editions Club). This latter group in particular gave Covarrubias highly visible and fiscally rewarding, but also aesthetically important, assignments, such as Macy's commissioning of illustrations for Harriet Beecher Stowe's *Uncle Tom's Cabin,* which Covarrubias regarded as a defining spiritual moment.

I conclude by focusing on Covarrubias as author because it was in his written work that he engaged an anthropological concept controversial both in its own day and today, though perhaps for different reasons. This concept, which Covarrubias himself called cross- or circum-Pacific culturation in his 1954 book *The Eagle, the Jaguar, and the Serpent,* encompasses the idea that archaic or primitive societies borrowed artifactual and symbolic elements from one another. For Covarrubias, who had in mind mainly Pacific Rim cultures, the idea implied actual physical contact between the peoples he studied, whether Meso-American, Malaysian, North American Indian, or third-millennium BC Chinese. Leaving aside for a moment the validity of the concept from the disciplinary perspective of the anthropologist, this transculturation contested the principle of discrete tribal coherence or—to translate into the geopolitics of Covarrubias's own time—the ide-

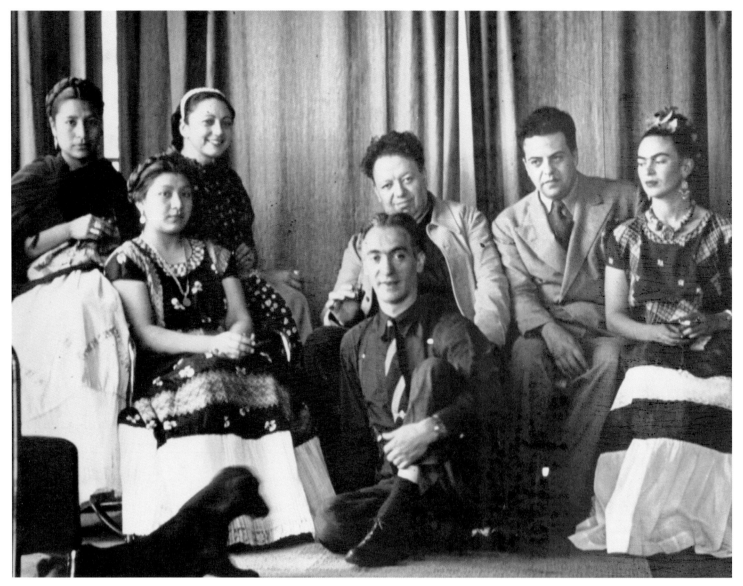

Figure 2. *Untitled,* by Nickolas Muray, 1939. Left to right: Beta and Alfa Ríos Pineda, Rosa Covarrubias, Diego Rivera, Miguel Covarrubias, Frida Kahlo, and Nickolas Muray (seated in front). Published in *Life,* January 23, 1939. Silver gelatin photograph. © Nickolas Muray Photo Archives, courtesy Mimi Muray.

ology of nationalism, the premise that particular tribal or national identities are distinct and inviolable . . . and that some are superior to others.

The political context is not incidental to the controversy, then or now. Again using 1922 as our prism, in that year the Irish Free State was founded, Mussolini formed a Fascist government in Italy, Mustafa Kemal declared Turkey a republic, and the Soviet states bonded together as the USSR. (Although Covarrubias might have considered this last event anti-nationalist, the founding of a true socialist republic, in retrospect we can see that the USSR was a union so hegemonically weighted toward certain Soviet states—Russia in particular—as to warrant comparison with other contemporary assertions of nationalistic dominance.) Under the conditions of nationalism—and these are the conditions of postwar life from the 1920s perhaps to the present day—one *must* make an argument that

to be Irish, say, is to be antithetical to the English. Or, alternatively, that to identify as Italian is to swallow up local distinctions separating Triestine from Amalfian. For Covarrubias, however, transculturation was a more complex balancing of factors, rather like the gardens and interior spaces of Tizapán as designed by Rosa Covarrubias, with their eclectic but decidedly "Mexican" aura accented by non-native plantings from all over the world, their pre-Columbian jades set beside African and Asian idols, and their bright contemporary paintings placed next to primitive tin and traditional terra-cotta objects.[4]

Perhaps an even better example is Rosa's kitchen. As a cook (and her prowess was legendary) she was not afraid to assert cross-cultural influences—what culinary lessons she had learned in China or Cuba, for example—against an essentialist view of a "natural" culinary taste (or culture). Put this way, transculturation may resemble what is now called in cooking circles "fusion." But fusion cuisine often obliterates the indigenous integrity of the dish. Transculturation is more like traditional Mexican cuisine itself, whose history Rosa researched and championed: a merger of diverse elements that became recognizably "Mexican" and yet remained distinct. The vermicelli may be Italian, the chocolate Nahuatl, but the dishes that use them are Mexican. Such is the merger part. The diversity part is that, to this day, regional Sonoran dishes may have nothing in common with those from the Yucatán; those from Chiapas may be entirely unlike those from Nuevo León.

In an intercultural spirit, we asked essayists from multiple disciplines and with diverse intellectual interests, both curators and scholars, to contribute to this volume. What their essays reveal is paradoxical—a modernism that was international in character and yet rooted in folk or indigenous traditions, transnational but also ethnocentric. Nancy Deffebach, in her discussion of the high-fashion photo by Muray of Frida Kahlo known as "The Magenta *Rebozo*," points out how the picture alludes to the fine arts (the modeling and coloration of Piero della Francesca, say) even as it becomes, like the *Mona Lisa,* a mass-reproduced image, as likely to show up on a refrigerator magnet or altar box as anyplace else. In its origin, the photograph is private in what it signifies—the love affair between Muray and Kahlo—yet there is evidence Kahlo's husband, Diego Rivera, hung it after her death where, traditionally, the image of the Madonna would hang: above his bed. The secular eros of marital infidelities thus meets the sacred and the devout, with the further irony that the *casa azul* where Rivera hung the photo is now a tourist site, the Museo Frida Kahlo. Where *casa* meets *museo,* where refrigerator magnet meets Quattrocento fresco, is, if nothing else, an intriguing site of cultural merger.

Or consider Covarrubias, one last time. Having begun in his teens to collect indigenous pre-Columbian art, Covarrubias then moved to New York and became famous for his depictions of African American culture, even as he practiced an art form—caricature—with deep roots in his own native Mexican tradition. José E. Limón, focusing on José Limón, the most famous Mexican dancer of the century, discovers how he, the scholar, unwittingly entered the circle of Covarrubias's influence and importance. Covarrubias was married to a dancer but he also, as the head administrator of the Bellas Artes, encouraged the revival of pre-Hispanic dance. It was Covarrubias who urged Limón the dancer to make a tour through Texas in the 1950s and to make stops not just in large

urban venues, like Dallas, but in places like Laredo, on the Mexican border. There he was seen by a young, reluctant, and awkwardly bespectacled would-be (at least if his mother had anything to do with it) dance student, also named José Limón. Later, Limón the scholar—to put crudely what he forms as a nuanced argument—came to the conclusion that the United States was indeed a part of greater Mexico.

For me, one of the more fascinating revelations of this book is the modernist rage for what I have called "cultural merger," meaning the blending of high and popular, fine and folk—but also Mexican and more northern American—arts. Also fascinating, though necessarily unaddressed here, is the question: what happened to this merger? The issue grows even more important as the population of the United States becomes ever more Hispanic. For now, though, the term "cultural merger" points to what Miguel Covarrubias, more than any other figure of that high modernist period, exemplified.

Notes

1. A few minor, redundant, or damaged images have not been included, but these are described in an appendix.
2. See *Frida Kahlo, Diego Rivera, and Twentieth-Century Mexican Art: The Jacques and Natasha Gelman Collection* (San Diego: Museum of Contemporary Art, 2000).
3. Adriana Williams, *Covarrubias*, ed. Doris Ober (Austin: University of Texas Press, 1994), 96.
4. See Williams's description of Tizapán in *Covarrubias*, pages 126–127; she also provides photographs of the gardens, terrace, and interior on page 112 and pages 114–115.

NICKOLAS MURAY, HIS FRIENDS, AND HIS ART COLLECTION

Peter Mears

Associate Curator of Art,
Harry Ransom Humanities Research Center

Photography . . . has not only been a profession but also a contact between people.
NICKOLAS MURAY, *Celebrity Portraits of the Twenties and Thirties*

Nickolas Muray (1892–1965), acclaimed celebrity photographer of the 1920s and 1930s, acquired a small but remarkable collection of Mexican art during his lifetime. The collection is valued today for the intrinsic worth of the artwork it contains, but it also represents the spirited interaction Muray shared with a circle of Mexico's first generation of modern artists visiting and living in New York City, which included Miguel Covarrubias and his wife, the dancer Rose Rolanda (who later changed her name to "Rosa"); Frida Kahlo and her husband, Diego Rivera; and Rufino and Olga Tamayo.

Spanning the years 1925 to 1954, Muray's collection includes eight artists whose works reflect a range of aesthetic shifts and modernist influences of the period in Mexico. Miguel Covarrubias's artworks compose the largest part of Muray's collection and represent his earliest acquisitions. Both men gained acclaim in New York as celebrity portraitists, becoming artistic peers and confidants in business and personal affairs. Their lasting relationship—initially sustained through the publishing business—enabled Muray to acquire ninety of his close friend's caricature drawings, paintings, and book and magazine illustrations, creating one of the largest collections of Covarrubias's artwork in North America. The collection offers rare examples of Covarrubias's artistic achievements as principal caricaturist for *Vanity Fair* and the *New Yorker*. His inventive ink and gouache drawings of café socialites, politicians, athletes, and trendsetting personalities of stage and screen—the latter prominent in *Vanity Fair*'s "Impossible Interviews" series—remain

as surprisingly fresh and upbeat today as they were during celebrity caricature's golden years in the 1920s and 1930s, when young artists, the mass media, and a burgeoning magazine readership all helped redefine and transform this subgenre of portraiture into a new and vibrant art form.

Throughout his career, Covarrubias maintained a scholarly interest in overlooked native cultures, eventually illustrating and authoring a variety of books whose subjects ranged from the blues and Harlem's cultural renaissance to the island of Bali and Mexico's Isthmus of Tehuantepec. Muray's collection includes illustrations for René Maran's African novel *Batouala* (1932), Herman Melville's *Typee* (1935), Covarrubias's own publication *Island of Bali* (1937), and Bernal Díaz del Castillo's sixteenth-century account *The Discovery and Conquest of Mexico* (1942), a book Covarrubias had wanted to illustrate for years. Illustrations for *In the Worst Possible Taste* (1932) continued Covarrubias's collaboration with the book's author, John Riddell (Corey Ford), with whom Covarrubias created the infamous ongoing "Impossible Interviews" series, first published in *Vanity Fair* and later seen in *Vogue*.[1]

Muray's alliance with Covarrubias also provided entry to a circle of artists distinguished today for their individual contributions to post-revolutionary Mexican art. With the exception of one or two works, the paintings in Muray's collection are fine examples of the time period's modernist experimentations. There are mysterious and surreal landscapes by Roberto Montenegro and Guillermo Meza, as well as tongue-in-cheek references to Cubist form and space in Rufino Tamayo's neo-primitive painting *Cow Swatting Flies*. Traces of surrealism are also found in the ominous, dream-like composition of Mexican folk toys by Rafael Navarro and in Frida Kahlo's transcendent work known as *Self-Portrait with Thorn Necklace and Hummingbird*, though the overwhelming religious (Christian) and indigenous (pagan) symbols interwoven throughout this work anchor Kahlo's vision in what is truly Mexican.[2] With its emphasis on patterning and simplified detail, Fernando Castillo's enchanting portrait of his daughter is also firmly grounded in native culture, but to different effect as the subject (childhood) and an unfettered artistic style are in complete harmony. Along with Meza and Navarro, Juan Soriano represents the younger generation of Mexican artists in Muray's collection. The delicate allegorical theme within his classic nude study exemplifies his investigation of the female figure and its potential to express the human spirit. With the exception of Castillo, all of these artists were participating in Mexico's greater artistic mainstream.

Along with Covarrubias, Kahlo and Tamayo also shared a close kinship with Muray, a fact made visibly evident by the dedicated work found in his collection. Rufino Tamayo's larger-than-life portrait of Muray, created in 1954 (Figures 1 and 2), and Frida Kahlo's intimate drawing *Diego y Yo*, a self-portrait with her husband Diego Rivera, inscribed in ink "For Nick with love" (Figure 3), are two fine examples of this intimacy. The former was a gesture of friendship, an act of one artist honoring another, the latter an ironic memento honoring both Kahlo's love affair with Muray and her marriage to Rivera.[3]

Nickolas Muray immigrated to New York from Europe in 1913, the same year that European modernism was unveiled to a shocked American public in the now-famous "Ar-

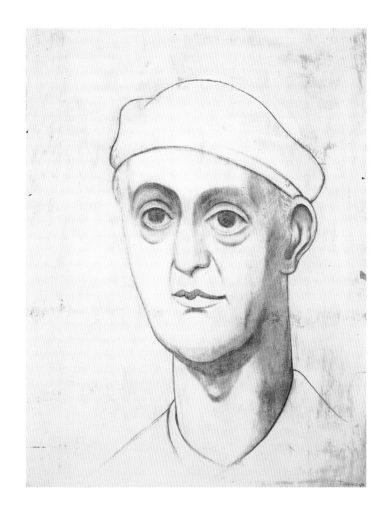

Figure 1. *Nickolas Muray,* by Rufino Tamayo, 1954. Charcoal on white wash on plywood, 102.5 x 77 cm. (40⅜ x 30⁵⁄₁₆ in.). Harry Ransom Humanities Research Center, University of Texas at Austin. © Estate of Rufino Tamayo

Figure 2. *Nickolas Muray sitting for his Tamayo portrait,* attributed to Nickolas Muray, 1954. Silver gelatin photograph. © Nickolas Muray Photo Archives, courtesy Mimi Muray.

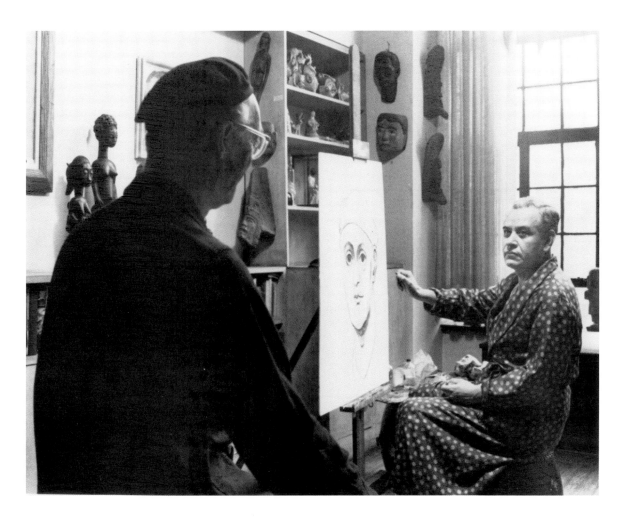

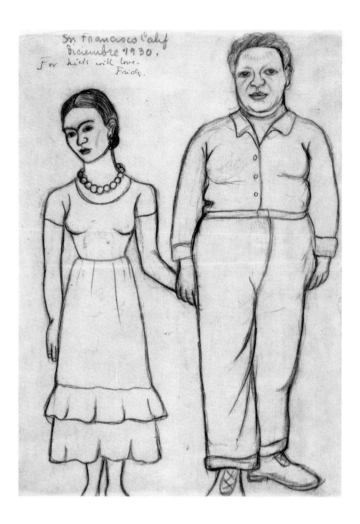

Figure 3. *Diego y Yo* (Diego and Me), by Frida Kahlo, 1930. Charcoal, graphite, and ink on paper, 29.5 x 21.5 cm. (11⅝ x 8⁷⁄₁₆ in.). Inscribed "For Nick with love." Harry Ransom Humanities Research Center, University of Texas at Austin. © 2003 Banco de Mexico Diego Rivera & Frida Kahlo Museums Trust. Av. Cinco de Mayo No. 2, Col. Centro, Del. Cuauhtémoc 06059, Mexico, D.F.

mory Show." Though coincidental, Muray's co-arrival with the modernists symbolizes an important moment in New York's fertile art scene. It was a time of great experimentation and vying international philosophies in the arts (from New York to London, Paris, and Berlin), a time when modernism seemed less a cohesive movement than a series of diverse cultural developments or "modernisms."[4] The shadow of war in Europe and the ensuing migration across continents were helping shape this transatlantic conversation in the arts. As Muray and thousands of others moved west to New York and the American land of economic promise, others were drawn east from New York to a decidedly more liberal Paris, still the center of modernist experimentation and the artistic freedoms associated with it. Much has been written about this east-west cultural exchange, but there was another important aspect of this cultural conversation, one that flowed north and south between New York and Mexico.

The 1920s marked both a turning point and a new beginning for Mexican politics and culture. Covarrubias's arrival in New York in 1923 followed a decade of revolutionary turmoil in Mexico. President Alvaro Obregón's post-revolutionary government launched literacy campaigns and focused on art education, open-air schools for working-class citizens, and a landmark mural movement. The muralists, José Clemente Orozco, David Alfaro Siqueiros, and Diego Rivera, would lead the nation's artists in forging a modern,

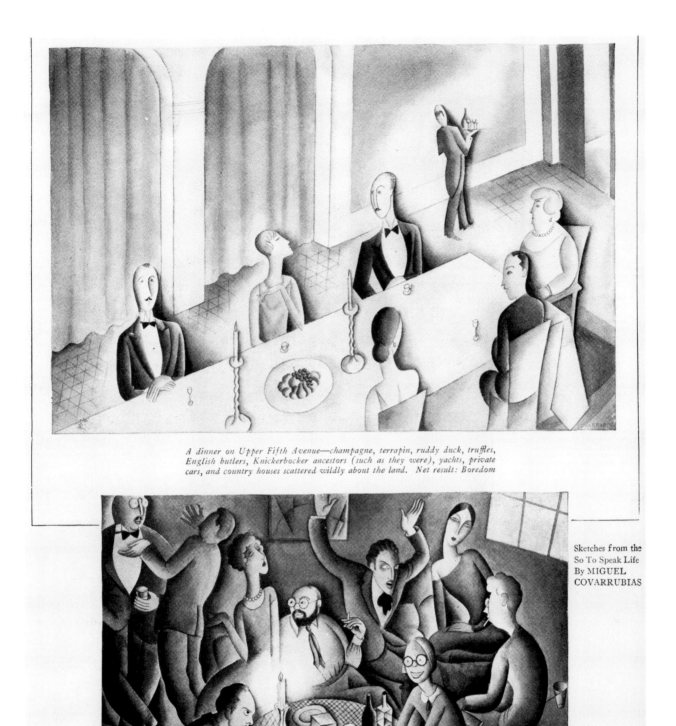

A dinner on Upper Fifth Avenue—champagne, terrapin, ruddy duck, truffles, English butlers, Knickerbocker ancestors (such as they were), yachts, private cars, and country houses scattered wildly about the land. Net result: Boredom

Sketches from the
So To Speak Life
By MIGUEL
COVARRUBIAS

Oscar Wilde was right! There is nothing more horrible than *not* to be in society—except to be *in* it. "Look now on this picture—and on this!" At the bottom of the page, we see lower Fifth Avenue, say Eighth Street, Greenwich Village. They are thinkers all. Yes, thinkers, and—even more—talkers. Steady talkers. They talk about Art and Paganism, the Shame of the Censors, the Crime of Plutocratic Government in America. Down with the bourgeoisie; up with the Soviet; up with Stravinsky; and, most of all, up with Sex. Net result: Boredom. At the top of the page we see upper Fifth Avenue: people with money, position, and Social Registers

The Horrors of Fifth Avenue Society—At Both Ends

Problem: Which is more ghastly, speaking socially,—upper or lower Fifth Avenue?

Figure 4. *The Horrors of Fifth Avenue Society—At Both Ends*, by Miguel Covarrubias. Published in *Vanity Fair*, May 1925. Covarrubias's full-page illustration pairs the lifestyles of the well-heeled with those of the avant-garde. See color plate 16.

national art movement that rejected earlier European influences in favor of more human-itarian subject matter inspired by indigenous culture. These artists, helped by the govern-ment-sponsored programs of Mexico's newly formed Ministry of Education, would foster a spirited artistic renaissance throughout the country.[5]

Covarrubias was a beneficiary of these ambitious programs, which promoted post-revolutionary Mexico and Mexican artists abroad. Already well established as a dedicated arts educator, theatrical set designer, and gifted caricaturist in Mexico, Covarrubias would find work in New York almost immediately. His refined india ink drawings dovetailed well with the restrained tastes of the publishers and discerning readership at *Vanity Fair,* where his portraits brought his first acclaim. Covarrubias's youthful energy and beguiling per-sonality impressed everyone. Thanks to the writer and photographer Carl Van Vechten, who tirelessly promoted the young artist, Covarrubias made a number of critical contacts, including Nickolas Muray, in New York's artistic and publishing circles. Van Vechten wrote, "From the beginning, I was amazed at his [Covarrubias's] ability to size up a person on a blank sheet of paper at once: there was a certain clairvoyance in this."[6]

The Horrors of Fifth Avenue Society—At Both Ends, published in May 1925 (Figure 4), is the earliest Covarrubias drawing in Muray's collection. This humorous, comparative critique of two New York lifestyles reflects the artist's post-revolutionary position on elit-ism as well as the magazine's interest in promoting style and exploring urban life. The mo-tivation for this caricature was undoubtedly inspired by Covarrubias's memories of his first New York apartment in Greenwich Village, as well as Muray's legendary Wednesday night parties in his photography studio and residence at 129 MacDougal Street, also in the midst of the Village. It was a decidedly avant-garde neighborhood, peopled by Edna St. Vincent Millay, E. E. Cummings, Djuna Barnes, Kenneth Burke, Marianne Moore, Hart Crane, William Carlos Williams, Georgia O'Keefe, Charles Sheeler, Katherine Anne Porter, and Paul Robeson, among many other artists and writers. Indeed, the talents of playwright Eugene O'Neill were being featured at the Provincetown Playhouse, only a few doors away on 133 MacDougal Street.[7]

In 1925, Muray moved his studio uptown, where he would eventually develop one of the first commercial color labs in the United States and become an expert in the carbro print, a medium—in the hands of a master—capable of producing lush colors of excep-tional brilliance and permanence. That same year, Alfred Knopf published Covarrubias's first illustrated book, *The Prince of Wales and Other Famous Americans,* a selection of celebrity caricatures created only two years after his arrival in New York. Interestingly, Muray had also captured on film at least twenty-four out of the sixty-six subjects appear-ing in Covarrubias's book (Figure 5).[8] Clearly the two men had become artistic peers within the publishing business. Their popular subjects suggest the kind of social and artistic circles in which both moved. In time, they would contribute images to such dis-tinguished publications as the *New York Times, Vanity Fair,* and *Vogue* and become life-long friends and confidants along the way, not to mention co-hosts of entertaining parties that remain legendary to this day.[9]

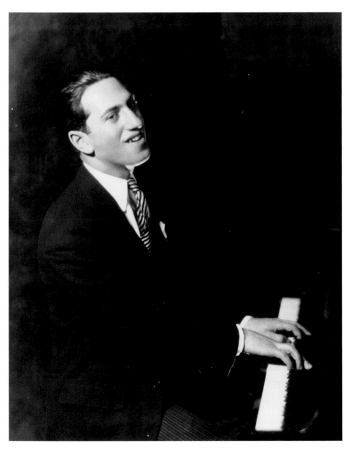

Figure 5a. *George Gershwin,* by Nickolas Muray, ca. 1922. Silver gelatin photograph. © Nickolas Muray Photo Archives, courtesy George Eastman House.

George Gershwin, by Miguel Covarrubias. Published in *The Prince of Wales and Other Famous Americans* (New York, 1925).

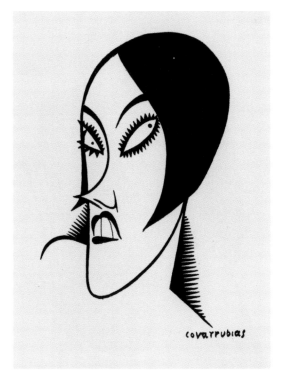

Figure 5b. *Gloria Swanson,* by Nickolas Muray, ca. 1922. Silver gelatin photograph. © Nickolas Muray Photo Archives, courtesy George Eastman House.

Gloria Swanson, by Miguel Covarrubias. Published in *The Prince of Wales and Other Famous Americans* (New York, 1925).

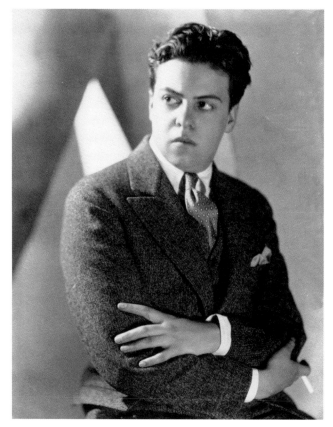

Figure 5c. *Miguel Covarrubias,* by Nickolas Muray, undated. Silver gelatin photograph. © Nickolas Muray Photo Archives, courtesy George Eastman House.

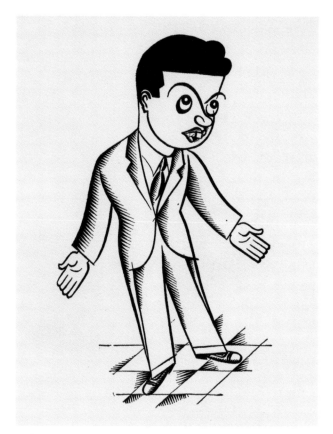

Self-portrait, by Miguel Covarrubias. Published in *The Prince of Wales and Other Famous Americans* (New York, 1925).

Figure 5d. *Eugene O'Neill with wife Agnes Bolton O'Neill, son Shane, and daughter Oona,* by Nickolas Muray, 1924. Silver gelatin photograph. © Nickolas Muray Photo Archives, courtesy George Eastman House.

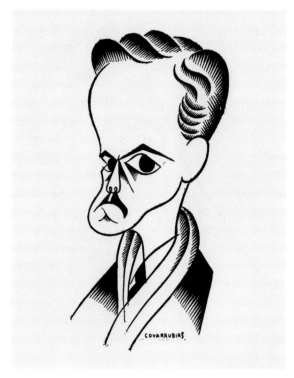

Eugene O'Neill, by Miguel Covarrubias. Published in *The Prince of Wales and Other Famous Americans* (New York, 1925).

In 1940, New York's Museum of Modern Art, in association with the Mexican government, organized the encyclopedic exhibition "Twenty Centuries of Mexican Art," whose scope included "Pre-Spanish, Colonial, Folk Art, and Modern" sections. As one of the exhibition curators, Covarrubias selected artwork for the "Modern" section; he also contributed an essay to the 198-page exhibition catalogue.[10] His friend Roberto Montenegro wrote the introduction to the "Folk Art" section. Of the eight artists in Muray's Mexican collection, seven appeared in this exhibition. Clearly, Muray's collection was influenced by Covarrubias's eye and shaped over time by friendship as much as by connoisseurship.

Muray's first documented contact with the University of Texas is a note dated October 10, 1963, addressed simply to the "Librarian." Muray wrote: "It is my understanding that you have a fine collection of memorabilia of Eugene O'Neill. In this connection you may be interested in some personal motion pictures which I was privileged to take while visiting him in Bermuda. These are unique in that they reflect a gaiety not usually associated with O'Neill, showing him at play with his family—Agnes, young Shane, and baby Oona. I also have many negatives of portraits, published and unpublished, from the many sittings I had with him"[11]

Muray's black-and-white silent film of the O'Neill family—perhaps the first ever to capture the famous but somber playwright at ease—joined the Ransom Center's film archive just three months following his inquiring note. The 1926 film clip includes a bonus sequence of the photographer hamming for the camera while walking upside down on his hands. Muray's poise, not to mention his demonstrated athleticism as captured on film, lends insight to his reputed charismatic character.[12] The scenes of O'Neill's "appealing sunny mood," mentioned in related correspondence,[13] demonstrate the photographer's ability to put his subjects at ease in front of a camera. Muray's capacity to connect with people, from developing business relations to cultivating lasting friendships with artistic peers, was a gift that lasted his lifetime. Through his collection it endures to this day.

Nickolas Muray's collection of Mexican art arrived in Austin just a few months after his death in November 1965. Listed in a New York auction catalogue as "Modern Mexican Artists: Covarrubias and His Distinguished Comrades," the collection joined Muray's film of O'Neill and the Ransom Center's immense Latin American collection, which includes: the Joshua B. Powers and Dr. Edward Larocque Tinker Collections, whose focus includes the pre-modern equestrian cultures of South America and Mexico as well as hundreds of broadsides by the inimitable caricaturist José Guadalupe Posada, an early influence on Covarrubias's work; the J. Frank Dobie and Dr. Thomas Cranfill Collections, containing, among other cultural materials, fine Texana and Mexican works of art; and the Dr. and Mrs. Dudley Winn Smith Collection of Latin American Art. Acquired in 1966, the Smith collection added eight important works by Diego Rivera and other artists to the Center's growing Modern Mexican Art Collection. Most recently, the Ransom Center received David Alfaro Siqueiros's *Portrait of George Gershwin in Concert*. Created in 1936 and based on a concert Gershwin gave at the Metropolitan Opera House on November 1, 1932 (his Concerto in F), this large oil on canvas was a gift from the Ira and Leonore Gershwin Estate.[14]

Notes

1. Humorist Corey Ford wrote under the pen name John Riddell. His articles, published in *Vanity Fair* during the Golden Age of Comedy, imitated current best-sellers. As collaborator on the "Impossible Interviews" series, Ford's lampoonery was the literary equivalent of Covarrubias's caricatures.

2. Kahlo would often disclaim her membership with André Breton's surrealists. She worked hard, however, to prepare two of her largest paintings—*Las dos Fridas*, 1939, and *The Wounded Table*, 1940—for the Mexico City "Exposición internacional del surrealismo" in 1940. See Dore Ashton, "Surrealism and Latin America," in *Latin American Artists of the Twentieth Century*, ed. Waldo Rasmussen (New York: Museum of Modern Art, 1993), 106–115.

3. Kahlo's ink inscription, "For Nick with love," is unique and substantially different from the location and date inscribed in pencil ("San Francisco Calif Diciembre 1930") during the creation of the artwork. This suggests that the drawing was given to Muray, possibly as much as a decade later, as a memento of their affair (which ended when Kahlo remarried Rivera in 1940).

4. Jack Selzer, *Kenneth Burke in Greenwich Village: Conversing with the Moderns, 1915–1931* (Madison: University of Wisconsin Press, 1996).

5. Laura González Matute, "A New Spirit in Post-Revolutionary Art: The Open-Air Painting Schools and the Best Maugard Drawing Method, 1920–1930," in *Mexican Modern Art*, ed. Mayo Graham (Ottawa: National Gallery of Canada, 1999), 29–43.

6. Carl Van Vechten, preface to *The Prince of Wales and Other Famous Americans*, by Miguel Covarrubias (New York: Alfred Knopf, 1925).

7. Jim Naureckas, "New York Songlines: MacDougal Street," http://home.nyc.rr.com/jkn/nysonglines/macdougal.htm.

8. Miguel Covarrubias, *The Prince of Wales and Other Famous Americans* (New York: Alfred Knopf, 1925); Paul Gallico, *The Revealing Eye* (New York: Atheneum, 1967).

9. Adriana Williams, *Covarrubias*, ed. Doris Ober (Austin: University of Texas Press, 1994), 51.

10. Miguel Covarrubias, "Modern Art," in *Twenty Centuries of Mexican Art* (New York: Museum of Modern Art, 1940).

11. Nickolas Muray to the librarian, October 10, 1963, Harry Ransom Humanities Research Center, University of Texas at Austin. Oona O'Neill would marry Charles Chaplin in 1943. They had eight children, one of whom was the actress Geraldine Chaplin.

12. Muray won the National Sabre Championship in 1927 and represented the U.S. Olympic Team in 1928 and 1932.

13. Nickolas Muray to F. W. Roberts, Director (HRHRC), November 11, 1963, Harry Ransom Humanities Research Center, University of Texas at Austin. Muray's 16 mm film was "shot early in 1926 . . . The playwright is shown relaxed, informally in a playful mood . . . So far as I know, this is the only motion picture instance of O'Neill, showing him in an appealing, sunny mood that runs directly counter to the general image of him as a somber, forbidding soul. All in all, a unique and revealing document."

14. The Ransom Center's collection compliments the greater circle of significant Latin American holdings at the Nettie Lee Benson Library, the Jack S. Blanton Museum of Art, and the Center for American History, all located at the University of Texas at Austin.

THE ESSENTIAL TACT
OF NICKOLAS MURAY

Mary Panzer

Hunter College

The essential tact in daring is to know how far one can go too far.

JEAN COCTEAU, *Le Rappel à l'ordre*

Nickolas Muray's fine collection of work by Miguel Covarrubias and other Mexican artists now brings attention to its collector, whose career has for too long been obscure to historians of photography and art. His success as a master of color photography, advertising imagery, and commercial illustration and portraiture has made him difficult to place within the history of photography as a fine art. Like many commercial photographers who began their careers after World War I, Muray made his best pictures expressly for the printed pages of magazines. He worked for editors and advertisers, for mainstream magazines like *McCall's* and *Good Housekeeping,* and for luxury publications like *Vanity Fair, Vogue,* and *Harper's Bazaar.* From his earliest celebrity portraits of avant-garde dancers like Ruth St. Denis and Martha Graham to his attention-grabbing color images of starlets smoking Lucky Strikes, Muray's talent lay in knowing just how far his images needed to go in order to look up-to-the-minute without ever crossing the line into the shocking or the difficult. But the same skill that earned him respect (and a very good income) during his lifetime now makes him, and his pictures, artifacts of the past. In 1973, when John Szarkowski looked at Muray's well-known 1927 black-and-white portrait of Babe Ruth (Figure 1), his admiration was colored by regret. Muray was an "excellent and dedicated" photographer, but never an innovator. In Szarkowski's eyes, Muray's choice of form and subject matter gave his images distinction, but he never seemed to transcend the moment; his pictures remain "wholly and contentedly of their time."[1]

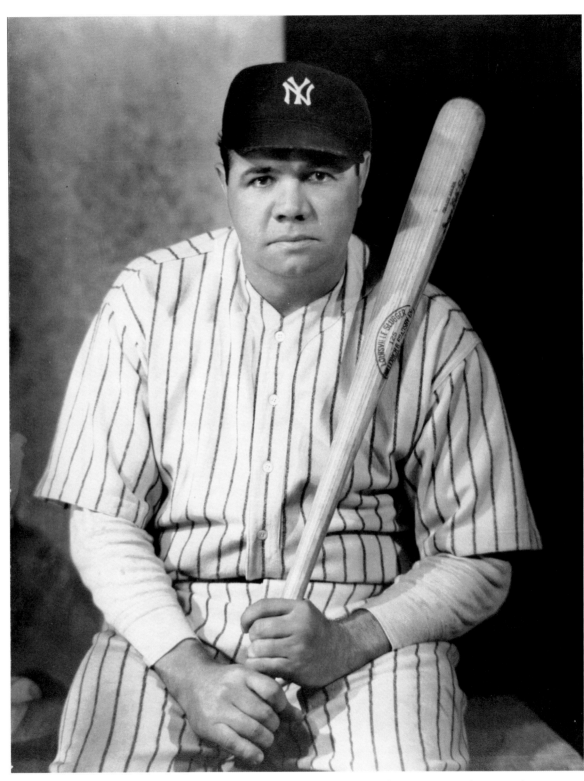

Figure 1. *Babe Ruth,* by Nickolas Muray, undated. Silver gelatin photograph, 36.1 x 28 cm. (14 x 11 in.).
© Nickolas Muray Photo Archives, courtesy George Eastman House.

Muray's long and close friendship with artist Miguel Covarrubias moves his story from the mundane edge of photographic history to the middle of one of the most exciting periods in the history of American culture and art (Figure 2). Together, in the mid-1920s, Covarrubias the Mexican and Muray the Hungarian rode their youth, charm, talent, and ambition to social and commercial success. They met in 1923, thanks to novelist, essayist, and society figure Carl Van Vechten (Figure 3), through whom they (and most of New York) became acquainted with the stars of the Harlem Renaissance, including James Weldon Johnson, Paul Robeson, and Langston Hughes. According to at least one source, Van

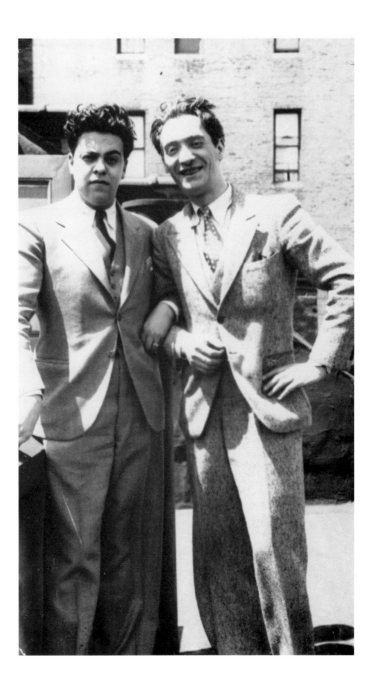

Figure 2. *Miguel Covarrubias and Nickolas Muray,* by Nickolas Muray, ca. 1925. Silver gelatin photograph, 15.1 x 8.9 cm. (5¹⁵⁄₁₆ x 3½ in.). © Nickolas Muray Photo Archives, courtesy George Eastman House.

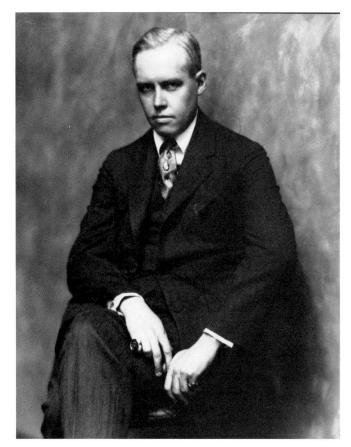

Figure 3. *Carl Van Vechten,* by Nickolas Muray, undated.
Silver gelatin photograph, 25.4 x 20.3 cm. (10 x 8 in.).
© Nickolas Muray Photo Archives, courtesy George
Eastman House.

Figure 4. *Frank Crowninshield,* by Nickolas Muray, undated.
Silver gelatin photograph, 36.1 x 28 cm. (14 x 11 in.).
© Nickolas Muray Photo Archives, courtesy George
Eastman House.

Vechten was responsible for Covarrubias's introduction to *Vanity Fair* editor Frank Crowninshield (Figure 4), the connection which began his brilliant career at the magazine.[2] Muray, who had been working for Crowninshield since 1920, must have been another important connection.[3]

Muray and Covarrubias quickly became famous for Wednesday night parties held at Muray's studio on MacDougal Street, where their guests included Andrés Segovia, Sinclair Lewis, Edna St. Vincent Millay, Jean Cocteau, Walter Lippmann, Gertrude Vanderbilt Whitney, Heywood Broun, and a host of other writers, artists, and public figures. Muray and Covarrubias each portrayed many of these figures, though Muray was far more flattering in his approach. Both men worked in theater, on and off Broadway: Covarrubias designing sets, Muray photographing the performers, producers, and writers. In addition, Muray was a serious fan of modern dance and wrote reviews for *Dance* magazine, where his images also appeared. Around 1925 he introduced Covarrubias to one of his favorite models, the dancer Rose Rolanda, who became Rose Covarrubias in 1930.[4] Covarrubias in turn introduced Muray to the community of Mexican artists who entered New York art circles in the 1920s and 1930s, including Diego Rivera, José Orozco, David Siqueiros, Rufino Tamayo, and Frida Kahlo. By 1931, Muray and Kahlo were lovers.[5]

From letters in the Nickolas Muray Papers collection at the Archives of American Art, we know that Muray helped Covarrubias secure sales and clients in New York and provided the occasional studio hideaway. Snapshots reveal that Muray and his family made frequent visits to Mexico. When Muray married for the fourth time in 1941, he vowed that Covarrubias would be godfather to his first child, and as a result, his daughter received an unusual name—Michael.

La Vie Bohème

Muray's best biographer is Katherine Ursula Parrott, a minor but prolific novelist (under the name Ursula Parrott) and a confessed "woman Mr. Muray has kissed." According to Parrott, Muray arrived from Hungary in 1913 "an engraver of experience, a photographer of enthusiasm . . . twenty-one, charming, but bad-tempered, unsophisticated, terrifically ambitious."[6] He got a steady job in the composing room of the *New York Journal-American* and lived in the Village because it was cheap. In a late interview, Muray called it "real Bohemian, none of the phony stuff you see and hear about."[7] Muray's friend and fencing partner, the sportswriter and novelist Paul Gallico, remembered it as a time of "vast cultural revolution, a time of emancipation from out-worn and out-moded ideas."[8]

Muray spent the wartime years dodging service in the Austro-Hungarian army, working for a time at a portrait studio in Chicago, learning English, and becoming a champion fencer. He married a Hungarian poet, Ilona Fulon, and joined the cluster of Hungarian artists and writers who found work in magazines, movies, book publishing, theater, and fashion design.[9] Everyone understood that these new opportunities came from the prosperous economy, or in Gallico's words, "those conditions always basic to any sudden cultural leap forward—peace, money, and leisure (Figure 5)."[10]

Figure 5. *Self-portrait,* by Nickolas Muray, ca. 1915. Silver gelatin photograph, 11.1 x 8.5 cm. (4⅜ x 3⅜ in.). © Nickolas Muray Photo Archives, courtesy George Eastman House.

A contentious body of literature describes the shift in the culture of Greenwich Village at this time. Before World War I, the cheap apartments, bars, and restaurants in the narrow old streets around Washington Square provided a home for radical culture and politics. After the war, the Village became an established Bohemian neighborhood, with the requisite rising rent, picturesque shops, and speakeasies, where mostly middle-class people came to have a good time. (Some chroniclers, including Caroline Ware and Malcolm Cowley, suggest that this shift began even before the war.) By the mid-twenties, many of the political, moral, and aesthetic freedoms Villagers had campaigned for—relaxed codes of social and moral behavior, political equality for women, modern theater, art, music, and literature—had become part of everyday life throughout the country.

True, flocks of newcomers continued to land in the Village every day, hoping to escape the "stultifying effects of a civilization ruled by business." But, as Cowley and many others observed, these new arrivals often settled right back down to business, running "tea shops, antique shops, book shops, yes and bridge parlors, dance halls, nightclubs, and real-estate offices." Though more idealistic artists and writers struggled to maintain their unconventional lifestyle, in the end they too had to make a living and were often happy to sell fiction and art to high-paying magazines like *Collier's* or the *Saturday Evening Post.*[11] Still, the speakeasies, art galleries, shops, and theaters thrived. New generations, lured by the Village myth, rented the old, cheap apartments in the narrow streets. And, as Caroline Ware explains, however far the boundaries of convention stretched, or however conventional the Village became, it was "always the place where one could go farther."[12]

In the mid-thirties, in his memoir of Village life that formed the opening chapters of *Exile's Return,* Malcolm Cowley insisted that the post-war Bohemian Village was mostly a

myth, and that *"la vie Bohème"* had become, primarily, an excellent excuse to support the consumer economy. Bohemian ideals of "self-expression" encouraged the purchase of all sorts of new products no one had needed before: "modern furniture, beach pajamas, cosmetics, colored bathrooms with toilet paper to match."[13] Because Bohemians "lived for the moment,"[14] they were willing to buy now and pay later, making it easy to acquire expensive new consumer goods like radios and automobiles. In Cowley's view, the Bohemian claim of equality for women was mostly a means to double the potential buyers for products like cigarettes, which had long been used by men alone.[15] The rampant pursuit of pleasure got "a jolt of illicit glamour"[16] from the thrills of evading Prohibition, while newly discovered Freudian psychology gave a scientific license to the pursuit of desire. The Village myth, embodied by residents, tourists, and sympathizers, "gave form to [the new style of living], created its fashions, and supplied the writers and illustrators who would render them popular."[17]

Muray was one of these artists. In the teens he joined the New York Camera Club, where his pictures of dancers hung in a group show next to Paul Strand's studies with his Akeley camera. In 1919, Muray opened a studio on MacDougal Street, just south of Washington Square, and began to make his name. In Parrott's words, "One's friends from the old village were beginning to arrive[;] one's connections became influential. One began to arrive, too"[18] Gallico remembered that Muray was soon *"the* Village photographer and *a* Village character," happy to be famous for his fencing demonstrations and his Wednesday night parties.[19]

Muray's big break came in the form of a commission to photograph the children of Gertrude Vanderbilt Whitney, an art patron and sculptor who had a studio on MacDougal Alley, around the corner from Muray's own studio (Figure 6). This commission led to an exhibition at the Whitney Studio Club, which impressed Frank Eaton, an editor at the *New York Tribune,* who in turn published a full page of Muray's pictures as part of a series on young photographers. The show also attracted Henry Blackman Sell, editor and art director of *Harper's Bazaar* (and a Village neighbor, with a house on Fourth Street). Sell asked Muray to drop by and gave him an assignment for a very good fee ($50 per page— enough to live on for a month).

From the start, the myth of the Village figured large in Muray's story. According to Eaton of the *Tribune,* Muray worked "in a quaint attic studio on MacDougal Street" and found inspiration "in the artist atmosphere of storied Washington Square."[20] The following year, four of Muray's portraits appeared in a *Vanity Fair* story on "The Apotheosis of Greenwich Village."[21] In *Harper's Bazaar,* Muray's portraits illustrated "The Beautiful Side of Greenwich Village."[22] The sophisticated *Harper's* acknowledged that the Village was mostly a "delightful state of mind," but offered Muray's portraits as proof that "many intelligent and hard-working artists" still lived around Washington Square, among them Paul Manship (Figure 7), Winold Reiss, Willa Cather, John Barrymore, and George Bellows.

The hundreds of images Muray published in the twenties, plus those in his archive (now on deposit at the International Museum of Photography and Film at George Eastman House), show that Muray's sitters were much like himself—competent, unpreten-

Figure 6. *Nickolas Muray's studio,* by Nickolas Muray, ca. 1920. Silver gelatin photograph, 23 x 19 cm. (9 x 7½ in.).
© Nickolas Muray Photo Archive, courtesy George Eastman House.

tious, successful professionals who cared more about pleasing the audience than they did about posterity. Yet was any audience ever again as open-minded, tolerant, and curious as the New Yorkers of the interwar years? One day they bought tickets for a melodrama by Susan Glaspell, the next for an expressionistic tragedy by Eugene O'Neill. The same folk who came to see modern artists like Martha Graham, Ruth St. Denis, and Ted Shawn happily lined up for the Greenwich Village Follies and watched a young dancer like Rose Rolanda swirl her Spanish shawls. Muray photographed many of the authors published by Horace Liveright, who made marketing history by using innovative advertising campaigns to sell everything from sensational fiction to serious literature by Ernest Hemingway, e. e. cummings, and Sigmund Freud.

The first critic to describe the period's convergence of popular culture, high art, and modernist innovation was Gilbert Seldes, who wrote *The Seven Lively Arts* in 1924 while on leave from *Vanity Fair*. Seldes believed that "entertainment of a high order existed in places not usually associated with Art, and the place where an object was to be seen or heard had no bearing on its merits."[23] He praised the Ziegfeld Follies, Krazy Kat cartoons,

Figure 7. *Paul Manship,* by Nickolas Muray, 1918. Silver gelatin photograph, 36.1 x 28 cm. (14 x 11 in.). © Nickolas Muray Photo Archives, courtesy George Eastman House.

Figure 8. *Rose Rolanda as Mexican dancer,* by Nickolas Muray, undated. Silver gelatin photograph, 23.5 x 19.3 cm. (9¼ x 7⅝ in.). © Nickolas Muray Photo Archives, courtesy George Eastman House.

Gershwin's music, and Chaplin's humor, offering them as modern improvements on tired versions of "high" art, whether opera, oil painting, genteel waltzes, or Broadway melodrama. Above all, he praised any form of art that strove to represent the present, any works "which specifically refer to our moment, which create the image of our lives." Moreover, according to Seldes, the best work had the greatest value in the present, in the form of pictures, words, and performances "which no one before us could have cared for so much, which no one after us will wholly understand." Their beauty lay in their evanescent quality. "We require for nourishment something fresh and transient," he explained. "There must be ephemera."[24] Though Seldes never mentions photography in his pantheon of lively modern arts, it is clear that Muray's work fulfills the mandate—from the high value Muray's documents held for his contemporaries and the fleeting reputations of his sitters to the fact that his brilliant art was made for the fragile, forgettable printed pages of a magazine.[25]

Figure 9. *Hubert Stowitts,* by Nickolas Muray, undated. Silver gelatin photograph, 25.4 x 20.3 cm. (10 x 8 in.). © Nickolas Muray Photo Archives, courtesy George Eastman House.

Seldes was a big fan of musical revues, whose stars included Rose Rolanda (Figure 8) and the "Serbian Desha,"[26] as well as many other dancers who came to Muray's studio. Muray also received considerable acclaim for his images of male dancers such as Ted Shawn and Hubert Stowitts (Figure 9). In a late memoir, Muray recalled that he first photographed dancers to impress Frank Crowninshield, for whom modern dance was a "pet project." Crowninshield immediately published one of Muray's barefoot dancers in a translucent costume, and Muray's reputation blossomed.

Today these images reveal the profoundly conservative nature of the aesthetics favored by Muray, Crowninshield, and *Vanity Fair*. The uninhibited (and undressed) poses, the slender bodies, beautiful according to the standards of a new generation, and the obvious pleasure these dancers take in performance all contrast with Muray's old-fashioned photographic style. His lens cannot focus sharply, and he applies Rembrandtesque shadows to add mystery. His dancers pose in exaggerated profile, recalling Egyptian hieroglyphs,

Figure 10. *Doris Humphrey,* by Nickolas Muray, undated. Silver gelatin photograph, 23.7 x 18.7 cm. (9⅜ x 7⅜ in.). © Nickolas Muray Photo Archives, courtesy George Eastman House.

Figure 11. *Rose Rolanda as a nymph,* by Nickolas Muray, undated. Silver gelatin photograph, 18.4 x 23.6 cm. (7¼ x 9⁵⁄₁₆ in.). © Nickolas Muray Photo Archives, courtesy George Eastman House.

Greek urns, art nouveau poster girls, or the popular archaic aesthetic exemplified by the work of his Village neighbor (and portrait subject) Paul Manship. Yet the images also stand up to scrutiny. When Muray photographs Doris Humphrey in a translucent veil, he creates an image far more arousing than any nude (Figure 10). Rose Rolanda's conventional pose of a classical nymph provides at once an advertisement and a shield for her sexual confidence (Figure 11).

In 1920, the conventions of popular erotic art got a jolt from Rolanda—called the "dancing sprite with a spark of wickedness"[27]—who, before marrying Covarrubias, lit up a series of revues on Broadway. Muray met Rolanda when publicity man Edward Bernays hired him to make some sexy but safe publicity shots of the cast of "The Rose Girl," a review about to go on national tour (the title was determined before Rolanda joined the road production, but her presence was so vivid that no one recalled her predecessor).[28] Muray remembered Rolanda's unique dance style as "partly Spanish, partly African, partly Mexican."[29] In 1925, when Covarrubias designed Mexican sets for a number in the Garrick Gaieties, Rolanda was hired to be the dancer, and together they stole the show. According to the *New York Times,* in place of the "usual over-swathed Spanish and Italian decoration" the dancer and setting conveyed a "direct sense of the dramatic and a sharp, hot power."[30]

In 1926, *Vanity Fair*'s editors put Nickolas Muray in their Hall of Fame, justifying their selection with a summary of his career: "Because . . . he began his career as a photogra-

pher in a Greenwich Village garret . . . he is now exhibiting photographs of international celebrities in New York . . . he is a skilled fencer and prizewinning athlete and finally because this portrait of him was made by his friend Edward Steichen."[31] (Alas, even in the midst of praise, Steichen cast his considerable shadow over Muray—and almost every other professional commercial photographer who worked during the middle decades of the twentieth century.)

Muray's Village days lasted barely a decade. Around 1925, he moved his studio to 50th Street, just east of Fifth Avenue. Covarrubias designed a series of ads for the new studio, using his trademark geometric style to create a caricature of Muray. As Parrott announced, "He had arrived . . . an incredible distance from Budapest, and almost as far in actuality from the studio on lower Fifth Avenue. He was a success"[32] This success came largely from his ability to capture Bohemian New York for a wide audience, one with plenty of money and time to spend on the search for pleasure.

Vanity Fair and Beyond

In 1923, *Vanity Fair* put Muray at the top of a select list of "Master American Portrait Photographers," along with Edward Steichen, Alfred Stieglitz, Arnold Genthe, and six others—all from New York.[33] The magazine praised these "artists and visual chroniclers of contemporary character" and credited their "sure taste, artistic vision and untiring effort" for the wide recognition that *Vanity Fair* had achieved in its first decade.[34]

For most of the 1920s, *Vanity Fair* published Muray's celebrity photographs in nearly every issue. There were full-page portraits of important entertainers like Al Jolson (Figure 12), Eugene O'Neill, and Katharine Cornell (Figure 13), and smaller cameos, often of writers, including D. H. Lawrence, Dorothy Parker, F. Scott Fitzgerald (Figure 14), Elinor Wylie (Figure 15), and Franklin P. Adams. In 1926, the magazine sent Muray abroad on an exclusive assignment to photograph portraits of international celebrities such as George Bernard Shaw, H. G. Wells, and Claude Monet, meetings that Muray proudly recalled for the rest of his life. The following year *Vanity Fair* sent Muray to make portraits of President Coolidge and his wife Grace at the White House, where he got surprisingly good results. Muray's last big assignment for *Vanity Fair* was in 1929, when he went to Hollywood to photograph Norma Shearer, Myrna Loy, and Joan Crawford, as well as Douglas Fairbanks and Mary Pickford, performing together for the first time in *Taming of the Shrew*.

By the end of the twenties, Edward Steichen had moved onto the Condé Nast payroll as a photographer for both *Vanity Fair* and *Vogue,* and photographic fashion had shifted away from the soft shadows Muray favored toward brighter images with a crisp, hard edge. Although Muray quickly took up the new style, he grew restless, and after 1925, when he left the Village to move uptown, his commercial career picked up momentum.

Frank Crowninshield wrote an essay for a brochure promoting Muray's new studio, praising his work for its "great technical mastery, disarming honesty, and very considerable degree of beauty." He also endorsed Muray's personal sincerity: "There is nothing of

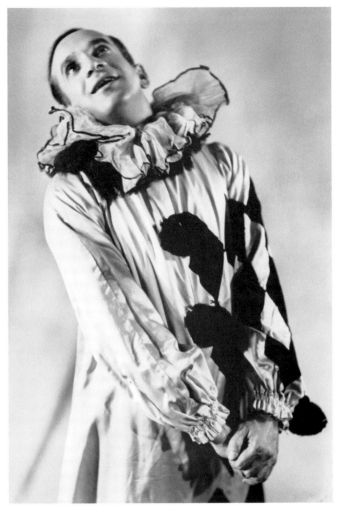

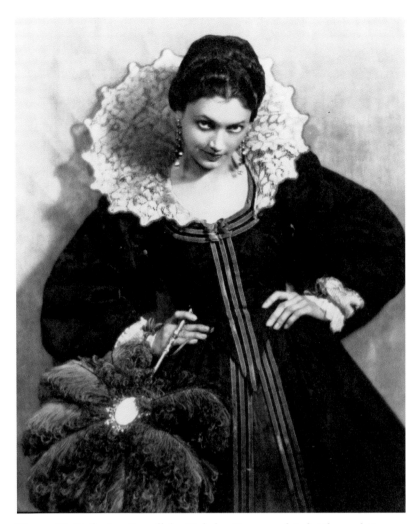

Figure 12. *Al Jolson,* by Nickolas Muray, undated. Silver gelatin photograph, 36.1 x 28 cm. (14 x 11 in.). © Nickolas Muray Photo Archives, courtesy George Eastman House.

Figure 13. *Katharine Cornell,* by Nickolas Muray, undated. Silver gelatin photograph, 36.1 x 28 cm. (14 x 11 in.). © Nickolas Muray Photo Archives, courtesy George Eastman House.

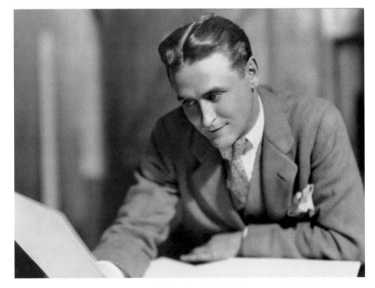

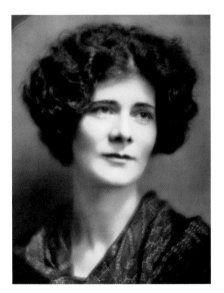

Figure 14. *F. Scott Fitzgerald,* by Nickolas Muray, 1930. Silver gelatin photograph, 26.1 x 33.7 cm. (10¼ x 13⅛ in.). © Nickolas Muray Photo Archives, courtesy George Eastman House.

Figure 15. *Elinor Wylie,* by Nickolas Muray, undated. Silver gelatin photograph, 36.1 x 28 cm. (14 x 11 in.). © Nickolas Muray Photo Archives, courtesy George Eastman House.

Figure 16. *Vanity Fair lingerie advertisement,* by Nickolas Muray, undated. Silver gelatin photograph, 23.5 x 18.5 cm. (9¼ x 7³⁄₁₆ in.). © Nickolas Muray Photo Archives, courtesy George Eastman House.

Figure 17. *Lucky Strike girl*, by Nickolas Muray, 1936. Color print, assembly (carbro) process, 35.4 x 28 cm. (13¹⁵⁄₁₆ x 11 in.). © Nickolas Muray Photo Archives, courtesy George Eastman House.

the charlatan in Muray, or in his work, nothing of the poseur, nothing of the man who likes to dim, sugar or distort Life."[35] Many shared Crowninshield's confidence in the "truthfulness" of Muray's pictures—undoubtedly an asset for any advertiser (Figure 16). Throughout the Depression, Muray worked steadily for advertising agencies such as J. Walter Thompson and Barton, Durstine, & Osborn, and department stores including Macy's, Lord & Taylor, Henri Bendel, and Bergdorf Goodman. His most memorable advertisements were made for Lucky Strike cigarettes, when his old friend Edward Bernays hired Muray to photograph slim starlets to illustrate the slogan, "Reach for a Lucky instead of a sweet" (Figure 17).[36]

In 1930, Muray spent several months in Europe studying the difficult new technology required to print photographs in color. The following June, his two large tableaux devoted to Hollywood swimwear appeared in *Ladies' Home Journal,* the first full-page color photographs to appear in that magazine and among the first to appear in any magazine in America.[37] Muray quickly signed a contract and worked steadily for the *Journal* and *Mc-Call's* through the end of World War II.

Did Muray lose status when he moved from *Vanity Fair* to *Ladies' Home Journal?* At the time, the move seemed both lucky and smart. In 1934, *Vanity Fair* called women's magazines "the most powerful group of periodicals in America." Readers were loyal, and sales were so healthy that "even in these lean-wallet days" the top five magazines for women claimed more than ten million readers.[38] (By contrast, circulation for *Vanity Fair* never exceeded 100,000 a year, and in 1936 the magazine folded.)

In 1934, *Vanity Fair* featured Muray's photographs in a story about "a new art form . . . Commercial Photography." The story highlighted the work of twenty photographers, including Margaret Bourke-White, Anton Bruehl, Lejaren a Hiller, and Steichen, as well as Muray. This new photographic genre conformed to the criteria editor Frank Crowninshield associated with success: it was born in New York and centered around the work of irreverent artists who ignored old-fashioned scruples, made money, pleased the public, and produced beautiful images all at the same time. Commercial photography was the creation of "renegades," whose financial prowess caused "arty" photographers to sulkily accuse them of "selling their souls." While these commercial photographers daily managed "to twist silk hats and steamships into patterns attractive to the consumer," they also "clung quietly to their integrity."[39]

Historian Ann Douglas and many others point out that Muray's contemporaries—both artists and their audience—were happy to find success on these terms. In the decades between the wars, public opinion tolerated—even approved of—close connections between leading artists, writers, and publishers and the world of advertising, magazines, and popular entertainment. Thus, Muray's work did not "represent an artistic compromise or sell out . . . though some . . . later saw it that way."[40]

Photography 1839–1937

Throughout the 1930s, Muray's color photographs appeared in large exhibitions organized by professional groups such as the National Association of Advertising Illustrations (NAII), the Commercial Artists Guild, and *U.S. Camera* magazine. These photographic exhibitions took place in prestigious public spaces, including Rockefeller Center and the galleries at Grand Central Station, and received wide reviews. Photographs in color—a relative novelty—attracted the most notice.

In 1934, the NAII show comprised more than 250 images, mostly of industrial subjects; the star was color photography, "which must come to the layman as a revelation."[41] In 1936, the Commercial Artists Guild held an exhibition in the Grand Central Palace featuring color illustration and advertising images by Steichen, Muray, Bruehl, and others, much of it first published in magazines like *Vogue* and *Harper's Bazaar*. Across town, at the Rockefeller Center, *U.S. Camera* magazine and the camera and film manufacturer Ansco sponsored their second annual competitive exhibition for amateurs and professionals, featuring 600 images by 175 photographers chosen from 10,000 submissions.[42] According to the *Christian Science Monitor,* color photography stood out here too, especially the "brilliant and lifelike" work of Muray, which included one irresistible image of a "sizzling steak."[43]

In 1937, when Beaumont Newhall mounted "Photography 1839–1937" at the Museum of Modern Art, he certainly broke new ground, yet his show can be seen as one of a nearly continuous series of exhibitions mounted in New York in the 1930s. Newhall wanted his show, like the others, to celebrate "the technical improvements which have been made in photography during the course of its existence [and which] have enlarged the camera's uses enormously." In addition, he sought to develop a set of aesthetic criteria, a "common denominator" that could be used to judge all photographs. Using a sophisticated modernist argument, Newhall carefully showed how the aesthetic content of a photograph came from its technical form, with the result that the key to the best photographs "lies in the photographer's knowledge of his medium." Newhall sought to show that all photographs were both documents and expressive records, conveying not only information about the subject but also the emotions and ideas of the photographer. "Our ways of looking change; the photograph not only documents a subject, but records the vision of a person and a period."[44]

Newhall's exhibition was divided into a number of sections. The historical photographs were organized by medium: daguerreotypes, calotypes, albumen prints, and dry plates. Contemporary photographs were divided by function. Many were created by photographers who considered themselves artists and their work art, including Walker Evans, Berenice Abbott, Man Ray, and Moholy-Nagy. Newhall also celebrated images by photographers who found their audience outside museums, exhibiting X rays, aerial photographs, industrial prints, press photographs, and photographs made as scientific evidence. "Color Photography" received a section of its own. It was partly a technological marvel (like the advances in the photographic process during the nineteenth century), and partly an occasion to celebrate another aesthetic triumph. Newhall refrained from comment and chose the best images he

could find, by the nation's most prominent color photographers: Edward Steichen contributed a portrait of Rachmaninoff, Paul Outerbridge showed a still-life titled "Cheese and Crackers," Anton Bruehl exhibited a "Fashion Plate," and Muray was represented by both "Opera Box," commissioned by Young & Rubicam for the Packard Motor Company, and "Vienna Sausage," made for J. Walter Thompson.[45]

Love Letters

Katherine Ursula Parrott, in her biographic essay on Muray, devoted an entire section to "Women and Mr. Muray," a melancholy defense of a man who has "ecstasy to rent to you, but not happiness on a long term basis." The most interesting passages discuss the way "Bohemian" social codes of the twenties had changed the life of the "modern female." For Parrott, "the responsibility of being a modern female" meant that she spent most of her waking hours simply being "a person. More than a female. One has one's job—and theaters and books and concerts . . ." In Parrott's view, the modern woman treats men as "just occasional companions." However, while this new role is thrilling, Parrott admits it is difficult to maintain, and in the end the modern female gets no more help than her non-modern sisters. Muray—and men like him—"persist in treating you as people, [they know] you are of identical clay with themselves . . . They will try to understand you [and] give you sincerity, tenderness, a relationship never sordid or commonplace—for a time that is. For the future they can promise—nothing whatever."[46]

Muray's many lovers included several women who had important careers: Ruth St. Denis, Martha Graham, Judith Anderson, and Frida Kahlo among them. He saved some of their letters. Most are emotional and endearing declarations which sound terribly familiar to anyone who has ever been in love.[47]

Kahlo's letters say more. No records show precisely when they met, but Kahlo's earliest surviving note to Muray, written in Hungarian on a paper doily, comes from Mexico and is dated May 31, 1931, soon after Diego Rivera's first solo exhibition at the Museum of Modern Art. Muray and Kahlo remained friends for life.[48] On many occasions, Kahlo told Muray she loved him intensely, "like I never loved anyone—only Diego will be in my heart as close as you—always."[49]

Muray received an especially interesting group of letters from Kahlo during the late winter, early spring, and summer of 1939, following a winter they spent together in New York. In February 1939, shortly after arriving in Paris, she wrote:

> Don't kiss any body else while reading the signs and names on the streets. Don't take any body else for a ride to *our* Central Park. It belongs only to Nick and Xochitl. Don't kiss any body on the couch of your office . . . Play very often Maxine Sullivan's disc on the gramophone. I will be *there with you* listening to her voice . . . I see you shooting at the sculpture near the fireplace . . . and I can hear your laugh just like a child's laugh, when you got it right. Oh my darling Nick I adore you so much . . .[50]

In June, back in Mexico, she received a print of the color carbro portrait he had made, now known as "The Magenta *Rebozo*" (see page 49):

Nick darling

I got my wonderful picture you send to me, I find it even more beautiful than in New York. Diego says that it is as marvelous as a Piero de la Francesca. To me [it] is more than that, it is a treasure, and besides, it will allways remind me that morning we had break-fast together in the Barbizon Plaza Drug Store and afterwards we went to your shop to take photos. This one was one of them. And now I have it near me. You will allways be inside the magenta rebozo (on the left side). Thanks million times for sending it . . . the only thing I want, is to tell you with my best words, that . . . no matter what happens to us in life, you will allways be, for myself, the same Nick I met one morning in New York in 18 E. 48th St.[51]

The most important information to be gleaned from the correspondence comes in let-ters Kahlo wrote from Paris in February, March, and April 1939 as she waited for the open-ing of a group exhibition of surrealist art organized by André Breton, which was the rea-son for her trip. She wasn't happy. When Kahlo arrived, Breton had yet to find a gallery for the show, her paintings were stuck in customs, and worst of all, she had to spend two weeks in the hospital with an intestinal virus. Marcel Duchamp—she wrote Muray that he was "a marvelous painter"[52]—came to her rescue, retrieved her art, found a gallery, and even brought her back to his apartment to recover after she left the hospital. Accord-ing to Kahlo, Duchamp was "the only one who has his feet on the earth, among all this bunch of coocoo lunatic son of bitches of the surrealists."[53]

Kahlo's harsh, funny account of Breton and his friends makes an intuitive connection between work, sex, and politics. Diego and Muray receive money for their work, a position that Kahlo associates with both virility and aesthetic power. Kahlo ridicules Breton and his disciples, who spend so much time talking in cafés and so little time making art. But she saves her strongest objections for Breton's economic status: in her view, he is weak because he produces little art and depends wholly upon the support of rich women. His café life seemed especially irresponsible when the rest of Europe could think of nothing but the coming war. As Kahlo moves quickly from her immediate experience of Paris to the larger world situation, her report exposes a serious flaw at the foundation of mod-ernist aesthetic practice:

I have decided to send every thing to hell, and scram from this rotten Paris before I get nuts myself. You have no idea the kind of bitches these people are. They make me vomit. They are so damn "intelectual" and rotten that I can't stand them any more. It is really too much for my character. I['d] rather sit on the floor in the market of Toluca and sell tortillas than to have any thing to do with those "artistic" bitches of Paris. They sit for hours on the "cafes" warming their precious behinds, and talk without stopping about "culture" "art" "revolution" and so on and so forth, thinking themselves the gods of the

world, dreaming the most fantastic nonsenses, and poisoning the air with theories and theories that never come true. Next morning they don't have any thing to eat in their houses because *none of them work* and they live as parasites of[f] the bunch of rich bitches who admire their "genius" . . . *Shit* and only *Shit* is what they are. I [have] never seen Diego or you wasting their time on stupid gossip and "intelectual" discussions. That is why you are real *men* and not lousy "artists"—gee weez! It was worthwhile to come here only to see why Europe is rottening. Why all this people—good for nothing—are the cause of all the Hitlers and Mussolinis.[54]

When Frida Kahlo aligns Muray's photography with Rivera's public art, she overturns many conventional assumptions about the aesthetic and political merit of advertising and commercial photography. In her view, the work of photographers like Muray belongs with that of Rivera because it is meant to be seen by a broad audience, not merely a tiny elite. In addition, Muray and Rivera are paid for their art, which Kahlo sees as a virtue—though more conventional modernists (Alfred Stieglitz, for example) considered all payment a form of corruption because it forced the artist to compromise his work to please the patron. In many ways, Kahlo's ability to evaluate commercial photography according to its audience, its public utility, and its value to the marketplace anticipates the vision of postmodern critics of the 1980s, such as Craig Owens, Douglas Crimp, and Abigail Solomon-Godeau.[55]

Today, with *Vanity Fair* back in business and portraits by Annie Leibowitz and caricatures by Bob Risko back in fashion, it has become easier to see and enjoy the humorous, colorful, celebrity-driven art of Nick Muray, with its conservative vision of Bohemian New York and its persuasive use of color to sell new and old commodities. At the same time, however, Kahlo's words offer a cautionary message. As I write in New York in the summer of 2003, daily headlines are full of sobering news from Iraq, Israel, and Afghanistan. It is impossible not to wonder how we might resemble Kahlo's Parisian colleagues, or the first viewers of Muray's work. When future generations look at the new *Vanity Fair*, what will they learn about us?

Acknowledgments

My great thanks goes to Ann Shumard, curator of photographs at the National Portrait Gallery, for her superb research and warm friendship. I also thank Sally Stein, Roy Flukinger, and Andy Eskind for expert advice. Mimi Muray generously shared memories of her father and her family. Kurt Heinzelman was an ideal editor. Every author should be so lucky.

Notes

1. John Szarkowski, *Looking at Photographs: 100 Pictures from the Collection of the Museum of Modern Art* (New York: Museum of Modern Art, 1973), 90. Muray appears in many biographical dictionaries such as the *ICP Encyclopedia of Photography* (New York: Crown Publishers, 1984), 348; and *Macmillan Biographical Encyclopedia of Photographic Artists and Innovators* (New York and London: Macmillan, 1983), 438. Information also appears on the Web site of the Harry Ransom Research Center, University of Texas, at http://www.hrc.utexas.edu. See also Therese Mulligan and David Wooters, eds., *Photography from 1839 to Today: George Eastman House, Rochester, NY* (New York: Taschen, 2000), 554–559; and Marianne Fulton Margolis, introduction to *Muray's Celebrity Portraits of the Twenties and Thirties,* by Nickolas Muray (New York: Dover Publications, 1978).

2. Carl Van Vechten remains a greatly understudied figure. On Covarrubias and Crowninshield, see "The Last Gentleman," *New Yorker,* September 19, 1942, 22–33; and September 26, 1942, 24–31.

3. Though sources for Muray's early life vary in the details, they remain consistent about the places and people he and Covarrubias knew in the twenties. See especially Paul Gallico, "The Revealing Eye" and "Memento Muray," in *The Revealing Eye: Personalities of the 1920s in Photographs,* by Nickolas Muray and Paul Gallico (New York: Atheneum, 1978), v–xxv. Muray wrote several autobiographical texts, all of which can be found in the Nickolas Muray Papers collection at the Smithsonian Institute's Archives of American Art in Washington, D.C. Ann Shumard added much depth and detail to the record by uncovering many contemporary articles and reviews.

4. Rose Rolanda Scrapbook, Billy Rose Theatre Collection, New York Public Library for the Performing Arts, New York.

5. Adriana Williams, *Covarrubias,* ed. Doris Ober (Austin: University of Texas Press, 1994). See also Nickolas Muray Papers, Archives of American Art, Washington, D.C.

6. Katherine Ursula Parrott, "A Profile (but not for the *New Yorker,* just for one New Yorker)," Nickolas Muray Papers, Archives of American Art, Washington, D.C., roll 4392, frames 0861–0870.

7. Jacob Deschin, "Nickolas Muray, Time Out for Lunch," *Popular Photography* 57, October 1965, 116.

8. Gallico, *The Revealing Eye,* viii.

9. Though their names are not familiar today, Hungarians prominent in New York in the 1920s included illustrator Willy Pogany, playwright Ferenc Molnar, and the *New Yorker* artist Ilonka Karasz.

10. Gallico, *The Revealing Eye,* ix.

11. This and the immediately preceding quotations refer to Malcolm Cowley, *Exile's Return: A Literary Odyssey of the 1920s* (1934; repr., New York: Viking Press, 1951), 58–59. Citations refer to the 1951 edition.

12. Caroline Ware, *Greenwich Village 1920–1930: A Comment on American Civilization in the Post-War Years* (Boston: Houghton Mifflin, 1935), 263.

13. Cowley, *Exile's Return,* 62.

14. Ibid.

15. Ware observed that consequences of the claims for equal rights often penalized liberated women, who ended up supporting the household while their husbands or partners remained true to old Bohemian ideals and devoted themselves to "Art." Ware, *Greenwich Village 1920–1930,* 258–261.

16. Cowley, *Exile's Return,* 64.

17. Ibid., 62–63.

18. Parrott, "A Profile," roll 4392, frames 0861–0870.

19. Gallico, *The Revealing Eye,* xvi.

20. Frank Eaton, "Nickolas Muray," *New York Tribune,* April 11, 1920.

21. "The Apotheosis of Greenwich Village: Muses of New York's so-called *Quartier Latin,* who have achieved the Highest Distinction in the Arts," *Vanity Fair,* February 1921, 37.

22. "The Beautiful Side of Greenwich Village," *Harper's Bazaar,* September 1920, 66–67.

23. Gilbert Seldes, *The Seven Lively Arts* (1924; repr. New York: Anchor Books, 1957), 3. Citations refer to the 1957 edition.

24. This and the immediately preceding quotations are from Seldes, *The Seven Lively Arts,* 293.

25. This argument follows Ann Douglas's in *Terrible Honesty: Mongrel Manhattan in the 1920s* (New York: Farrar, Straus and Giroux, 1995), 69. See also Seldes's introduction and notes to the 1957 edition of *The Seven Lively Arts,* and Michael Kammen, *The Lively Arts: Gilbert Seldes and the Transformation of Cultural Criticism in the United States* (New York: Oxford University Press, 1996).

26. "The Serbian Desha" was the stage name of Desha Delteil.

27. *Public Ledger* [Philadelphia], untitled, undated, in the Rose Rolanda Scrapbook, Billy Rose Theatre Collection, New York Public Library for the Performing Arts, New York.

28. "The Dancer's Brain Is Not in Her Feet," undated, in the Rose Rolanda Scrapbook, Billy Rose Theatre Collection, New York Public Library for the Performing Arts, New York.

29. Nickolas Muray, "Untitled Memoir [on Dance Photography]," Nickolas Muray Papers, autobiographical texts, Archives of American Art, Washington, D.C.

30. Stark Young, *New York Times,* June 7, 1925, in the Rose Rolanda Scrapbook, Billy Rose Theatre Collection, New York Public Library for the Performing Arts, New York.

31. "We Nominate for the Hall of Fame," *Vanity Fair,* December 1926, 99.

32. Parrott, "A Profile," roll 4392, frames 0861–0870.

33. "Master American Portrait Photographers," *Vanity Fair,* January 1923, 54; and "Laurel Crowns—Freshly Bestowed," *Vanity Fair,* April 1925, 66. The others were Francis Brugière, Pirie MacDonald, Edward Thayer Monroe, Alfred Cheney Johnston, Maurice Goldberg, and James E. Abbe.

34. "Master American Portrait Photographers," *Vanity Fair,* 54. Was this an oblique reference to the fact that wide prestige did not generate deep profits for publisher Condé Nast? See also George H. Douglas, *The Smart Magazines: Fifty Years of Literary Revelry and High Jinks at Vanity Fair, The New Yorker, Life, Esquire, and the Smart Set* (Hamden, CT: Archon Books, 1991).

35. Frank Crowninshield, "A Word about Artistic Photography," Nickolas Muray Papers, Archives of American Art, Washington, D.C., roll 4393, frame 0412ff.

36. On the Lucky Strike campaign, see Edward Bernays, *Biography of an Idea* (New York: Simon and Schuster, 1965), 372–398; Larry Tye, *The Father of Spin: Edward Bernays and the Birth of Public Relations* (New York: Crown, 1998), 23–25; and Roland Marchand, *Advertising the American Dream: Making Way for Modernity* (Berkeley: University of California Press, 1985), 96–100.

37. The best single source on the development of color photography is Louis Walton Sipley, *A Half Century of Color* (New York: Macmillan, 1951). On Muray's first color layout for *Ladies' Home Journal,* see pages 87–89.

38. This information and the immediately preceding quotations are from Dora Copperfield [pseudonym], "The Women's Magazines," *Vanity Fair,* January 1934, 22.

39. This and the immediately preceding quotations refer to "Commercial Photography," *Vanity Fair,* December 1934, 22–23.

40. Douglas, *Terrible Honesty,* 68.

41. *New York Times,* September 15, 1934, 13; *New York Times,* September 23, 1934, X8. I am deeply grateful to Ann Shumard for tracking down these reviews.

42. "Through a Lens," *New York Times,* November 8, 1936, X9.

43. "Color Photographs Hold Spotlight at New York Exhibit," *Christian Science Monitor,* October 9, 1936, 8.

44. This and the immediately preceding quotations are from Beaumont Newhall, *Photography 1839–1937* (New York: Museum of Modern Art, 1938), 90.

45. Ibid., 121.

46. This and the immediately preceding quotations are from Parrott, "A Profile," roll 4392, frames 0861–0870.

47. We know this thanks to Mrs. Peggy Muray, who kept the letters and gave them to the Smithsonian's Archives of American Art along with her husband's papers.

48. Mimi Muray remembers going to Mexico with her parents to visit Kahlo shortly before the artist's death. Mimi Muray, in conversation with the author, June 2003.

49. Kahlo to Muray, Paris, February 16, 1939, Nickolas Muray Papers, Archives of American Art, Washington, D.C.

50. Kahlo to Muray, Paris, February 27, 1939, Nickolas Muray Papers, Archives of American Art, Washington, D.C.

51. Kahlo to Muray, Coyoacán, Mexico, June 13, 1939, Nickolas Muray Papers, Archives of American Art, Washington, D.C.

52. Kahlo to Muray, February 16, 1939.

53. Ibid.

54. Ibid.

55. Douglas Crimp, Craig Owens, and Abigail Solomon-Godeau are among the critics closely associated with the postmodernist movement that flourished in the 1980s. See especially Douglas Crimp, *On the Museum's Ruins* (Cambridge, MA: MIT Press, 1993); Craig Owens, *Beyond Recognition: Representation, Power and Culture,* ed. Barbara Kruger and Jane Weinstock (Berkeley: University of California Press, 1984); and Abigail Solomon-Godeau, *Photography at the Dock: Essays on Photographic History, Institutions, and Practices,* Media and Society Series (Minneapolis: University of Minnesota Press, 1991). Useful and important collections of essays include Richard Bolton, ed., *Context of Meaning: Critical Histories of Photography* (Cambridge, MA: MIT Press, 1989) and Brian Wallis, ed., *Art after Modernism: Rethinking Representation* (New York and Boston: The New Museum and David R. Godine, 1984).

THE MAGENTA *REBOZO*

Nancy Deffebach

Rice University

The cult of remembrance of loved ones, absent or dead, offers a last refuge for the cult value of the picture. For the last time the aura emanates from the early photographs in the fleeting expression of a human face. This is what constitutes their melancholy, incomparable beauty.

WALTER BENJAMIN, *Illuminations*

During her lifetime Frida Kahlo (1907–1954) was best known as the nearly beautiful, invalid wife of Diego Rivera, and also as a painter in her own right. Since the early 1980s her reputation has escalated, so that now she is regarded by many—though hardly by everyone—as the greatest Mexican artist of the twentieth century. In the last two decades, she has entered both the art history canon and popular culture. Her oeuvre is small, consisting of only about two hundred works, approximately eighty of which are self-portraits, the paintings for which she is best known. One of the consequences of Kahlo's ascendant reputation has been the proliferation of her image in art books and the popular media. The majority of the images are reproductions of her self-portraits; however, they are often accompanied by photographs of the artist and sometimes only photographs appear. The preponderance of photographs is probably due to our desire to know what Kahlo *really* looked like, a quest for the "true" image of an artist who has become an icon.[1]

Kahlo was one of the most photographed women of her era. Her frequent appearance in photographs was prompted by her almost-beautiful face, exotic clothing, celebrity status as Rivera's wife, and—at least among the most discerning—the compelling nature of the art she produced. As a member of the Mexican avant-garde who had international

contacts through Rivera, she met numerous photographers in Mexico and abroad. Not only did internationally famous photographers (Edward Weston, Imogen Cunningham, Ansel Adams) photograph her on isolated occasions, but she also had significant relationships with artists who recorded her over extended periods. This latter group included her father, Guillermo Kahlo, her friend Manuel Alvarez Bravo, her close friend and ally Lola Alvarez Bravo, and her lover Nickolas Muray.[2]

Many photographs of Kahlo incorporate elements that she used in her self-portraits—traditional Mexican clothing, animals, folk art, and pre-Columbian artifacts—in ways that invite questions about the degree to which the photographs were set up. Kahlo wore the Mexican clothing—especially the regional dress of Tehuantepec—on a daily basis as an affirmation of *mexicanidad,* and the parrots, monkeys, and deer that show up in the self-portraits and photographs were her pets. However, the frequency with which she appears in photographs next to folk art and pre-Columbian art—which were part of her home environment, but also a major source of inspiration for her work—suggests that she may have played a significant collaborative role in the staging of the photographs. In an undated black-and-white photograph by Nickolas Muray, for example, in which she pets her deer Granizo, the white flowers on her skirt echo the white spots on the fawn's back.[3] Kahlo created a similar visual pun when she depicted herself and her pet monkey wearing matching ocher bows in *Autorretrato con mono* (Self-Portrait with Monkey) (1945). Both the photograph and the painting imply a kinship between person and animal that parallels the kinship Kahlo constructed between humans and nature in many earlier and later works.

One photograph of Frida Kahlo has been reproduced more than any other. It was made by the Hungarian American photographer Nickolas Muray (1892–1965) in New York in late 1938 or early 1939, when Kahlo was thirty-one years old. This essay concerns this one photograph: the image, its history, and its perpetual circulation.

Kahlo and Muray met in Mexico, where they were introduced by Miguel and Rose Covarrubias.[4] The exact date of the meeting is unknown, but by May 1931 they had become lovers.[5] He lived in New York, she lived in Mexico, and it is not known how frequently they met or whether they saw each other again before 1938. In the fall of 1938, she traveled to New York to prepare for her first solo exhibition, which opened at the Julien Levy Gallery in November, and during this time the two became deeply involved. The letters Kahlo sent Muray in early 1939 from Paris, where she awaited another show, reveal the depth of her feelings. On February 16 she wrote (in English): "Your letter, my sweet, came yesterday, it is so beautiful, so tender, that I have no words to tell you what a joy it gave me. I adore you my love, believe me, like I never loved anyone—only Diego will be in my heart as close as you—always."[6]

Muray made his first color photographs of Kahlo either in the winter of 1938–1939, before she left for Paris, or in the early spring of 1939, immediately after she returned to New York and before she went back to Mexico. One of the photographs shows her standing with her arms gently folded at her waist, in a half-length format (Figure 1). Her head is tilted at a slight angle and turned away from the camera, but she gazes directly at the

Figure 1. *Untitled* [Frida Kahlo in magenta *rebozo*], by Nickolas Muray, ca. 1939. Color print, assembly (carbro) process, 40.1 x 29.9 cm. (15¹³⁄₁₆ x 16¾ in.). © Nickolas Muray Photo Archives, courtesy George Eastman House.

viewer and seems to radiate a peaceful, contented confidence. Her hair is braided with a thick skein of purple yarn and arranged above her head in an indigenous hairstyle from Oaxaca, held in place with two black combs. She wears silver earrings, a loose white blouse, a gray-violet skirt, and a magenta *rebozo,* or shawl, which is draped around her neck and over her shoulders, partially covering a pre-Columbian shell necklace. The studio lighting draws attention to her face and neck, which are subtly modeled, but casts a sharp shadow on the wall to the right and creates more diffused dark shadows below her arms and behind her. The chiaroscuro lighting that falls on the *rebozo* emphasizes the undulating folds of the fabric.

The untitled photograph—which has attracted countless admirers, been cited by artists, and repeatedly reproduced—is a highly conventional studio portrait. The lighting casts shadows in two directions, making it obvious that the work was created in a studio. The tilt of Kahlo's head is a standard trope for photographing women, so much so that although no record survives of what took place in Muray's studio on the day that the photograph was shot, the art historian Carla Stellweg can write with confidence that "Muray asked Frida to tilt her head so that her already feline eyes took on the quality of the female faces in Rivera's murals."[7] The image is a classic "good" photograph in that it flatters the subject: it records Kahlo when she was young, pretty, healthy, and happy. And, in fact, it is one of only a few color photographs to do so.

In April Kahlo abruptly went back to Mexico. Her departure may have been provoked by Muray's romantic involvement with another woman, or by her desire to be with Rivera and live in Mexico again, or, most probably, by all of these factors. On June 13, 1939, she wrote Muray a letter, which begins:

> Nick darling,
>
> I got my wonderful picture you send to me, I find it even more beautiful than in New York. Diego says that it is as marvelous as Piero de la Francesca. To me [it] is more than that, it is a treasure, and besides, it will always remind me that morning we had breakfast together in the Barbizon Plaza Drug Store, and afterwards we went to your shop to take photos. *This one* was one of them. And now I have it near me. You will always be inside the magenta *rebozo* (on the left side). Thanks million times for sending it.[8]

Rivera's comparison of the photograph to the work of Piero della Francesca is remarkable in a period when photography's status as fine art was not always accepted. Yet the comparison is based on stylistic similarities. The composition of the photograph has a classical renaissance stability, and the image of Kahlo shares with Piero della Francesca's figures a calm dignity and a serene self-assurance. Both the photographer and the painter used light to subtly model flesh tones and to render drapery with greater contrast. Muray employed magenta with the same striking effect that Piero, in his murals, achieved with red, rose, and burgundy.

Rivera certainly admired the photograph, for he used it in two of his own most important works. He first cited it in his mural *Sueño de una tarde dominical en la Alameda Cen-*

Figure 2. *Sueño de una tarde dominical en la Alameda Central* (Dream of a Sunday Afternoon in Alameda Park), detail, by Diego Rivera, 1947–48. Fresco. Museo Mural de Diego Rivera, Mexico City (formerly in the Hotel del Prado, Mexico City). Photograph by Nancy Deffebach. © 2003 Banco de Mexico Diego Rivera & Frida Kahlo Museums Trust. Av. Cinco de Mayo No. 2, Col. Centro, Del. Cuauhtémoc 06059, Mexico, D.F.

tral (Dream of a Sunday Afternoon in Alameda Park) (1947–1948) at the Hotel del Prado in Mexico City. The mural depicts a throng of people, many of whom are recognizable individuals, promenading in the historic park across the street from the hotel. In the central foreground is a grouping that includes Rivera, Kahlo, the printmaker José Guadalupe Posada, and Posada's most famous character, Calavera Catrina, a skeleton who wears a large plumed hat and a feather boa. Rivera portrays himself as a chubby, mischievous, ten-year-old boy with a frog and a snake in his pockets.[9] An adult Kahlo stands behind him, one hand resting reassuringly on his shoulder, the other holding a yin-yang symbol (Figure 2). Kahlo's portrait is quite clearly based on Muray's photograph. Rivera repeats the tilt of her head, the direct gaze, the mysterious half-smile, the pendant earrings, the purple yarn braided into her hair, the black combs, and the magenta *rebozo* partially revealing the shell necklace. The image that Rivera considered worthy of a renaissance muralist had been restored to the medium of fresco.

The painter Rina Lazo, who worked as Rivera's assistant on *Dream of a Sunday Afternoon in Alameda Park,* recalls that Kahlo was ill at the time and could not pose for her portrait, so Rivera brought the photograph to the site and worked from it.[10] Rivera made two significant additions to her portrait: her gesture toward the boy Diego, which emphasizes the couple's emotional bond, and the prominent inclusion of the Taoist yin-yang

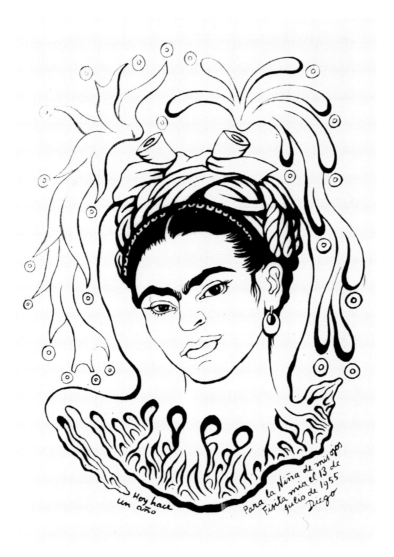

Figure 5. Aztec symbol *atl tlachinolli,* which means "water fire" or "burning water." The symbol is composed of two intertwining elements, one indicating a stream of water, the other indicating flames. Drawing by Nancy Deffebach, based on the way *atl tlachinolli* is represented in the *Tonalamatl Aubin.*

Figure 4. Aztec matrons wearing their hair coiled and wrapped around their heads, ending in horn-like protrusions at the crown. (Published in Bernardino de Sahagún, *Florentine Codex,* Paso y Troncoso's facsimile edition, Book 10, plate 69, figure 83.) Nettie Lee Benson Latin American Collection, University of Texas at Austin.

symbol, which embodies her world view. Yin and yang stand for "two principles, one nega-tive, dark, and feminine (yin), one positive, bright, and masculine (yang), whose interac-tion influences the destinies of creatures and things."[11] Rivera's daughter, Guadalupe Rivera Marín, recalls that Kahlo avidly read Chinese philosophy and mythology, was pro-foundly concerned with the concept of time, and saw "the symbol of yin-yang as the eter-nal, the cosmos seen through perpetual movement." According to Rivera Marín, "the yin-yang was the symbol of [Kahlo's] life."[12]

A year after Kahlo's death, Rivera again cited Muray's photograph, this time using it only as a point of departure. In *Portrait of Frida Kahlo on the First Anniversary of Her Death* (1955), he retains the tilt of her head, direct gaze, pendant earrings, and combs, but he transforms her hair into a symbolic statement (Figure 3). In this drawing Rivera bases Kahlo's coiffure on the distinctive hairstyle of Aztec matrons, in which the hair is coiled and wrapped around the head, ending in two short horn-like protrusions at the crown (Figure 4).[13] Taking poetic license with the traditional Aztec hairstyle, Rivera shows Kahlo's dark hair braided with light ribbons that metamorphose into two thick arteries, which are severed. The liquid squirting from the arteries should logically be blood, but it is depicted in the same way that the Aztecs represented water: with tiny concentric circles at the edge of the flow. Below Kahlo's neck is a flame-like pattern suggesting fire. Just below the flames are the words *Hoy hace un año / Para la Niña de mis ojos / Fisita mia el* 13 *de / Julio de* 1955 / *Diego* (Today makes one year / For the Girl of my eyes / my Fisita the 13 of / July 1955 / Diego). The combination of the Aztec symbol for water and the flame-like lines evokes the Aztec concept of *atl tlachinolli,* or burning water (Figure 5). On the most basic level, *atl tlachinolli* refers to warfare, but Rivera probably intended to convey the pre-Columbian concept of duality and the union of opposites. Speaking about *atl tlachi-nolli,* Kahlo's former student Arturo García Bustos says: "*Atl tlachinolli* signifies the strug-gle, the permanent struggle of opposites. *Atl* is water, and *tlachinolli* is fire, so burning water is the unity of opposites. It is war, the flowery war, the war itself is like a form of life."[14] García Bustos remembers Kahlo and Rivera talking about *atl tlachinolli,* and his explanation of the term probably preserves their personal symbolism and conveys the con-cept Rivera wished to express in his memorial portrait of his wife. If so, the meaning par-allels Rivera's 1947 portrait of Kahlo holding the yin-yang symbol.

That Rivera relied upon the photograph when his wife was absent or deceased was probably not a coincidence, or even a matter of conveniently producing her likeness. Wal-ter Benjamin, Roland Barthes, and Susan Sontag have all drawn connections between photography, memory, and death. For Benjamin the "aura" that emanates from old pho-tographs is the last refuge of the cult value of art, which in photographs is transformed into the cult of remembrance of loved ones, absent or dead.[15] Barthes writes that photog-raphy creates "a perverse confusion between two concepts: the Real and the Live." Pho-tography attests that an object or person has been real, but shifts the reality to the past ("this-has-been"), thereby suggesting that the object is gone and the person is already dead.[16] Sontag insists that "the link between photography and death haunts all pho-tographs of people."[17]

Figure 6. Covers of books, exhibition catalogues, and a magazine featuring a reproduction of Nickolas Muray's photograph of Kahlo wearing the magenta *rebozo*.

In the 1940s, Kahlo kept the photographic portrait in her studio, where it hung in a hand-painted colonial frame. Since the 1950s it has hung above Rivera's bed in the *casa azul,* or blue house, where Rivera must have put it after Kahlo's death.[18] The placement is ironic, since in traditional Catholic homes this place would be occupied by an image of the Virgin or a crucifix. The irony of Rivera having hung a work of art by his wife's former lover above his bed was presumably unintentional.[19]

In 1968 Rivera's copy of the photograph in its hand-painted frame appeared on the cover of a new catalog to the Museo Frida Kahlo. The photograph has been used subse-

Figure 7. *À la mode*
(In Style), by Luis Fernando
Enríquez, 1985. Ink on paper,
15 x 24 cm. (5¾ x 9⅜ in.).
Courtesy of the artist. All
rights reserved. Photograph
by Nancy Deffebach.

quently on several covers, primarily in the last three years. It was reproduced on an exhi-
bition catalogue, a biography of Kahlo, a novel about her, a magazine, and a book about
Latin America (Figure 6). The photograph seems most appropriate on the cover of the
novel. Kahlo's more critical admirers might reasonably insist that one of her self-portraits
would more effectively represent her on the exhibition catalogues. The most opportunis-
tic use of the photograph is on the cover of Fabienne Rousso-Lenoir's *America Latina,*
where the photograph shot by the New York–based Hungarian American photographer is
used to represent all of Latin American visual culture.[20] Here, the benefits of Kahlo's in-
ternationally recognized face and proven marketability have outweighed the merits of
using a work *by* a Latin American artist to represent Latin America.[21]

With Kahlo's phenomenal rise in fame during the last two decades, the photograph
has been cited in fine art, folk art, and popular culture. Contemporary art based on the
photograph includes María de Lourdes Domínguez's drawing *Besos a Frida* (Kisses for
Frida) (1991) and Virginia Benavides's too-literal photographic collage *Frida* (1991).[22] Of
much greater interest is Luis Fernando Enríquez's *À la mode* (In Style) (1985), which uses
the photograph as a point of departure from which to comment on Kahlo's apotheosis
into an icon (Figure 7). In this ink drawing Enríquez shows the tilted head, braided hair-
style, combs, and earrings of the prototype, but she is encircled by the spiky mandorla of
the Virgin of Guadalupe. Small hands reach up to touch her shoulders, as if she were a
holy relic, and *milagros* (miracle amulets) representing a leg, heart, and frog hang from
her blouse.[23]

Enríquez's image draws on the subtle references to Marian imagery in the photograph. The tilt of Kahlo's head, the three-quarters view of her face, her calm dignity, her serene composure, and her magenta mantle evoke paintings of the Virgin Mary; these Marian references are undoubtedly a subliminal factor in the popularity of Muray's photograph.

In the summer of 2001, several shops in the artisan market near the Balderas metro station in Mexico City offered small altar-like boxes that enshrine the photograph (Figure 8). The boxes are almost identical to others featuring the Virgin of Guadalupe. Both versions have a blue exterior: blue is the color of the Virgin, and the shade of the boxes matches the intense blue of Kahlo's home, the *casa azul*. The interiors of the boxes contain a collaged reproduction of the photograph of Kahlo or of the Virgin's face above a crescent of pink ribbon rosettes. Sequins star the backgrounds.[24] According to one vendor, the Frida Kahlo boxes and the Virgin of Guadalupe boxes sell equally well.[25]

The photograph also appears on an enormous quantity of merchandise for sale in museum shops, bookstores, tourist sites, and on the Internet. Mass-produced commercial

Figure 8. Altar box. 10.7 x 13 cm. (4¼ x 5⅛ in.). Purchased in the Balderas Market in Mexico City, 2001. Courtesy of Nancy Deffebach.

Figure 9. Refrigerator magnet. Purchased in the Museo Nacional de Antropología in Mexico City, January 2003. Courtesy of Nancy Deffebach.

Figure 10. Frida Kahlo paper doll with the magenta *rebozo* costume. Published in *Aquí cuelgan mis vestidos* (My Dresses Hang Here). Courtesy of Francisco J. Estebánez. All rights reserved.

products include posters, postcards, T-shirts, mugs, aprons, light-switch plates, and refrigerator magnets (Figure 9). The cover of the paper doll book *Aquí cuelgan mis vestidos* (My Dresses Hang Here) features a Barbie-doll-like Frida dressed only in her orthopedic corset and panties; inside the book the selection of paper doll costumes includes an ensemble with a magenta *rebozo,* white blouse, and gray-violet skirt (Figure 10). In addition to mass-produced items, limited quantities of handmade jewelry and other crafts have been sold by individual artisans and craft collectives. Admirers of Kahlo who can never hope to own one of her paintings, which sell for as much as $3.2 million, or even Muray's photograph of her wearing the magenta *rebozo,* which is currently selling for $6,500 in a non-vintage limited edition, can buy an image of the artist on a refrigerator magnet for $2.

The photograph's mass circulation is epitomized by the United States Postal Service's use of it to promote a Frida Kahlo postage stamp in 2001. The 34-cent stamp features a reproduction of Kahlo's *Self-Portrait* (1931), a beautiful work that is atypically, and conveniently, devoid of the challenging themes that characterize her work. The stamps were sold in sheets of twenty that included a short quotation and a proportionally enormous image of Kahlo wearing the magenta *rebozo* (Figure 11). Kahlo seems to look down with benevolent approval at the proliferation of her image.

Figure 11. Sheet of twenty United States postage stamps, issued in 2001. Courtesy of Nancy Deffebach.

Kahlo's posthumous fame, her apotheosis to the status of heroine, is related in part to the ways that her art and life speak to people on a personal level. For many of her admirers, she is a figure of intense personal identification; the way her public persona combines ethnicity, gender, art, and politics makes her a figure of empowerment for a number of diverse groups. Art historian Edward Sullivan believes that Kahlo has achieved celebrity status because she is "a role model for many people—feminists, lesbians, gay men and others who were searching for a hero—someone to validate their struggle to find their own voice and their own public personalities. Frida, as a woman of personal and aesthetic strength and courage, met that need."[26] One woman who participated in a Frida Kahlo look-alike contest in San Francisco said that she admired the artist because she gave people courage: "I am forty years old," she explained, "and I don't have any children and I'm Mexican . . . That's almost criminal for a Mexican woman . . . She allowed me to be what I am."[27] For many Chicano artists, Kahlo is a cultural icon. In a catalogue to a landmark exhibition of Chicano art she is identified in the glossary as an important Mexican artist who has "inspired Chicano artists, and especially Chicanas, to pursue an artistic identity without denying their indigenous heritage, severing their familial ties, or restricting their political activism."[28]

Because many of Kahlo's most ardent admirers identify strongly with her, the talismanic use of photographs plays a role in her cult. Reproductions of the photographs of

Kahlo simultaneously express her absence and her pseudo-presence, evoking her: they are attempts to contact Frida.[29] As Walter Benjamin has noted, photography has the power to put an original work of art (or, in this case, a photograph of the artist) in situations that would be impossible for the original itself, thus allowing the image "to meet the beholder halfway."[30] Photographs fulfill the desire to bring people and things "'closer,' both spatially and humanly."[31] And they feed the desire to possess through vision.

Muray's photograph of Kahlo wearing the magenta *rebozo* is one of only a few color photographs of Kahlo (most of the others were also made by him), and the color gives it an intimacy and a palpable presence that contribute to its talismanic power.[32] The color provides specific information about her that black-and-white photographs lack: we know, for example, the tone of her complexion and the shade of nail polish she was wearing on the day she was photographed. Because color adds information that we do not get from other sources, it fosters an illusion of intimacy; thus the photograph seems to embody the "true" image of the artist.

Another attraction of the photograph may be the way it mimes Kahlo's imagery in a limited way. The photograph connotes images of the Virgin, and as such it corresponds to Kahlo's self-portraits, which draw heavily on Catholic symbolism. Yet the photograph lacks the complexity and irony of the painter's work. Kahlo's paintings address difficult themes, including violence toward women, eroticism, loss and longing, life and death. The photograph eschews troubling themes while presenting Kahlo's highly recognizable face, using her color palette, and incorporating some of her iconography: the indigenous hairstyle, pre-Columbian necklace, and Mexican clothing. As such it creates a foil to her work that functions as a sign or symbol for Kahlo, while eliminating the qualities that make her art disturbing and significant.

Acknowledgments

I am profoundly indebted to Kim Grant, who read and critiqued two drafts of this text. I wish to thank Guadalupe Rivera Marín, Arturo García Bustos, and Rina Lazo for interviews. I have talked about ideas presented in this essay with friends and colleagues and especially benefited from conversations with Jacqueline Barnitz, Eduardo de J. Douglas, Ana Garduño, Rosamaría Graziani, Kurt Heinzelman, Kenneth Josephson, Peter Mears, Sue Murphy, Debra Nagao, Judy Rohr, and Susan Webster.

Notes

1. I am indebted to Kim Grant for suggesting this idea.

2. Guillermo Kahlo (1872–1941) was a German Jew of Hungarian descent who at the age of nineteen immigrated to Mexico, where he became a photographer specializing in architectural photography. Though he was an atheist, he is best known for his handsome photographs of Mexican colonial churches. The only portraits that he ever made were of members of his own family. According to the Mexican writer Martha Zamora, he explained his preference for photographing architecture rather than people with the comment: "No quería mejorar lo que Dios había hecho naturalmente feo." ("I didn't want to make beautiful what God had made naturally ugly.")

 Frida Kahlo's choice of subject matter—human beings—was the opposite of her father's, but she shared his aversion to flattery. Her portraits of family, friends, acquaintances, and art collectors are in the realist tradition of nineteenth-century Mexican provincial paintings, exemplified by artists like Hermenegildo Bustos and José María Estrada. In Kahlo's self-portraits she looks out at the viewer with a direct, penetrating gaze. She depicted herself wearing lipstick, elaborately braided coiffures, and antique jewelry, but she also emphasized her faint mustache and exaggerated her heavy eyebrows. Photographs of her as a young woman invariably show a prettier face, at least by conventional standards, than do the paintings.

 The men and women who photographed Frida Kahlo include Ansel Adams, Lola Alvarez Bravo, Manuel Alvarez Bravo, Florence Arquin, Lucienne Bloch, Imogen Cunningham, Guillermo Davila, Gisèle Freund, Héctor García, Juan Guzmán, Fritz Henle, Peter A. Juley & Son, Antonio Kahlo, Guillermo Kahlo, Bernice Kolko, Julien Levy, Dora Maar, Leo Matiz, The Brothers Mayo, Martin Munkacsi, Nickolas Muray, Emmy Lou Packard, S. Ernesto Reyes, Bernard Silberstein, Carl Van Vechten, Edward Weston, and Guillermo Zamora. Martha Zamora, *Frida: El pincel de la angustia* (La Herradura, Estado de México: n.p., 1987), 90.

3. The dates that have been suggested for the photographs of Frida Kahlo and her pet deer Granizo are circa 1939 (Hayden Herrera), circa 1940 (George Eastman House), and the 1940s (Carla Stellweg).

4. Raquel Tibol in *Escrituras*, by Frida Kahlo, comp. Raquel Tibol (Mexico City: Universidad Nacional Autónoma de México/Consejo Nacional para la Cultura y las Artes, 2001), 90.

5. Kahlo's first known letter to Muray is dated May 31, 1931; in this letter she is clearly writing to a lover. Kahlo, *Escrituras*, 90, 347.

6. Hayden Herrera, *Frida: A Biography of Frida Kahlo* (New York: Harper & Row, 1983), 236; Kahlo, *Escrituras*, 170.

7. Carla Stellweg, "The Camera's Seductress," in *Frida Kahlo: The Camera Seduced*, by Carla Stellweg and Elena Poniatowska (San Francisco: Chronicle Books, 1992), 116.

8. The rest of the letter contains Kahlo's response to Muray's announcement that he was about to be married. In fact, before she finished writing the letter, Rose Covarrubias phoned to tell her that Muray had just married. By mid-summer Kahlo and Rivera had separated, and in September they began divorce proceedings. In mid-October Kahlo wrote Muray to tell him about her separation from Rivera and to let him know that she had sold the painting she made for him to pay for a lawyer. Later she sent Muray *Self-Portrait* (1940), a work that is usually interpreted as her response to her divorce from Rivera. In this canvas she wears a necklace of thorns with a dead hummingbird hanging from it. The hummingbird is an amulet that, according to Mexican folk custom, brings good luck in love. The imagery may allude to her recent break with Muray, as well as her separation from Rivera. Herrera, *Frida: A Biography of Frida Kahlo,* 271–272; and Kahlo, *Escrituras,* 181–183, 187–188.

9. Diego Rivera with Gladys March, *My Art, My Life: An Autobiography* (New York: Citadel Press, 1960), 254.

10. Rina Lazo, in interview with the author, January 9, 2003, Mexico City. The fact that Rivera based his portrait of Kahlo on Muray's photograph has been previously noted by José Antonio Rodríguez in "Frida fotográfica," in *Pasión por Frida,* comp. Blanca Garduño and José Antonio Rodríguez (Mexico City: Museo Estudio Diego Rivera/De Grazia Art and Cultural Foundation, 1992), 92, 195.

11. *Random House College Dictionary,* revised edition, s.v. "yin and yang."

12. Guadalupe Rivera Marín's exact words were: "El símbolo de yin y yang como lo eterno, el cosmos visto a través del movimiento perpetuo," and "El yin y el yang era el símbolo de la vida de ella." Guadalupe Rivera Marín, in interview with the author, August 2, 1984, Mexico City.

 Rivera and Kahlo saw a relationship between the Taoist symbol of yin-yang and the Aztec concept of *nahui olin,* or four movement. In *Dream of a Sunday Afternoon in Alameda Park* Rivera depicts the Aztec glyph *olin* on the belt of the Calavera Catrina, thus creating a visual dialogue between the Taoist and Aztec symbols. *Olin* means "movement" or "earthquake" and is associated with the sun. According to Aztec mythology *nahui olin* is the name of the world era in which we live, the Fifth Sun, which, like its predecessors, will be destroyed, this time by an earthquake. In "Frida Kahlo and Mexican Art," Rivera argues that *nahui olin* was one of the most potent religious symbols of the Aztec civilization, so vital to the Indians that after the conquest they covertly integrated it into "apparently Catholic paintings." Diego Rivera, "Frida Kahlo y el arte mexicano," in *Bolitín del Seminario de Cultura Mexicana,* no. 2, Mexico City, Secretaría de Educación Pública (October 1943): 89–101.

13. The hairstyle is repeatedly represented in the *Florentine Codex,* an illustrated sixteenth-century manuscript that Rivera often consulted for his many depictions of pre-Columbian culture. The shape of Kahlo's coiffure is almost identical to the Aztec prototype. Bernardino de Sahagún, *Florentine Codex: General History of the Things of New Spain: Book 4- The Soothsayers and Book 5- The Omens* (Salt Lake City: University of Utah Press, 1979), *passim.*

14. Arturo García Bustos's exact words were: "El signo *atl tlachinolli* significa la lucha, la lucha permanente de los contrarios. El *atl* es el agua y el *tlachinolli* es el fuego. Entonces 'agua quemada' es la unidad de los contrarios. Es la guerra, la guerra florida, la guerra misma, es como una forma de vida." García Bustos made this statement in the context of explaining the relationship that Rivera and Kahlo perceived between the Aztec glyph *nahui olin* and the Taoist symbol yin-yang. Arturo García Bustos, in interview with the author, August 14, 1984, Mexico City.

15. Walter Benjamin, "The Work of Art in the Age of Mechanical Reproduction," in *Illuminations,* ed. Hannah Arendt (New York: Schocken Books, 1969), 225–226.

16. Roland Barthes, *Camera Lucida: Reflections on Photography,* trans. Richard Howard (New York: Farrar, Straus and Giroux, 1981), 79.

17. Susan Sontag, *On Photography* (New York: Farrar, Straus and Giroux, 1973), 70.

18. A photograph shot by Juan Guzmán of Kahlo's studio, circa 1949, shows Muray's photograph in the hand-painted colonial frame hanging on a wall. The date that it was hung above Rivera's bed is unknown; Rivera probably moved it to his bedroom after Kahlo's death in 1954 and before his in 1957. The *casa azul* was turned into the Frida Kahlo Museum in 1958. The museum was arranged by the poet Carlos Pellicer, who was Kahlo's close friend. After he finished his work he wrote her a letter—though she had died four years earlier—in which he explained what he had done to her house so that when she returned she would not become angry with him. In the letter he stated that he had left Rivera's room just as it was. Carlos Pellicer Cámara, "Carta a Frida," *Revista de la Universidad,* Universidad Juárez de Tabasco, 2, no. 7 (March 1985): 3–6.

19. According to Hayden Herrera, Rivera encouraged his wife's homosexual affairs, but although he "believed in free love for himself and was cavalier about the openness with which he carried on, he did not . . . tolerate his wife's heterosexual affairs." Herrera, *Frida: A Biography of Frida Kahlo,* 199.

20. Fabienne Rousso-Lenoir, *America Latina* (New York: Assouline, 2002).

21. What an author or publisher chooses to put on the cover of a book has political meaning as well as the more obvious aesthetic and economic dimensions. The award for the least appropriate and most flagrantly commercial cover goes to the 2002 movie tie-in edition of Hayden Herrera's *Frida: A Biography of Frida Kahlo*, which displays a publicity photograph of Salma Hayek dressed as Frida Kahlo.

22. María de Lourdes Domínguez's *Besos a Frida* and Virginia Benavides's *Frida* are reproduced in Garduño and Rodríguez, *Pasión por Frida*, 75, 95.

23. *Milagros* (literally "miracles") are small metal representations that are hung on religious figures as votive offerings or as devout petitions.

24. In December 2002 similar altar boxes were being sold at the Bazar Sábado in the San Angel neighborhood of Mexico City. Many of the boxes contained Muray's photograph of Kahlo wearing the magenta *rebozo*, while others had a reproduction of one of her paintings. Other boxes featured the Virgin of Guadalupe or another advocation of the Virgin.

25. Anonymous vendor in the Balderas market, in conversation with the author, January 9, 2003, Mexico City.

26. Edward Sullivan, "Frida Kahlo in New York," in Garduño and Rodríguez, *Pasión por Frida*, 184.

27. Rosa Chavez cited by Jane Meredith Adams, "In Death, Mexican Artist a Cult Figure," *Chicago Tribune*, November 8, 1992.

28. From the entry on Frida Kahlo in the "Chicano Glossary of Terms," in *Chicano Art: Resistance and Affirmation*, 1965–1985. Many Chicano artists have paid tribute to Kahlo in their work, including Alfredo Arreguin, Barbara Carrasco, Enrique Chagoya, Yreina D. Cervantes, Rupert García, and Marcos Raya. Richard Griswold del Castillo, Teresa McKenna, and Yvonne Yarbro-Bejarano, eds., *Chicano Art: Resistance and Affirmation*, 1965–1985, exh. cat. (Los Angeles: Wight Art Gallery/ University of California, Los Angeles, 1991), 37, 242, 243, 247, 363; Garduño and Rodríguez, *Pasión por Frida*, 139, 187.

29. I am applying some of Susan Sontag's ideas and paraphrasing her words. Sontag, *On Photography*, 16.

30. Benjamin, "The Work of Art in the Age of Mechanical Reproduction," 220.

31. Ibid., 223.

32. Muray made many photographs of Kahlo. To see a set of these portraits, visit the George Eastman House Web site: http://www.geh.org/ar/celeb/htmlsrc4/kahlo_sum00001.html.

MIGUEL COVARRUBIAS AND THE VOGUE FOR THINGS MEXICAN

Wendy Wick Reaves

Curator of Prints and Drawings
National Portrait Gallery, Smithsonian Institution

"To be seen through so easily by a boy of twenty," Ralph Barton wrote in 1925, "and by a Mexican, a national of a country that we have been patronizing for a century or two, an outlander and a heathen, was a bitter but corrective pill."[1] The boy in question, the young Mexican-born artist Miguel Covarrubias (1904–1957), had just produced *The Prince of Wales and Other Famous Americans,* a volume of sixty-six caricature portraits published by Alfred Knopf. The book portrays an impressive array of café society celebrities, including writers, actors, artists, and musicians, with Calvin Coolidge (Figure 1), Babe Ruth, and the British prince thrown in for good measure. Its publication capped two years of remarkable achievements for the twenty-year-old artist. Since his arrival in New York in 1923, Covarrubias had met and drawn everyone of note, published his work in *Vanity Fair* and other periodicals, exhibited drawings at the Whitney Studio Club, and designed the sets for "La Revue Nègre," the jazz revue starring Josephine Baker that was just then dazzling Paris.

Barton, a renowned caricaturist himself, reviewed *The Prince of Wales* enthusiastically. Covarrubias's art, to Barton and other critics, seemed unerringly precise.[2] In india ink caricatures such as *Irving Berlin* (Figure 2), he drew with a tight, geometric stylization and used sharp, tapering lines of shading. In contrast to the grainy charcoal images so frequently seen in the press, Covarrubias's portraits jumped off the page, bristling with sophistication. Barton undoubtedly found the spirit of this work compatible with his own. Unlike their predecessors in the field of caricature, Barton and Covarrubias did not strip away the public face to expose hidden weaknesses. They seized upon the public image itself, not the person behind it, as their subject. Spoofing already well-publicized characteristics, they satirized the new celebrity culture as much as they attacked their victims.

Calvin Coolidge, Barton pointed out, might dream in the depths of his soul that he is a tailed satyr among a bevy of nymphs, "but the Calvin Coolidge that is any of our business is the Calvin Coolidge that Covarrubias has drawn." In Barton's opinion, it was not the caricaturist's business to be penetrating: "It is his job to put down the figure a man cuts before his fellows in his attempt to conceal the writhings of his soul."[3] This new form of celebrity caricature, just emerging in New York City at the time, would flourish in no small measure because of Covarrubias.[4]

In addition to the caricatures for which he was best known, Covarrubias's contributions to theater design, mural painting, book illustration, museum exhibition, and anthropology helped spur that cultural phenomenon of the 1920s and 1930s which the *New York Times* called "the enormous vogue of things Mexican." When the 1920s ushered in a period of prosperity in the United States and relative calm in Mexico after a decade of revolutionary turmoil, the scene was set for an explosion of interest in cross-cultural exchanges. Artists, intellectuals, writers, musicians, entertainers, and scholars flowed across

the border in both directions, creating an unprecedented awareness of cultural differences and affinities. The first American travelers, praising in print Mexican politics, peasant life, native crafts, ancient ruins, and contemporary art and mural painting, encouraged others. Katherine Anne Porter, Hart Crane, Aaron Copland, Leopold Stokowski, Martha Graham, Paul Strand, and Marsden Hartley were among the many such travelers visiting Mexico during these years. The Mexicans traveling northward introduced exciting new cultural traditions to the United States. Artists and mural painters were particularly renowned, especially Diego Rivera, José Clemente Orozco, David Siqueiros, Rufino Tamayo, and Covarrubias. "Mexico is on everyone's lips," photographer Edward Weston wrote, "Mexico and her artists."[5]

But how did the teenaged Covarrubias, who barely spoke English upon his arrival, make such an impact? The precocious artist had brought with him a sophisticated blend of aesthetic influences. As Adriana Williams has detailed in her biography of him, Covarrubias grew up in Mexico City in a prominent family. Artistically gifted and vivacious, the young prodigy preferred the theater and the café to the classroom. Armed with his sketchpad, Covarrubias haunted Los Monotes, a gathering spot for artists and intellectuals. There he met Orozco, Rivera, Tamayo, Adolfo Best Maugard, the distinguished poet José Juan Tablada, caricaturists Ernesto García Cabral and Luis Hildago, and other emerging stars. Amused by the clever portraits he drew, the group befriended the young man they nicknamed "El Chamaco" ("The Kid"). He acquired an informal schooling among them, imbibing the revolutionary ardor of the reformers' lessons in art and literature and their respect for the powerful Mexican caricature tradition. In the hands of the influential self-taught printmaker José Guadalupe Posada, caricature had become a highly politicized tool of populist reform and revolutionary propaganda; Covarrubias's contemporaries were struck by the strong, crude forms of Posada's prints, with their uncompromising political messages, and the artist's use of folklore traditions such as the haunting, skeletal "*calaveras*" imagery. Encouraged by his new friends, Covarrubias soon started publishing his own work in Mexico City newspapers. Eventually his drawings were syndicated throughout Mexico, Cuba, and South America.[6]

Covarrubias also joined Best Maugard and other artists in reviving interest in indigenous Mexican art, dance, and craft. In Mexico, the renaissance of the arts in the 1920s had a strong nationalistic element, which affected Covarrubias profoundly.[7] His own art reflected both the graphic patterning of ancient and native cultures and the influence of contemporary political caricature. Covarrubias also taught traditional arts to children in open-air schools, designed theater sets for folk dancers at the centennial anniversary of independence, and helped to organize an exhibition of Mexican arts and crafts which traveled to Los Angeles. His own collections grew with his passionate pursuit of indigenous objects. With far more experience than his youth would indicate, Covarrubias was thus well equipped to encounter New York City in 1923 when the poet Tablada, visiting the Mexican capital from his home in Manhattan, promised to help arrange a travel grant.[8]

Some credit for Covarrubias's success, however, must be given to that interesting brew of cultures—Mexican, European, Anglo, and African American—that he encountered

upon his arrival in New York. He connected immediately with the Mexican intellectual community. Tablada had arranged, through diplomatic friends, for Covarrubias to receive a government grant with a six-month living allowance. The effort to counteract Hollywood's negative Mexican stereotypes and promote nationalist interests was, for Tablada, a "holy crusade."[9] He established a bookstore on Fifth Avenue that became a center for Spanish-speaking intellectuals; many Mexican actors and artists visiting New York benefited from his encouragement and generous support.[10] Even before Covarrubias's arrival, Tablada had published one of his caricatures in the magazine *Shadowland,* praising his ingenuity and the "continuous calligraphic arabesque" of his line.[11] Through Tablada, as well as through acquaintances newly arrived from Mexico City and letters of introduction from diplomatic sponsors, Covarrubias immediately encountered the support and friendship of fellow Mexicans.

New York in the 1920s also provided the strong stimulus of exposure to the latest ideas from European art capitals. Covarrubias's artist friends in Mexico City had rebelled against the Europeanization of art and architecture, but they were acutely aware of contemporary trends from abroad. Like the international café culture of many other capital cities, their circle eagerly consumed illustrated journals from Germany, France, and England such as *Simplicissimus, L'Assiette au Beurre,* and *The Graphic.*[12] Living in New York undoubtedly increased Covarrubias's awareness of the prevailing artistic currents. His caricatures suggest an absorption of modern European aesthetics in art, theater, and graphic design. In his watercolor drawing of jazz band conductor Paul Whiteman (Figure 3), probably drawn in 1924, Covarrubias spoofs Picasso and Braque's cubism in his use of the violin and his abstraction of the facial features. The clean lines and geometric stylization of the image also reflect the Parisian design trend known as art deco.[13]

The Anglo culture of New York also left an imprint on Covarrubias's developing style. Tablada's friend Sherrill Schell, a photographer and travel writer who specialized in Mexico, introduced the young artist to Carl Van Vechten, a popular novelist, critic, and café society socialite who later became renowned as a photographer. This fortuitous meeting provided introductions to Manhattan celebrities. In the preface to *The Prince of Wales and Other Famous Americans,* Van Vechten wrote that he so admired the drawings Covarrubias showed him that he immediately telephoned various prominent acquaintances to persuade them to sit for a Covarrubias portrait. "I was immediately convinced," he wrote, "that I stood in the presence of an amazing talent, if not indeed genius."[14] Van Vechten introduced Covarrubias to Ralph Barton as well as a host of writers, actors, and other notables. Later he took Covarrubias to lunch at the celebrated Algonquin Hotel, the stomping ground of those renowned wits known collectively as the Algonquin Round Table. There, according to Van Vechten, the young artist was "acclaimed at once."[15] Van Vechten was not surprised at this reception. Such caricatures as Covarrubias's 1927 *Mae West* (Figure 4) mined a vein of high-style, sophisticated mockery analogous to the urbane wit of the Algonquin authors. The newspapers and magazines for which these authors wrote seemed perfect venues for Covarrubias's work. Before the year was out, Van Vechten had sent him

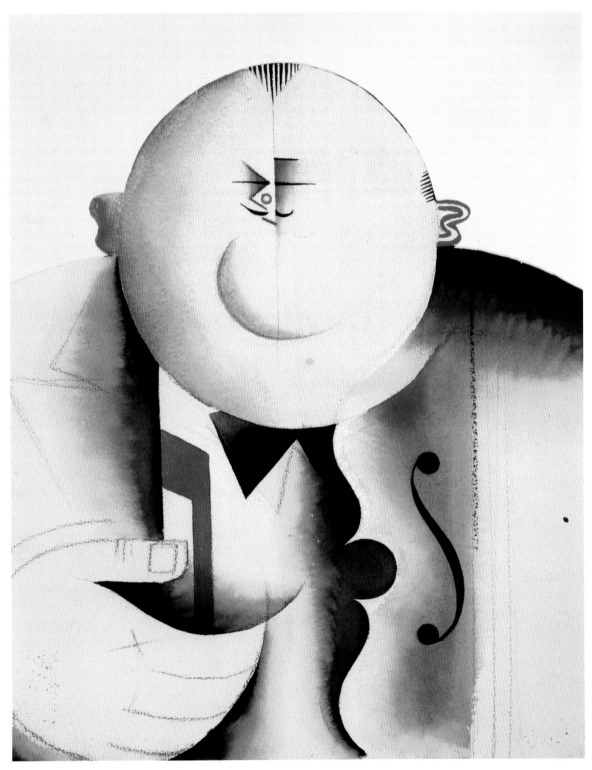

Figure 3. *Paul Whiteman* (1891–1967), by Miguel Covarrubias, ca. 1924. Watercolor over charcoal on paper, 29.1 x 24.5 cm. (11½ x 9⅝ in.). Courtesy of Prints and Photographs Division, Library of Congress, Washington, D.C.

Figure 4. *Mae West in "Diamond Lil"* (1893–1980), by Miguel Covarrubias, 1928. Published in the *New Yorker,* May 5, 1928. Ink and wash with gouache on paper, 33 x 27.9 cm. (13 x 11 in.). Courtesy of National Portrait Gallery, Smithsonian Institution, Washington, D.C.

to *Vanity Fair,* one of the most prestigious of the "smart" magazines; his first drawings appeared there in January 1924.

Vanity Fair editor Frank Crowninshield was another critical contact for a young man poised to enter the New York publishing world. Crowninshield had already had a considerable impact on the generation of the Algonquin Round Table, and his influence on Covarrubias was no less transformative.[16] A genteel and cosmopolitan clubman, Crowninshield also had an eye for the adventurous. Secure in his sense of taste, he promoted vibrant new popular arts and entertainments as well as emerging writers and artists. But he always insisted on a refined, urbane approach. Algonquin writers Robert Benchley, Robert Sherwood, and Dorothy Parker had all worked for *Vanity Fair,* and although they didn't last long, some of the polite, detached tone of voice they adopted probably derived from Crowninshield. Benchley once joked of the editor's "willingness for any writer who writes entertainingly to say practically anything he wants to say in *Vanity Fair* so long as he says it in evening clothes."[17] Parker often launched her sharp, outrageous barbs from a quite demure and ladylike stance.

Crowninshield liked the crisp stylization of Covarrubias's drawings, but he also undoubtedly encouraged him in the direction of restraint. In his introduction to the young artist's 1927 book *Negro Drawings,* Crowninshield admired Covarrubias's grasp of charac-

Figure 5. *Frank Conroy and Ethel Barrymore in "The Constant Wife"* (1890–1964; 1879–1959), by Miguel Covarrubias, ca. 1926. Published in the *New Yorker*, January 1, 1927. Ink and wash with gouache on board, 38.8 x 32.1 cm. (15¼ x 12⅝ in.). Harry Ransom Humanities Research Center, University of Texas at Austin. See color plate 19.

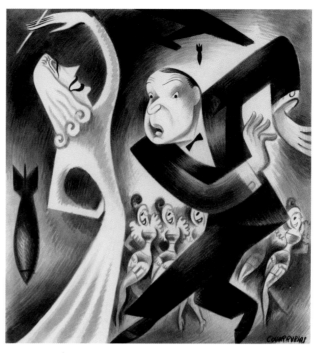

Figure 6. *Alfred Lunt and Lynn Fontanne in "Idiot's Delight"* (1892–1977; 1887–1983), by Miguel Covarrubias, 1936. Published in the *New Yorker*, April 11, 1936. Ink and wash on board, 37.8 x 27.7 cm. (14⅞ x 10⅞ in.). Harry Ransom Humanities Research Center, University of Texas at Austin. See color plate 46.

Figure 7. *Minnie Maddern Fiske and Sidney Toler in "Mrs. Bumpstead-Leigh"* (1865–1932; 1874–1947), by Miguel Covarrubias, 1929. Published in the *New Yorker*, April 17, 1929. Ink and wash on paper, 30.5 x 25.4 cm. (12 x 10 in.). Harry Ransom Humanities Research Center, University of Texas at Austin. See color plate 24.

Figure 8. *Jim Londos* (ca. 1897–1975), by Miguel Covarrubias, 1932. Published in the *New Yorker*, March 5, 1932. Ink and wash on paper, 36.8 x 28.8 cm. (14½ x 11⁵⁄₁₆ in.). Harry Ransom Humanities Research Center, University of Texas at Austin. See color plate 41.

Figure 9. *Nickolas Muray* (1892–1965), by Miguel Covarrubias, ca. 1927. Graphite, gouache, and ink on paper, 40.6 x 33 cm. (16 x 13 in.). Courtesy of National Portrait Gallery, Smithsonian Institution, Washington, D.C.; gift of Mimi and Nicholas C. Muray.

ter and his "extraordinary control of plastic form."[18] He praised the absence of anything farcical, vulgar, or grossly overstated. The mockery of most humorists, he pointed out, depended upon extreme distortion, comic situations, and clever captions; but in Covarrubias's portraits, the satire results from the draftsmanship alone with "only a chemist's trace of exaggeration."[19] Some of the caricatures Covarrubias had drawn in Mexico attacked their victims quite mercilessly. His horrific, distorted portrayals, such as those of Dr. Atl, Javier Algara, or Tablada, have a harsh, emotional thrust.[20] The New York drawings were far more detached. Although he did not know his subjects and was still struggling with the language, Covarrubias also seems to have consciously avoided the more brutal exaggerations admired in Mexican and German caricature of the period. Remarkably, however, this restraint did not weaken his interpretations; they remained deft, powerful characterizations.

Covarrubias's talent soon seduced other New York editors, who published his images in a variety of journals and newspapers. In 1925 his drawings began to appear in the *New*

Yorker. Launched only the previous year, the magazine had seized on theatrical caricature as a critical element of its editorial mix. Covarrubias contributed blithe, elegant reprises of theatrical offerings such as *The Constant Wife,* with Frank Conroy and Ethel Barrymore (Figure 5), *Idiot's Delight,* with Lynn Fontanne and Alfred Lunt (Figure 6), and *Mrs. Bumstead Leigh,* with Minnie Maddern Fiske and Sydney Toler (Figure 7). His multiple characters fit together like the pieces of a puzzle. Lively contrasts of curves and angles delineate characteristic gestures and poses; clever visual tricks differentiate eyes, brows, mouths, and hair with humorous abbreviation. As the "Profiles" biographical essay became a regular feature of the *New Yorker,* Covarrubias illustrated several of these as well. His image of Jim Londos translates the wrestler's physique into a muscular triangularity (Figure 8).

Indeed, Covarrubias's winning personality and skill seem to have conquered all of Anglo Manhattan. Caricaturist Al Hirschfeld, who shared a studio with Covarrubias in the 1920s, reminisced that he liked to "be out where the action was . . . He knew everybody in the literary world, in the arts, in the theater, in the ballet and all other allied arts. He also knew the Vanderbilts, the Whitneys, and the Rockefellers; the wealthy of the city."[21] Endowed with legendary energy, Covarrubias designed theater sets, illustrated books, played in a band, and fell in love. The beautiful dancer Rose Rolanda became his frequent companion; they married in 1930. Photographer Nickolas Muray, who also made a reputation capturing celebrity faces, became an especially close friend. Covarrubias depicted him as a championship fencer and ladies' man (Figure 9), and Muray collected many of the artist's original drawings. Today this collection resides at the Harry Ransom Humanities Research Center at the University of Texas at Austin.

One other powerful influence added to the cultural blend that inspired Covarrubias's unique vision. Black Manhattan proved as eye-opening as New York's café society. The ubiquitous Van Vechten, a strong integrating force between the white and black sectors of the city, introduced Covarrubias to Harlem and the burgeoning African American renaissance in literature, jazz, and dance. Van Vechten befriended writers, musicians, and artists, praising them in critical reviews, inviting them to his cocktail parties, and introducing them to publishers.[22] He took his white friends to tantalizing Harlem nightspots. In a drawing titled *A Prediction,* Covarrubias fondly suggested that Van Vechten's obsession would soon turn his skin black (Figure 10). Covarrubias himself was profoundly changed by the culture he came to love in Harlem. Most evenings he could be found club hopping "uptown," often in the company of Al Hirschfeld and, sometimes, playwright Eugene O'Neill. He began to make both sketches and friends—Ethel Waters, Florence Mills, Langston Hughes, Zora Neale Hurston, and W. C. Handy among them. Collaborations followed. Covarrubias contributed to Alain Locke's *The New Negro* (1925), a key anthology of the Harlem Renaissance. He designed book covers for Hughes and Hurston and illustrated books by Handy and Taylor Gordon. He published his own observations in *Vanity Fair* as well as in *Negro Drawings,* issued by Knopf in 1927.

Covarrubias's visual travelogue from Harlem can still strike a controversial note. He drew only a few portraits of his new acquaintances.[23] Most of his imagery depicted types:

Figure 10. *Carl Van Vechten* (1880–1964), by Miguel Covarrubias, ca. 1925. Ink and watercolor over graphite on board, 18.7 x 12.7 cm. (7⅜ x 5 in.). Courtesy of National Portrait Gallery, Smithsonian Institution, Washington, D.C.

the gambling man, the jazz baby, the blues singer, the Harlem dandy (Figure 11). Today, the thick lips, enlarged hands, sensuous bodies, and typecast roles creep close to stereotypes, but in the 1920s, an audience attuned to the demeaning racist imagery of minstrelsy and the "Darktown Comics" saw Covarrubias's drawings as celebratory. Although W. E. B. Du Bois, for one, was uncomfortable with these depictions, most of Covarrubias's black friends understood his admiration for the vitality of Harlem, and they praised his work enthusiastically.[24] *Negro Drawings* was internationally acclaimed, and, like Josephine Baker's musical revues in Paris, it furthered the vogue for African American arts. Covarrubias's experiences in Harlem also proved pivotal to his future development, serving to renew in this sophisticated urbanite a passion for the non-mainstream folkways that he had first encountered as a teenager in Mexico City. This growing interest would change the course of his career.

Figure 11. *Harlem Dandy,* by Miguel Covarrubias, undated. Litho crayon on paper, 27.7 x 21.3 cm. (10⅞ x 8⅜ in.). Harry Ransom Humanities Research Center, University of Texas at Austin. See color plate 32.

Figure 12. *The Abuang,* by Miguel Covarrubias, 1937. Published in *Island of Bali* (New York, 1937). Watercolor on paper, 27.8 x 21.5 cm. (11 x 8½ in.). Harry Ransom Humanities Research Center, University of Texas at Austin. See color plate 67.

Frank Crowninshield remained a loyal supporter as Covarrubias pursued his next major interest: travel. Just as *Vanity Fair* had previously published the artist's observations of Harlem, it now featured his visual reportage from wherever he and Rose were wandering: Havana, Paris, Morocco, Bali. As Covarrubias's ethnographic interest in non-Western cultures grew, his fascination with Bali became quite serious. The couple paid the island two extended visits—one of them courtesy of a Guggenheim grant. While Rose took photographs, Covarrubias studied the region's history, politics, ceremonial rituals, music, dance, and daily life. His book *Island of Bali,* illustrated with his drawings (Figure 12) and Rose's photographs, was published in 1937 to nearly unanimous international praise, establishing his credentials as a serious writer and anthropologist.

Crowninshield had his spats with Covarrubias, but eventually their roles were reversed: the editor came to need the increasingly famous artist more than the other way around. In the 1930s, when *Vanity Fair* faced financial challenges and contemplated more serious themes and global coverage, Crowninshield and his fellow editors renewed their emphasis on caricature. Publisher Condé Nast's new plant led the industry in the quality of its color printing, and *Vanity Fair* began to replace many of its black-and-white artists

Figure 13. *Helen Wills* (1905–1998), by Miguel Covarrubias, 1932. Published in
Vanity Fair, August 1932. Gouache and ink on paper, 40.5 x 29 cm. (15⅞ x 11⅜ in.).
Harry Ransom Humanities Research Center, University of Texas at Austin. See color
plate 36.

with colorists.[25] Crowninshield had always admired Covarrubias's "rich, haunting color"
in paint, watercolor, and gouache; Covarrubias was one of the three artists *Vanity Fair* re-
cruited to create cover art and full-page featured illustrations.[26] Along with Paolo Garretto
and Will Cotton, Covarrubias dominated the look of *Vanity Fair* in the 1930s, pushing
celebrity caricature to new heights of popularity. His image of tennis star Helen Wills, a
white-clad figure catapulting off the ground against a brilliant blue sky, made a stunning
cover for the August 1932 issue (Figure 13). The eye-catching image highlights both Co-
varrubias's sharply geometric design and the magazine's glorious color printing.

In December 1931, *Vanity Fair* introduced the "Impossible Interview," a soon-to-be legendary series drawn by Covarrubias with captions by humorist Corey Ford. Featuring such ill-matched pairs as a birth control advocate with the mother of quintuplets, a speakeasy hostess with the president of the Women's Christian Temperance Union, or a sultry Marlene Dietrich with moralist Senator Smith Brookhart (Figure 14), each interview offered rich potential for comic conversation and visual contrasts. Covarrubias had already illustrated Ford's 1928 book *Meaning No Offense* (with Ford writing pseudonymously as John Riddell), and the two were about to issue *In the Worst Possible Taste* (1932), featuring such novelists as a dirt-digging William Faulkner (Figure 15) and a whip-wielding Edna Ferber (Figure 16).

Figure 14. *Senator Smith W. Brookhart vs. Marlene Dietrich, "Impossible Interview No. 10"* (1869–1944; 1901–1992), by Miguel Covarrubias, 1932. Published in *Vanity Fair*, September 1932. Gouache and ink on paper, 38.8 x 32.7 cm. (15⁵⁄₁₆ x 12⅞ in.). Harry Ransom Humanities Research Center, University of Texas at Austin. See color plate 38.

But the "Impossible Interviews" proved to be the team's greatest success. Covarrubias matched Ford's comic genius with his own visual wit. Al Capone faced off against Chief Justice Charles Evans Hughes in October 1932 (Figure 17). As in many of the "Interviews," the less respectable figure achieves a slight edge. It is unclear which person is behind the bars, and Capone holds a dominating position in the composition as he proclaims in the caption, "Ain't my gang the real Government of the U.S.A.?"[27] Covarrubias played with pictorial contrasts between the two: loud plaid and diamond stickpin versus somber judicial robe and dainty lace jabot, dark brow and swarthy complexion versus fluffy white hair and pink skin. But the commonality of each "impossible" pair, as established by the caption, was always their shared fame. The "Impossible Interview" series was a well-aimed spoof on celebrity culture and its inability to distinguish between solid achievement and shallow renown.

Ford and Covarrubias teamed movie star Clark Gable with the Prince of Wales as New versus Old World heartthrobs in a November 1932 "Interview" (Figure 18). Gable is billed as the Prince's successor, a Hollywood heir to royal glamour. In Covarrubias's rendition,

Figure 15. *William Faulkner* (1897–1962), by Miguel Covarrubias, 1932. Published in John Riddell's *In the Worst Possible Taste* (New York, 1932). Ink and wash on paper, 35.6 x 28 cm. (14 x 11 in.). Harry Ransom Humanities Research Center, University of Texas at Austin. See color plate 57.

Figure 16. *Edna Ferber* (1885–1968), by Miguel Covarrubias, ca. 1932. Published in John Riddell's *In the Worst Possible Taste* (New York, 1932). Ink and wash on paper, 36.8 x 26.7 cm. (14½ x 10½ in.) Harry Ransom Humanities Research Center, University of Texas at Austin. See color plate 55.

Figure 17. *Al Capone vs. Chief Justice Charles Evan Hughes, "Impossible Interview No. 11"* (1899–1947; 1862–1948), by Miguel Covarrubias, 1932. Published in *Vanity Fair*, October 1932. Gouache on paper, 35.3 x 28.8 cm. (13⅞ x 11⁵⁄₁₆ in.). Harry Ransom Humanities Research Center, University of Texas at Austin. See color plate 39.

Figure 18. *Clark Gable vs. Edward, Prince of Wales, "Impossible Interview No. 12"* (1901–1960; 1894–1972), by Miguel Covarrubias, 1932. Published in *Vanity Fair*, November 1932. Gouache and ink on paper, 32.7 x 27.5 cm. (12⅞ x 10¹³⁄₁₆ in.). Harry Ransom Humanities Research Center, University of Texas at Austin. See color plate 40.

Gable dominates the Prince in every way: his strong physique, powerful mask-like face, fashionably suntanned complexion, chic white turtleneck, and crisply pleated trousers all outclass the Prince's cringing, woolen figure. Edward, glancing askance at the star's machine-like presence, acknowledges in the caption that Gable is "the chap who has usurped my role as the heartbreaker of the world."[28]

Covarrubias was a major contributor to *Vanity Fair* until its demise in February 1936, even though he and Rose had moved to Mexico in 1935, establishing their home in the village of Tizapán outside of Mexico City. There Miguel's spectacular pre-Columbian collection and Rose's legendary skills as a hostess and chef attracted visitors from around the world. From Amelia Earhart to Nelson Rockefeller to Merce Cunningham, Americans made their way to Tizapán. Other careers beckoned as husband and wife settled in Mexico. Covarrubias's growing archaeological and anthropological interests evolved into serious study, teaching, publication, and museum work; his lifelong fascination with dance led to a position running a national dance academy in Mexico City.

Figure 19. *Lightning Conductors,* by Miguel Covarrubias, 1937. Published in *Vogue,* November 15, 1937. Gouache on board, 34.9 x 29.5 cm. (13¾ x 11⅝ in.). Courtesy of National Portrait Gallery, Smithsonian Institution, Washington, D.C.

Figure 20. *Radio Talent,* by Miguel Covarrubias, 1938. Published in *Fortune,* May 1938. Watercolor on board, 38.1 x 61.8 cm. (15 x 24⁵⁄₁₆ in.). Courtesy of National Portrait Gallery, Smithsonian Institution, Washington, D.C.

But Covarrubias remained involved in the arts in America. He kept up relationships with long-term friends such as Nickolas Muray. Publishers hounded him for more pictures, and although he was notoriously late and easily distracted by other interests, illustration remained a steady source of income. His group portraits *Lightning Conductors* (Figure 19), published in *Vogue* on November 13, 1937, and *Radio Talent* (Figure 20), which appeared in the May 1938 issue of *Fortune,* both depicted broadcast personalities wafting out over the airwaves. Although the ghostly evocation of familiar faces, from Toscanini to Roosevelt to Donald Duck, has a slightly unsettling effect, these ambitious pictures retain a distinctive energy and humor.

Covarrubias's various activities promoted Mexican culture in America even after he left New York. He continued to exhibit his own work in museums, and he painted murals, including six panels for the San Francisco World's Fair in 1939. Back in 1930, Covarrubias had loaned pieces of his folk art collection as well as several of his own paintings to René

d'Harnoncourt for an influential exhibit of Mexican art that traveled to New York's Metropolitan Museum of Art and thirteen cities thereafter. Now, he collaborated with d'Harnoncourt in the massive "Twenty Centuries of Mexican Art" exhibition that opened at the Museum of Modern Art in 1940. Covarrubias organized the modern art portion of the show and loaned some of his pre-Columbian artifacts.

As the Muray collection at the University of Texas so amply demonstrates, Covarrubias's art added an important dimension to American visual culture. The story of his life reminds us that the explosive creativity in New York City between the two world wars had much to do with a vibrant, multicultural community challenging stereotypes, exchanging ideas, and exploring new frontiers.

Notes

1. Ralph Barton, "It Is to Laugh," *New York Herald Tribune,* October 25, 1925.

2. "There was no fumbling around either for the idea or for the method," Henry McBride wrote in the *New York Sun* on December 24, 1927, "but an adult assurance that was as startling as it was pleasing."

3. Barton, "It Is to Laugh."

4. For an in-depth look at the vogue for caricature and Barton's and Covarrubias's roles, see Wendy Wick Reaves, *Celebrity Caricature in America* (New Haven, CT: Yale University Press, 1998).

5. Helen Delpar, *The Enormous Vogue of Things Mexican* (Tuscaloosa: University of Alabama Press, 1992), 72.

6. Adriana Williams, *Covarrubias,* ed. Doris Ober (Austin: University of Texas Press, 1994). Unless otherwise cited, biographical details of Covarrubias's life come from this detailed source.

7. Delpar, *The Enormous Vogue of Things Mexican,* 12.

8. "Covarrubias Turns Scene Designer," *New York Times,* December 13, 1925.

9. Delpar, *The Enormous Vogue of Things Mexican,* 41.

10. Williams, *Covarrubias,* 17.

11. José Juan Tablada, "Caricature That Stings," *Shadowland,* April 1923, 54–55, 70.

12. Bernard Reilly, "Miguel Covarrubias: An Introduction to His Caricatures," in *Miguel Covarrubias Caricatures,* by Beverly J. Cox et al. (Washington, DC: Smithsonian Institution Press, 1985), 24–25.

13. In fact, when Covarrubias lived for several months in Paris in 1926–1927, he gravitated to the avant-garde circles of Edward Steichen, Man Ray, and Gertrude Stein.

14. Carl Van Vechten, preface to *The Prince of Wales and Other Famous Americans,* by Miguel Covarrubias (New York: Alfred A. Knopf, 1925), unpaginated.

15. Ibid.

16. Cynthia L. Ward, *Vanity Fair Magazine and the Modern Style, 1914–1936* (Ph.D. diss., State University of New York at Stony Brook, 1983), 117–123.

17. Robert C. Benchley, "Mr. Vanity Fair," *Bookman* 50 (January 1920): 432.

18. Frank Crowninshield, introduction to *Negro Drawings,* by Miguel Covarrubias (New York: Alfred A. Knopf, 1927), unpaginated.

19. Ibid.

20. For Dr. Atl, see *Miguel Covarrubias Caricatures,* page 27; Algara and Tablada are published in *The Prince of Wales.* Tablada was good-natured about Covarrubias's portrayals; he reproduced another quite hideous portrait of himself in his *Shadowland* article.

21. Williams, *Covarrubias,* 36.

22. Bruce Kellner, *Carl Van Vechten and the Irreverent Decades* (Norman, OK: University of Oklahoma Press, 1968), 195–223.

23. Covarrubias's extraordinarily powerful ink drawing of James Weldon Johnson, now at Yale University, is a striking exception. See Cox et al., *Miguel Covarrubias Caricatures,* 55.

24. Archie Green, "Miguel Covarrubias' Jazz and Blues Musicians," *JEMF Quarterly* 13 (Winter 1977): 187; Williams, *Covarrubias,* 37–40, 48.

25. Caroline Seebohm, *The Man Who Was Vogue* (New York: The Viking Press, 1982), 246–258.

26. Crowninshield, introduction to *Negro Drawings,* unpaginated.

27. "Impossible Interviews no. 11," *Vanity Fair,* October 1932, 49.

28. "Impossible Interviews no. 12," *Vanity Fair,* November 1932, 40.

GREATER MEXICO, MODERNISM, AND NEW YORK: MIGUEL COVARRUBIAS AND JOSÉ LIMÓN

José E. Limón

Director, Center for Mexican American Studies,
University of Texas at Austin

Lest the reader unfamiliar with modern dance misunderstand the repetition of name in the title and byline above, let me explain: this essay involves another José Limón (1908–1972), the great figure of American modernist dance (Figure 1). I happen to share his name (although we also shared a bit more than that, as I will suggest later). This essay also concerns another great, though not yet fully recognized, modernist figure: Miguel Covarrubias. Covarrubias, together with Limón, shaped modernist culture between the United States and what I will call "Greater Mexico" in the first half of the twentieth century. Following Américo Paredes, the foremost scholar of Mexican culture, I use the term "Greater Mexico" to refer to Mexican people, whether they are living in national Mexico or in the United States.[1] Modernism is an equally complicated transnational phenomenon. Habitually understood as an east-west global circuit including Chicago, New York, London, Paris, Geneva, and Vienna, modernism's south by southwest connections merit further exploration.

Thanks to recent scholarly and biographical work, the lives and careers of Covarrubias and Limón are now much more available. I will add little to the existing data; the purpose of this essay is to place these rich findings within a more historically informed conceptual framework. Thus a better understanding of the cultural politics that shaped Limón and Covarrubias's contributions to modernist culture along this north/east-south/west axis emerges. Moreover, I offer a conjunctive, not simply a comparative, analysis of the historically significant and productive intersection between the lives of the two men.

Limón and Covarrubias's contributions to modernist culture, however, cannot be understood apart from what President Polk, in 1845, termed the "Mexican Question" on the eve of the U.S.-Mexico War—an event that produced modern Greater Mexico's fraught

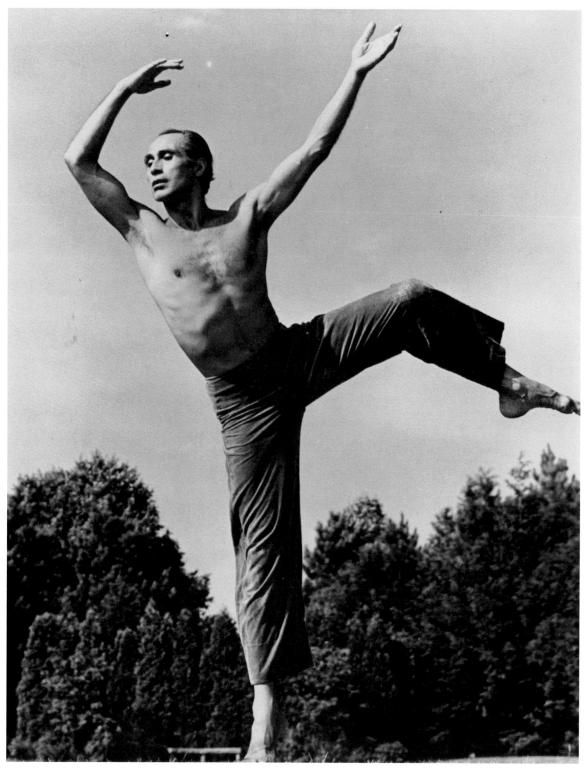

Figure 1. *José Limón,* unidentified photographer, undated. Silver gelatin photograph, 25.4 x 20.3 cm. (10 x 8 in.). Harry Ransom Humanities Research Center, University of Texas at Austin.

and racially/culturally inflected subordinate relationship to the United States. In this essay, I argue that the separate but conjunctive experience of these two men can now be understood as a particular, Greater-Mexican, modernist effort to overcome the vicissitudes of this asymmetrical binational relationship.

Modernity and Its Greater Mexican Vicissitudes

The historical context of both Covarrubias's and Limón's specific encounters with the Mexican Question can be traced back to the watershed period in Greater Mexico that began with the onset of the regime of Porfirio Díaz in national Mexico in 1876, and culminated in the Mexican Revolution of 1910 and its aftermath. The scholarship is voluminous, but at least one essential point can be distilled: an international capitalist and colonialist modernity was imported into national Mexico, largely from the United States. This importation greatly contributed to the grossly uneven distribution of national resources in Mexico and the massive and widespread impoverishment of the Mexican masses. It also brought about the emergence of an elite, dominant Mexican class with close ties to its world counterparts and a particular *economic* connection to the United States on the one hand, and a *cultural* connection to the upper-class French on the other (although American culture would soon also make its weight felt in Mexico). Mexico's rampant and exploitative poverty toward the end of the century initiated a process of emigration into the neighboring United States. The Mexican dispossessed came to better their lives, but they acted within the same process of capitalist modernity also unfolding in the United States—for Mexicans, largely within the agricultural sector in the Southwest. Emigration massively accelerated in the context of a violent revolution against the Díaz regime beginning in 1910, which largely failed to improve the situation for what a Mexican novelist of that period, Mariano Azuela, famously termed *los de abajo* (the underdogs). Later, novelists Juan Rulfo and Carlos Fuentes vividly captured the revolution's tortured failure in their respective works, *Pedro Páramo* and *La muerte de Artemio Cruz*.[2]

Portraits of the Artists as Young Men

Limón began writing his autobiography in the 1960s, continuing until his death in 1972. The manuscript was left unfinished. In these memoirs, the modernist dancer turned writer vividly describes a personal moment in his experience of the Mexican Revolution, recalled from age four with perhaps a bit of permissible embellishment. No true dancer exactly follows the choreographer, and no choreographer expects it.

My . . . Uncle Manuel received a bullet in the head shortly after the opening of the battle of Cananea [1912]. It happened in the dining room of our house . . . bullets began to shatter the windowpanes and whistle into the room . . . everyone hit the floor, except my gallant young uncle. He had to see what was going on and looked out the window. He laughed, I remember, and then he was hit. He fell back and a pool of blood grew around him.[3]

The revolution failed to better the general fortunes of the Mexican people. Like so many of their compatriots, José Limón's parents and their progeny—José was seven—emigrated to the United States in 1914. From Parral, Chihuahua, they came first to El Paso, Texas (where Azuela had written *Los de abajo* in exile), moved to Arizona, and then to Los Angeles. Young José recalled his entrance into what I earlier termed the racially but also culturally inflected negations of modernity. Children and teachers in Texas schools made fun of his native Spanish, but the situation, a source of psychic undoing in most ordinary Mexican children, seemed instead to put a resolve into the young Limón to learn English well and become an American at any cost. And indeed, balanced against the gain, there would be a cost to pay. "I was soon to learn," he tells us, "that for the rest of my life, I was to be a translator and conciliator. It would be my task to translate perpetually, within myself the tongue of Castile into that of the Anglo-Saxon. To reconcile many disparate and contradictory cultural habits and ways of living, and to resolve hostilities within and around me." Among and probably central to such hostilities was his relationship to the "*norteamericano,* the *yanqui,* the *gringo*" who had "invaded our *patria* and inflicted a humiliating defeat on a weaker nation and imposed a peace of galling ignominy."[4]

Such hostilities appear to have been repressed and/or displaced into other not-unrelated struggles in Los Angeles. "As the family grew, the struggle to feed, clothe, and house us became ever more brutal. We were poor." Yet there was another potent cultural and familial resource: "Not once, living as we did in what would one day be referred to as the Mexican ghetto, did I see my father ever falter in his manners and his dignity. His clothes, worn and often threadbare, were always decent and in order . . . he was a handsome and distinguished presence."[5] In such threatening social circumstances, Don Florencio Limón, a reasonably educated man and an orchestra musician, undoubtedly provided José with a source of strength, not to mention an artistic orientation. But such a man could be many things at once: "my father, my enemy, a figure of fear, awe, contempt, hatred, and ultimately and too late, reverence and love."[6] In this conflicted situation, Limón the child discovered a compulsive pleasure in drawing and painting, a talent soon pressed into service in his struggles with his new country. "Besides the Catholic religion," he tells us, "art . . . bridged the chasm separating the scared Mexican child from the slowly acclimatizing youth and adult. My accent may have been ridiculed, but my prowess as an artist was accepted with total and gratifying admiration."[7] Later, Limón found another artistic source of countervailing strength in the Los Angeles of the 1920s: "In my last year of high school I became acquainted with another set of mentors . . . three young men, aspiring artists . . . aesthetes, bohemians and rebels" who read "Omar Khayyam . . . Oscar Wilde . . . Beaudelaire [*sic*]" even as they all listened to "not only Debussy and Satie but also a terrifying composer called Schoenberg." In this group, "bourgeois society and its values, pretensions and hypocrisies were not merely dissected, but dismembered and annihilated."[8] In college this conversion to the classic posture of modernism was completed and "destined. My mother's death, the break with my father, my loss of religious faith, my disenchantment with the University of California, Southern Branch [as UCLA was then called] were unmistakable signs that my young life was in crisis."[9]

The same Mexican Revolution that gave us this young, incipient, modernist *mexicano de afuera,* also gave us Miguel Covarrubias.[10] Only four years older than Limón, Covarrubias was born in 1904 but into very different social circumstances, beginning with his birth and upbringing in Mexico City, the center of political cultural authority in Mexico. He was the son of upper-middle-class parents; his family had successfully negotiated the passage from the Díaz regime to the new "revolutionary" governments that later took power. His father, a civil engineer, also had an artistic avocation and taught the young Covarrubias to draw and paint. And, perhaps unlike the poor immigrant Florencio Limón with *his* teenage son, the elder Covarrubias apparently did not discourage Miguel's intoxication with the theater, the arts, and bohemian life in the rapidly growing capital city.[11]

But in the early 1920s the new revolutionary governments, in critical reaction to the European cultural influences that had so dominated the Díaz years, focused much of this artistic life toward a new nationalism based on Mexico's indigenous cultures and common folk. Today the great Mexican muralists such as Diego Rivera are the best-known examples of this renaissance, but it is important to note the flourishing of other, disparate artistic practices, such as the beginnings of the modernist Mexican novel, the collecting and exhibition of folk art, and the skillful, satirical wielding of caricature (the first of several artistic skills mastered by Covarrubias) in the many cultural journals and magazines of the capital.

Even as a teenager Covarrubias began to make his mark in caricature, and his drawings were soon well known throughout Latin America. But in Mexico, the art of caricature was not a culturally abstracted exercise. Caricature is the graphic expression of the essentially Mexican, satirical, predominantly verbal art of double entendre and richly allusive wordplay called variously *vacilada* and *albures,* among other names. The practice was of great service in a Mexican cultural economy that was continually dealt a bad hand in terms of social domination and political betrayals. "When he was not at the theatre," says Covarrubias's biographer,

> Miguel would likely be found at Los Monotes ("Big Monkeys"), a café owned by José Clemente Orozco's brother . . . where Mexico City's intellectuals, writers, artists, and hangers-on congregated . . . On any given evening one might meet the painters José Clemente Orozco, [and] Diego Rivera . . . the distinguished poet José Juan Tablada made it their meeting place.[12]

Covarrubias met Tablada at Los Monotes, an encounter that would take him into the next productive phase of his life as he came under the old man's mentorship. The connection with Tablada would also result in Covarrubias's later fruitful meeting with his compatriot Limón, at that moment in the throes of incipient teenage modernism in California. At odds with the new Mexican government of President Venustiano Carranza, Tablada was actually living in New York City at that moment—his initial meeting with Covarrubias occurred during a brief return visit to Mexico City.

North toward Home

At that time, of course, New York City was a particularly intense place for intellectuals and artists interested in the development of modernism. By modernism, I refer to that period of experimental creativity in the arts and thought in the first half of the twentieth century. The movement had clear sources in continental Europe, but a distinct American version existed as well, whose "moderns repudiated the long ascendant English and European traditions and their genteel American custodians as emblems of cultural cowardice." Ann Douglas, quoted here, further notes the fascinating nurturing alliance, by way of the Harlem Renaissance, between American modernism and the emergence of an African American arts movement in the city.[13]

Mexican participation in the modernist movement, led principally by José Juan Tablada, is less noted in conventional accounts of American modernism. In New York, Tablada had become a journalist, but he was also more than that: he was an avid, energetic exponent of Mexican art and culture in the United States. His home was described as a "minor museum of Indian and Mexican art," and it became a salon for the Mexican intelligentsia and artists who came to the city.[14] Tablada bought a bookstore on Fifth Avenue, named it Librería de Los Latinos, and "stocked it with Spanish language books"; the store became "the creative center for Latinos in the city."[15] These actions were not politically or culturally unfocused. "An ardent [Mexican] nationalist despite his residence in New York from 1920 to 1936," Tablada was, in Helen Delpar's words, involved in nothing less than a "holy crusade on behalf of Mexican culture in the United States."[16] This crusade had a particular cultural objective:

> Tablada was dedicated to negating America's prevailing stereotype of his countrymen as gun-wielding bandits or lazy good-for-nothings—notions popularized by current movies such as *The Greaser's Revenge, The Gringo, Barbarous Mexico,* and *The Martyrs of the Alamo* . . . for every drunken desperado that appeared on the silver screen, Tablada brought along another talented actor or musician or painter whose work would make a deeper impression than celluloid.[17]

Yet another formidable, well-armed soldier in this war was Latin America's best-known caricaturist, especially given that this individual happened to be already exploring his native Mexican traditions with a nationalist outlook. In 1923, after Covarrubias and Tablada's initial meeting, Tablada, who by then was on good and influential terms with the Mexican government, arranged for Covarrubias to spend some time in New York, where his considerable talents might be put to the cause. As expected, the young, witty, and engaging Covarrubias joined Tablada as an active participant in the salon conversations among the city's visiting Mexican intellectuals and artists: painters Diego Rivera, Frida Kahlo, and Rufino Tamayo, and musicians Carlos Chávez and Ignacio "Tata Nacho" Fernández among them. It was Tablada who introduced these visitors and, of course, Covarrubias into the New York modernist arts scene. At no point did Covarrubias disappoint his mentor; indeed, he may have outdone him.[18]

The many wonderful caricatures Covarrubias produced during his New York period were certainly at the heart of this contribution. These appeared in *Vanity Fair* and the *New Yorker,* but also on book covers, in art galleries and private collections, and in Covarrubias's own book, *The Prince of Wales and Other Famous Americans.* The caricatures, as noted earlier, had a particular Mexican satirical flair.[19] At that very moment, however, racial segregation was acting full-force against Mexican families like Limón's throughout the Southwest, so as if in recognition of the victims of an even more vicious racism, Covarrubias allied himself with the Harlem Renaissance literati, befriending James Weldon Johnson, Zora Neale Hurston, and Langston Hughes, in addition to Ethel Waters, Florence Mills, and W. C. Handy. Covarrubias drew these and other well-known figures in caricature, but he also depicted the anonymous African Americans he observed at Harlem revues and cabarets. The drawings strove "to capture the essential dignity of his subject."[20] Thus Tablada, speaking of his protégé's efforts, could write the headline "Miguel Covarrubias, the Man Who Discovered the Negroes in the United States: Beauty Where No One Has Seen It," continuing on to state that "all of a sudden there is a new image of the Negro, all due to the pencil of Miguel Covarrubias."[21] Such images led to warm collaborations with Langston Hughes and W. C. Handy to draw jackets for their new books. But whether focused on African Americans or other figures, Covarrubias's caricatures in the United States carried a sense of mission. According to one reviewer, "At a time when we [Americans] were on the point of exploding with our own importance . . . He began at once to giggle at us . . . It has done us good. To be seen through so easily by a boy of twenty, and by a Mexican, a national of a country that we have been patronizing for a century or two, an outlander and a heathen, was a bitter but corrective pill."[22]

Covarrubias soon made his way full-force into the New York theater, dance, and music worlds as well. He was asked to do set design for theater productions, some with Mexican themes, always with a modernist flair. "There is bright hope for our theater in the person of a new designer, Miguel Covarrubias," said a *New York Times* reviewer of one of his sets,[23] while another tells us of "the audacity of the young Mexican's challenge to eyes habituated to realistic conventions in the theater."[24] Covarrubias and some of his Mexican compatriots also organized an orchestra (including Rufino Tamayo as conductor and Carlos Chávez on the mandolin) to play and sing Mexican music, folkloric and not, for their many friends at weekly soirees. This same group also produced "a fantasy theatrical piece—a marionette show called 'Love's Dilemma, or The Astounding Miracle of the Apparition of Our Lady of Guadalupe.'"[25] Covarrubias's involvement with theater and dance also led to his meeting his future wife, the dancer Rose Rolanda, born Rosemonde Cowan in California to a Mexican American mother, Guadalupe Ruelas, and Henry Cowan.

Covarrubias and his Mexican circle's wide influence would not have been possible without Tablada, but in addition to Tablada, Carl Van Vechten and Nickolas Muray also deserve credit. Both of these significant New York figures developed their own long-lasting and productive relationships with Covarrubias. Van Vechten, a novelist, man of letters, and major artistic figure in New York life, extended the Tablada circle for Covarru-

bias, adding to the artists and musicians of the Harlem Renaissance other literati such as Eugene O'Neill. He also introduced Covarrubias to many of the venues the artist would use for his caricatures. It was Van Vechten who introduced Covarrubias to Nickolas Muray, one of the period's leading New York photographers and later a distinguished collector of Mexican art. Muray became Covarrubias's closest friend in America—indeed, Covarrubias was godfather to his child, a serious ritual relationship in Mexican culture. During one period, the two men shared an apartment in New York, which soon became the site for a Wednesday-evening salon that intertwined American and Mexican artistic and intellectual circles.

Tablada, Covarrubias, and their Mexican circle made tangible contributions to modernist arts in the United States—which is to say, at that moment, in New York City. But there was another, less tangible contribution that is much more difficult to recover and assess: the *talk* in the salons and at the parties and dinners, especially *chez* Muray/Covarrubias. Given all the known interlocutors and the virtual absence of a historical record, we can only imagine this talk as undoubtedly marvelous—stimulating and performative, artistic and intellectual. While a detailed historical record of actual conversation is negligible, we do have at least this observation of Covarrubias's conversational skills: "A rendezvous with him at a café was invariably stimulating," said Fernando Gamboa,

> All of his friends and colleagues commented on his enthusiasm, and on his ability to manifest his ideas artistically. Inundated by the rush of ideas in his head, he spoke in a broken, stuttering voice, as though there was not enough air. In this breathless fashion, he jumped from one subject to another, regaling friends with his new projects, the latest gossip, a hilarious joke, or advice.[26]

Such talk probably centered on modernism itself—its fundamental outlook and principal figures—but most likely embraced U.S.–Latin American relations as well. Undoubtedly it was interlaced with liberal drink, insight, silliness, wit, discerning intellect, and gossip in varying proportions; surely such talk played its own distinctive role in shaping critical opinion and launching or terminating new projects and cannot be underestimated as part and parcel of the modernist project.

Dancing with the Devil

It was in such conversational circumstances that Covarrubias first met José Limón, "halfway through the decade of the 1930s," as Limón himself tells us, "at an after-theater party."[27] In 1928 Limón had come east to New York, riding a motorcycle across the country in seeming flight from his background—the father, the family, the Catholicism, the Los Angeles *barrio*—to fulfill his life's emerging modernist artistic purpose. Initially intent on realizing his earlier ambition to be a painter, he wholly absorbed the New York art world only to discover that he could not overcome the achievements of "Manet, Renoir, Cézanne, Braque and Picasso," and especially his culturally telling favorite, the Spaniard El Greco, who "had done all I hoped to do and done it supremely well."[28] At a total loss for

what to do with his artistic ambitions, Limón happened to attend a dance recital where, to "the stirring preamble to the Polonaise in A-flat major of Chopin," he watched Harald Kreutzberg dance. "Instantly and irrevocably, I was transformed. I knew . . . that I had not been alive . . . that I had yet to be born."[29]

Limón employs this "birth" metaphor at greater and revealing length in the very first sentence of his memoirs. "Early in the year nineteen hundred and twenty-nine, I was born at 9 East Fifty-ninth Street, New York City. My parents were Isadora Duncan and Harald Kreutzberg" and "my foster parents, Doris Humphrey and Charles Weidman. It was at their dance studio and in their classes that I was born." "My grandparents," he adds "were Ruth St. Denis and Ted Shawn." We witness a fascinating disownment of Limón's real birth and pedigree and an equally fascinating appropriation of another. The latter, he says, was "an impossible pedigree and, with the exception of Harald Kreutzberg, a very American one." But Limón also feels the need to add, in Spanish: "*Muy Americano. Muy yanqui.*"[30]

The rest is not only modern dance history but also the history of *the* José Limón, the modern dancer and choreographer who, from the 1930s well into the 1960s, achieved total preeminence in his field. As the formidable dance critic John Martin put it in the *New York Times* in 1949, "There is no other male dancer within even comparing distance of him."[31]

During the great majority of Limón's career, he produced dances of a Western "universalist" character, suggesting no connection whatsoever to Greater Mexico. Yet, as we have already seen, this rank as the leading male figure of a socially abstracted modernist dance movement, of an art form meant to "decry systems and codification," soon also meant that for Limón, "taking his place in the family of American modern dance involved investigating his Mexicanness. He too needed to speak with the violence of his birthplace, of his 'race.'"[32] Such an articulation, however, took different forms:

> You put on the leotard . . . stretch . . . bend . . . flex . . . turn . . . pant . . . sweat . . . hurt.
> You learn that the past—the *jarabes* . . . the Mexican in you, the fearful passage to
> the land of the *gringos*, the wounds, the deaths—have been only a preparation for this
> new life.[33]

Yet despite the modernist injunction to "make it new," nothing is ever new and nothing is past, and sometimes the body itself can become the site of struggle. As perceived by others and by himself, Limón's racialized body spoke to his identity and was foregrounded as such: with "cheek bones that belonged on a Mayan bas-relief and dark deep-set eyes," his tall, dark and indeed very handsome body was compared by critics "to a bull, an eagle."[34] But this body had to be put into dance, and Limón insisted on emphasizing the particular and valuable dance features of the *male* body. Implicitly, which is to say unconsciously, he seemed to join this sharp sense of dance maleness to his Mexican identity. Says Deborah Jowitt:

> During the years he built a career, male dancing had to be distinguished from the female
> in order to give it credibility as a profession. In an article entitled "The Virile Dance,"
> Limón took a swipe at ballet, which was degraded at birth, he said, by its association with

the "high born sycophants and courtiers" surrounding Louis XIV and later guilty of a "feminization of technique."[35]

Allowing Limón this indulgence in his masculinity, I suggest that here we are seeing a rehearsal—through an idiom of the body and dance genres—of the Mexican Revolution's very masculinist overturning of the Porfirio Díaz regime's sycophantic relationship to an effete French *haute* culture—replaced after the revolution by an overcompensating emphasis on a masculinized identity.[36]

Limón's career emphasized abstract modernist dance, but Greater Mexico also took explicit dance form within him as he struggled to bring his repressions to the surface. For example, he modeled some of his dance moves and poses on the concept of the Spanish/Mexican bullfighter, even when a particular dance had nothing to do with such a figure. To Limón, the bullfight "was a dance—profound, formal, and elegant."[37] By 1939, however, Limón's "Other" identity was emerging more forcefully. In that year he choreographed and was principal dancer in a new work called *Danzas Mexicanas*. It must be noted that this dance was performed not in New York but in California, at Mills College in Oakland, as if to return Limón in full cultural force to the complicated significance that state held for him.[38] Other such dances would follow, principally *La Malinche* (1947), in which Limón comes to critical terms with what he called his sense of guilt—on his Spanish masculine side—over the Spanish conquest of indigenous Mexico, particularly of its women. In Limón's revisionary rendition of this historical, mythic-foundational story, Malinche, the Indian woman who became Cortez's lover and counselor, "comprehends and loves" the "oppositional forces" of Indian and Spaniard and is "burdened by guilt. She is a traitor to her people, but then, in Limón's version of the story, she joins forces with 'El Indio' and together they defeat 'the Conquistador.'"[39] In this rendering, Limón anticipates the revisionary critical posture toward *la malinche*—or in Nahuatl, *Malintzin*—current in Chicana feminist criticism.[40]

Other Mexican yet modern dances would follow, but this part of Limón's story requires that we return to the after-theater party in the mid-1930s, when Limón first met Covarrubias.

One is tempted—one might very much like—to say that Limón then became an active participant in Covarrubias and Tablada's Mexican circle in New York, and that this circle played a role in inspiring the choreography of *Danzas Mexicanas* and *La Malinche*. But the historical record offers another (and in light of my own ethnic investment in these issues, more satisfying) option, which is that no such conjunction occurred, and that Limón—like most of us who are Mexican Americans—was on his own, dealing with the social and cultural contradictions of being a Mexican raised largely in the United States with whatever resources and symbolic solutions he could muster. By the mid-thirties, both Covarrubias and Tablada were back in Mexico, and it is quite likely that Limón met Covarrubias—very briefly—during one of the latter's quick visits to New York to deal with his many residual commitments.[41] Limón would not see Covarrubias again until 1950.

The Return of the Natives

Covarrubias and Rose, consistent with the sometimes obsessive modernist interest in the "primitive," spent most of 1933–1934 on the island of Bali. There they worked on Covarrubias's book of sketches and commentary on Balinese culture, subsequently published as *Island of Bali*. But soon after traveling back to New York, they decided to return, more or less permanently, to Mexico, where the frenetic Covarrubias launched a number of projects—murals, painting, and caricature, of course, but also archaeological research and artisanal collecting, which then led to teaching and museum work. Even when Covarrubias was responding to projects in New York, Mexico's rising cultural significance acted as the implicit Tabladian impetus guiding all of this new work. In Mexico City, the many wonderful cafés, restaurants, and bars also guaranteed the continuation of the same kind of modernist salon society that had so engaged Covarrubias in New York. The beautiful Covarrubias home now replaced the New York apartment as the center for such activity, with Rose's famous cooking and table providing an even greater attraction for the Mexico City literati and their many famous foreign guests, such as the director John Huston and, very frequently, Covarrubias's best American friend, Nick Muray. But amidst all of this activity, Covarrubias found an additional new interest: dance in Mexico. The interest was so strong that he was appointed director of the Dance Department at the National Institute of Fine Arts.

Covarrubias had been monitoring the activities of José Limón; soon he invited Limón and his New York company to Mexico, not only to dance but also to instruct aspiring young Mexican dancers in the dance synthesis between modernism and *mexicanidad* that Limón had created in the United States (Figure 2). Always Tablada's nationalist protégé, but also always the visionary energetic innovator, Covarrubias wanted Mexican dancers to move beyond both Mexican folkloric dancing and the European ballet to articulate Mexican identity within a modernist idiom that would push the boundaries of form while offering a national content. As Williams notes, Covarrubias knew he was taking a chance inviting *yanquis* to instruct Mexicans.[42] That one of these *yanquis* was Mexican American and the exemplar of world modern dance no doubt made the task easier, but there was still an element of risk, for such Mexicans are *de afuera* (outsiders) in more than one sense. The credit for the project's huge success goes to Covarrubias more than Limón. Limón and his New York dancers—now joined by newly trained Mexicans—performed at the famous Palacio de Bellas Artes to full houses. The Mexican public and its intelligentsia received Limón and modern dance with great enthusiasm. Limón revisited Mexico three more times through 1952, and for these occasions he created new, Mexican-themed dances at the Institute. He was joined in his work by Covarrubias, who designed some of the sets (Figure 3), but also by composers Carlos Chávez and Silvestre Reyes, both prominent figures in the New York days, and by other Mexican artists.[43] These new productions included *Los cuatro soles* (The Four Suns), *Tonanatzintla, Dialogo,* and *Redesas,* but Limón and his dancers also performed *La Malinche,* a courageous, audacious act in Mexico given the dance's revisionary treatment of the *la malinche* female figure. These productions, in turn, required exten-

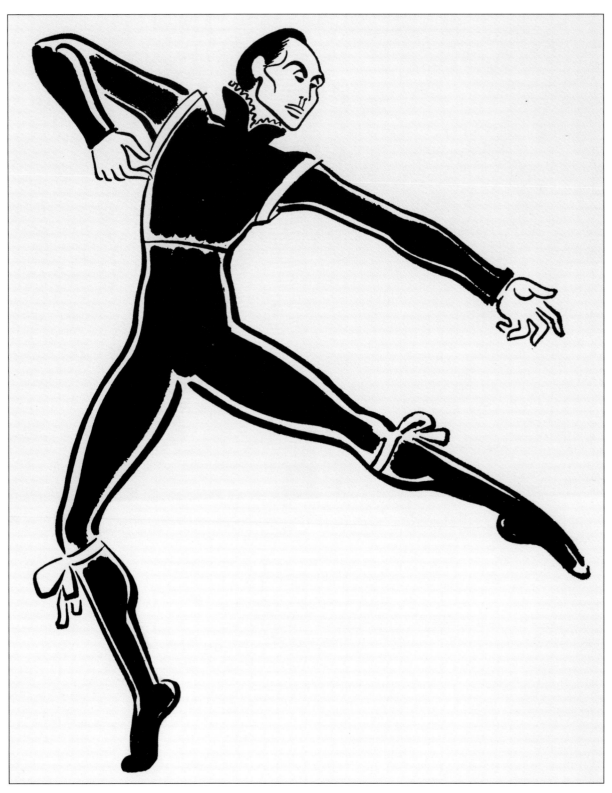

Figure 2. *José Limón bailando La Chacona en Re menor* (José Limón dancing La Chacona in D minor), by Miguel Covarrubias, 1951. Printed illustration, 37 x 28 cm. (14⁹⁄₁₆ x 11 in.). Published in Sylvia Navarrete, *Miguel Covarrubias: Artista y Explorador* (Consejo Nacional para la Cultura y las Artes, Mexico, 1993).

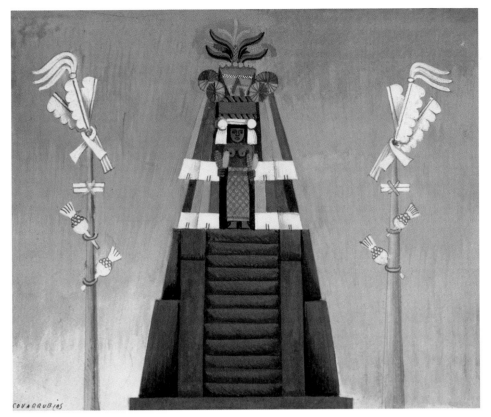

Figure 3. Set design for Carlos Chávez's ballet, *Los cuatro soles* (The Four Suns), by Miguel Covarrubias, 1951. Gouache on paper, 22.6 x 27 cm. (8¾ x 10⅝ in.). Harry Ransom Humanities Research Center, University of Texas at Austin. See color plate 88.

sive research and writing on Mexican cultural history by cadres of young intellectuals, all carefully instructed and supervised by Covarrubias and Limón. Perhaps of longer-lasting significance, Limón, always with the active participation of Covarrubias, established his name within the most influential intellectual and artistic circles of Mexico; he had missed this kind of opportunity in New York. He also left behind a key group of dancers and choreographers who continued to carry on his work.[44]

Not satisfied with this great success, the two reunited *mexicanos* then arranged for other young Mexican dancers to come to the United States for instruction under Limón, as well as to perform on their own. According to Williams, "Bellas Artes wowed" American audiences and "the best loved of their performance pieces was *Los cuatro soles,* for which Limón had done the choreography, Miguel the sets and costumes, and Carlos Chávez the orchestration."[45] The production displayed, in other words, the best of Greater Mexico at that time and would be difficult to surpass even today (Figure 4). For the dance critic Walter Terry, as quoted by Williams, *Los cuatro soles* "represented a new peak of accomplishment in Mexican theatre dance and augured still greater accomplishments through the directorial capacities of [Limón, Covarrubias, and Chávez]."[46]

Covarrubias did not accompany his young dancers on their triumphal return to the United States. The ugly 1950s politics that stained so much of American culture reached him as well, and he was denied a visa. Sena-

Figure 4. "The Passing Show," by John Rosenfield. Asserting that Miguel Covarrubias "reclaimed" José Limón for Mexico, this article announces their ballet *Los cuatro soles* for October 25, 1951, at the Dallas McFarlin Auditorium. Published in the *Dallas Morning News,* October 6, 1951. Reprinted with permission of the *Dallas Morning News.*

tor Joseph McCarthy's House Un-American Activities Committee (HUAC) had discovered that Covarrubias was on the list of supporters for Lazaro Cárdenas's "Americanos por la Paz" conference in Mexico in 1951; that he endorsed the "Cultural and Scientific Conference for World Peace" held in New York in 1949; that he had taken into his home an old New York friend, Professor Maurice Swadesh of Columbia University, who had emigrated to Mexico fleeing HUAC persecution; and that he had hidden the communist organizer Arnoldo Martínez Verdugo from the Mexican police after a violent demonstration in 1952. In 1943, the U.S. Embassy in Mexico City filed a report to the Secretary of State in Washington, D.C., listing Covarrubias, along with Diego Rivera and David Alfaro Siqueiros, as individuals who "may drop their socialism, in view of the circumstances, while others may seek other means of bringing about the world revolution."[47] Most of these "charges" were true. Covarrubias could certainly not be described as radical or revolutionary in his outlook, and nor could José Limón, but neither shied away from endorsing and actively supporting progressive causes. But in the United States of the 1950s, even tepid endorsements could ruin lives.

The Last Dance

Covarrubias continued his active cultural life in Mexico while remaining in close touch with his colleagues in New York until the end of his days in 1957. Limón also continued to develop his dance career in New York and Connecticut until his death in 1972. New York had done much for each man, but New York and therefore, by extension, the United States as a whole was also enlarged by their presence. For both men, this reciprocal growth occurred in the context of a historical, ongoing relationship between what I have been calling Greater Mexico and the United States—a relationship born in war and hostility and always encumbered by animosity, suspicion, repression, and racial offense even as, on occasion, moments of amity occurred. A less than politically candid view of this relationship might emphasize the amity, the rhetoric of "good neighbors," or "the enormous vogue of things Mexican" in the United States.[48] Indeed, the Mexican "culture industry" of this time, in which Covarrubias played a central role, has been the object of a recent left-wing critique for its masking effect on Mexico's continuing political and economic inequalities, and for its complicity with dominant sectors of the United States.[49]

But, for me, the Covarrubias-Limón connection stands as a particularly productive moment for Greater Mexico and for the dissident modernist art community in the United States. The record clearly shows that Covarrubias and Limón's intersection with and in New York was a form of responding to the social dominance of the United States via an artistic valorization of their native culture. This response simultaneously engaged and enlarged the cutting-edge cultural movement at that moment—which was, in short, modernism. Such interventions, however, are often articulated with ambivalence and contradiction.

The often-frenetic energy both men lent to this task spoke to its urgency. Of the two men, however, Covarrubias had the easier job. In a beautiful, richly informed essay, John

Durham Peters distinguishes exile, diaspora, and nomadism. The diasporic figure, he suggests, always exists in a collective, "a relationship among scattered fellows, whose sense of community is sustained by forms of communication and contact such as kinship, pilgrimage, trade, travel and shared culture."[50] What Peters does not say is that such a diasporic existence implies a well-formed, coherent sense of home, even if it exists only as a well-articulated historical memory in the form of a master narrative. The Jewish diaspora is the primal case, but thus figures like Covarrubias and his fellow Mexicans in New York, with their collective sense of national Mexico and its long history and traditions, can be understood as well. Peters also does not say that such diasporas can be materially well-sustained, through both the initiatives of the diasporic community and the support of the origin country and host societies.

By contrast, "nomadism dispenses altogether with the idea of a fixed home or center" or even with a coherent narrative memory (for example, either of Mexico or of the United States); it "can involve active defiance of or furtive avoidance of the sedentary authority of state and society" (gringos, on the one hand, and a disowning, sometime even hostile Mexican state, on the other). Nomadism also suggests a face-to-face community, usually linked by ties of kinship stemming from a real or imagined ancestor, that travels as family units moving among *barrios* and/or work sites in the United States—in short, Mexican America, the nomad society that brought forth José Limón. But yet another variation can occur when such a salient figure emerges: the exile, "solitary," "pining for home," more often "occurring in a relation to some looming authority figure who wields power over life and death," like a Chilean or Argentinean dictator or *junta*.[51] But this authority figure can also take the form of a Mexican father trying to preserve his immediate, nomadic, face-to-face community in a new country.[52] This is exile not from a nation-state but from the nomadic group itself. Under such doubled nomadic conditions, the exile is that person who seeks definition and meaning beyond the group, even though he is irrevocably bound to it and longs to return. Bereft of the nomad's group identity and certainly of the diasporic community's sustaining traditions, this kind of exile, of which I take Limón to be an example, may have only the solitary body-in-dance in modernist movement to lend a sense of meaning (although, as I have argued elsewhere, the nomads may also provide their collective and circular dance solutions).[53] Paradoxically, Limón's modern dance solutions—possible only to an exile from a nomadic community—also assisted Mexico in its perpetual dilemma concerning the proper cultural posture toward the United States. This was especially important in the 1950s. In the end, yet another contribution Covarrubias may have made to his beloved Mexico was his sagacity in understanding that José Limón—the Spanish-speaking, Mexican American modernist—was possibly more important to Covarrubias and his home country than Mexico and Covarrubias could ever be to Limón, a man whose family Mexico had made nomads.

Limón returned to the United States from Mexico a seemingly changed man—changed as a result of Covarrubias. It is wholly instructive that at the end of his memoirs, Limón offers a separate chapter called simply "Covarrubias," summarizing his activities with his good friend while in Mexico. Undoubtedly Limón's time with Covarrubias in the

latter's home country greatly influenced him. In a letter to Rosa Covarrubias (she had changed her name from "Rose" in the early 1940s), he says,

> I have not recovered from the impact of Mexico, and the Covarrubiases . . . I look out the window on Woodland Avenue, an old and familiar sight to me for two decades, and suddenly I am a stranger here and I say, "What in the world are you doing here? Go on home. Go back." . . . I have always been a torn man. Pulled apart and asunder in many ways by one thing and another and now more than ever the conflict is greater because where at one time I only had dim memories, now I have seen it. And it makes me tremble, because my safe little world is no more. And I have to start all over again.[54]

I suspect that Limón is being Mexican-courteous to his former hosts and perhaps giving them a bit too much credit. For the record is clear that prior to this visit, Limón had been contending with his identity all of his conscious life; his memories of Mexico may indeed have been dim, but his memories of Texas, Arizona, and especially California were not. They had been repressed and elided, needing and demanding articulation and resolution. It was a fraught resolution that Limón was finally able to make explicit in 1939 in *Danzas Mexicanas,* when he was back in California only a year after reconciling with his father; this was followed by *La Malinche* in 1947. His little world was never safe, always torn asunder, and he was always in search of a home. But Mexico did not create these sentiments of exiledom, although perhaps this visit did reactivate them: as Limón himself said, they were now simply "greater." Ann Vachon has also traced the "Mexican" ambivalence in Limón's life and its expression in his dance, but she suggests that the journeys to Mexico resolved the problem.[55] Such nomadic, rather than diasporic, exiles are good at imagining fixed ancestries, however, and it is in this sense that Limón "found" Mexico through the intervention of Covarrubias, although he did so only as a temporary and imaginary solution for his circumstance. For in the end, he had to come "home." He was an American, albeit one fated to live in ambivalence and contradiction, a Mexican American, a child of nomads, and in the 1950s still living in a nomadic Mexican America offering little native sustenance for such a man. That would begin to change in the late 1960s, as this Mexican American community began to acquire greater self-consciousness. It is a sad irony that Limón was very ill during this period and died so soon after—it is easy to imagine him identifying and training young Mexican American dancers the same way he had trained the young dancers of national Mexico.

Today, the once nomadic Mexican American community has increased in social strength and acquired a coherence and sense of place and purpose such that it may be one of Mexico's greatest resources in the struggle to rebalance its continuing asymmetrical relationship with the United States.[56] Those in Mexico with the sophistication, energy, intelligence, and generosity of a Miguel Covarrubias—who did so much for both the United States and for Mexican America—may wish to reach out to these former nomads, now socially effective citizens of the United States, who, like José Limón's modernist brown body, can now be seen as "rugged, modeled, sensitively responsive, mature."[57]

I think both men would approve.

It is a Saturday in the early 1950s in the small border town of Laredo, Texas, and the seven-year-old boy is in a foul mood. For some time now, his mother has been trying to persuade him to take dancing classes with Miss Azios, the local and very popular dance teacher: jazz, flamenco, modern . . . even ballet, perhaps?

NO!

Life is tough enough already, having to contend with the other boys in the barrio with his scrawny body, and then there is the not-small matter of the eyeglasses. DANCE? . . . If they were to find out . . . Please, José, she pleads. Te va a gustar. (You'll like it.)

NO!

He does have his father in his corner, who has grave suspicions about having his SON involved in such cosas de mujeres. The boy's powerful grandmother, who has known the Mexican Revolution first-hand, agrees. She has seen men die, and no one has yet guaranteed her the future for this family so el niño tiene que ser hombre (the child has to become a man). The boy relaxes; the odds are turning in his favor. But the mother—she who recently discovered the magic of the Avon lady and canasta parties—has other dreams that go beyond this little town, or at least to its other side, to Las Lomas (the Heights); for her, such cosas are CULTURE and she wishes her son—this son—to have them. She prevails upon the father. The father will not oppose if his son wants to do it. "How much is it?" The grandmother is uncharacteristically silent . . .

OH NO!

It is a Saturday, a very valuable play day. A time to see your neighborhood buddies who don't attend your Catholic school. Boys can go fish in the Rio Grande or go to a movie downtown at the Royal for ten cents: feature cowboy movie (Roy Rogers), two cartoons, and a Superman serial. Even the newsreel, with scenes from the war in Korea, is terrific. The boy's mother tries another line of attack—out-and-out bribery. If he will attend just one class—just to watch— at the dance studio that morning, she will provide ten cents for him and several friends to go to the movies that afternoon . . . Popcorn? Candy? Drinks? . . . Yes . . .

It is a very special class that I want you to see, she tells him, because a very famous man—a dancer—will be there, es de Noo Jork, y sabes qué? He has exactly the same name as you! In the car going down San Bernardo Street, she explains—not that the boy really cares—that Sr. Limón is in town for a couple of

days with the rest of his dancers while they wait for the next train to Mexico City. At this moment anyone who is anyone going by train to Mexico from the eastern United States goes through Laredo and, given the train schedules, they often stay over. This border factoid is not lost upon the astute Miss Azios. While the Limón entourage is in town, she has persuaded the man himself to come to her studio this morning to talk to the students and show them some dances. He is a famous man, the mother continues, and he has accepted! ¡Qué amable! No? *(How gracious of him, no?) Sitting in great gloom in the front seat—his little sister burbling in the back, his older brother, miraculously free of such oppressions, running around the* el cuatro *(Fourth Ward) neighborhood—the boy stares straight ahead.*

Well, OK, so here we are, and there HE is. A really tall mexicano-*looking guy, and he does some funny stuff with his body. The room is full of giggling girls and only ONE other boy. Big glasses. (Wonder what he got?) The boy will not remember more than this.*

Later, at the movies, he and his friends will cheer U.S. Army Patton tanks rolling against the Chinese Army. The salty, buttery popcorn is great! Roy Rogers is about to start. Esta es la vida. *His vision blurs. With his shirttail, he cleans the butter off the glasses. While the reel is being changed, he recollects the morning. What's wrong with his mother? What does she think he is? Catholic school.* Estudia! *(Study!)* Pórtate bien. *(Be well-behaved!)* ¿Qué va a decir la gente? *(What will people say?) Good manners. All those books. The endless encyclopedias that gringo sold her. And now this dance man. Through chews of popcorn, he quietly pronounces his name . . . José Limón.*

Notes

1. Américo Paredes, *A Texas-Mexican Cancionero: Folksongs of the Lower Border* (Austin: University of Texas Press, 1995), iv.

2. Mariano Azuela, *Los de abajo,* trans. Frederick H. Fornoff (Pittsburgh: University of Pittsburgh Press, 1992); Carlos Fuentes, *La muerte de Artemio Cruz,* trans. Alfred MacAdam (New York: Farrar, Straus, and Giroux, 1991); Juan Rulfo, *Pedro Páramo,* trans. Margaret Sayers Peden (New York: Grove Press, 1994). See also James D. Cockcroft, *Mexico: Class Formation, Capital Accumulation and the State* (New York: Monthly Review Press, 1983); Alan Knight, *The Mexican Revolution,* 2 vols. (Cambridge, UK: Cambridge University Press, 1986); and Friedrich Katz, ed., *Riot, Rebellion, and Revolution: Rural Social Conflict in Mexico* (Princeton, NJ: Princeton University Press, 1988).

3. José Limón, *An Unfinished Memoir,* ed. Lynn Grafola (Middletown, CT: Wesleyan University Press, 1998), 3.

4. Ibid., 8–9.

5. Ibid., 10.

6. Ibid.

7. Ibid., 15.

8. Ibid., 13.

9. Ibid. Limón blamed his father for his mother's death as a result of giving birth to several children. When she died, Limón took her gold wedding band from her finger, "irrationally," he said. Ibid., 11–12.

10. The common expression *mexicano de afuera* (a Mexican from the exterior) refers to those Mexicans living mostly in the United States.

11. Adriana Williams, *Covarrubias,* ed. Doris Ober (Austin: University of Texas Press, 1994), 6–7.

12. Williams, *Covarrubias,* 8.

13. Ann Douglas, *Terrible Honesty: Mongrel Manhattan in the 1920s* (New York: Farrar, Straus, and Giroux, 1995), 4–5.

14. Howard Thomas Young, *José Juan Tablada, Mexican Poet (1871–1945)* (Ph.D. diss., Columbia University, New York, 1956), 38–39.

15. Williams, *Covarrubias,* 14.

16. Helen Delpar, *The Enormous Vogue of Things Mexican: Cultural Relations between the United States and Mexico, 1920–1935* (Tuscaloosa: University of Alabama Press, 1992), 41.

17. Williams, *Covarrubias,* 17.

18. Tablada's diary for this period has many entries for Covarrubias. José Juan Tablada, *Obras-IV, Diario (1900–1944),* ed. Guillermo Sheridan (Mexico City: Universidad Nacional Autonoma de Mexico, 1992).

19. Williams, *Covarrubias,* 19–20.

20. Ibid., 38.

21. José Juan Tablada, *El Universal,* November 30, 1924, as cited by Williams in *Covarrubias,* 38.

22. Ralph Barton, "It Is to Laugh," *New York Herald Tribune,* October 25, 1925.

23. Albert Carroll, *New York Times,* June 25, 1925, as cited by Williams in *Covarrubias,* 41.

24. *Theatre Arts Monthly* 10, 1925, as cited by Williams in *Covarrubias,* 45.

25. Williams, *Covarrubias,* 21–22.

26. Fernando Gamboa, interview with Elena Poniatowska, as cited by Williams in *Covarrubias,* 37.

27. Limón, *An Unfinished Memoir,* 25.

28. Ibid., 15.

29. Ibid., 16.

30. This and the immediately preceding quotations are from ibid., 1.

31. As quoted in Deborah Jowitt, introduction to *An Unfinished Memoir,* ix.

32. Ibid., xii, xiv–xv.

33. José Limón, *An Unfinished Memoir*, 16.

34. As quoted in Deborah Jowitt, introduction to *An Unfinished Memoir*, ix.

35. Ibid., xiv.

36. Américo Paredes, "The United States, Mexico and Machismo," in *Folklore and Culture on the Texas-Mexican Border*, ed. Richard Bauman (Austin: Center for Mexican-American Studies, University of Texas at Austin, 1993), 215–234.

37. Jowitt in *An Unfinished Memoir*, xiv.

38. Limón, *An Unfinished Memoir*, xv. Limón had danced in Los Angeles the previous year, where he reconciled with his father and saw the rest of his extended family for the first time since his departure. See *An Unfinished Memoir*, 86–87.

39. Ann Vachon, "Limón in Mexico, Mexico in Limón," in *José Limón: The Artist Reviewed*, ed. June Dunbar (Amsterdam: Harwood Academic Publishers, 2000), 73.

40. Norma Alarcón, "Chicana Feminist Literature: A Re-vision through Malintzin/or Malintizin: Putting Flesh Back on the Object," in *This Bridge Called My Back: Writings by Radical Women of Color*, ed. Cherrie Moraga and Gloria Anzaldua (New York: Kitchen Table Press, 1983), 182–190.

41. Williams, *Covarrubias*, 91–92.

42. Ibid., 183.

43. Ibid., 182–187.

44. Vachon, "Limón in Mexico, Mexico in Limón," 78–83.

45. Williams, *Covarrubias*, 193.

46. Walter Terry, "Mexico Produces a New Triumvirate," in *Dance*, June 1951, as cited by Williams in *Covarrubias*, 193.

47. Williams, *Covarrubias*, 188–190.

48. Delpar, *The Enormous Vogue of Things Mexican*.

49. Gilbert Joséph, Anne Rubenstein, and Eric Zolov, eds., *Fragments of a Golden Age: The Politics of Culture in Mexico since 1940* (Durham: Duke University Press, 2001).

50. John Durham Peters, "Exile, Nomadism, and Diaspora: The Stakes of Mobility in the Western Canon," in *Home, Exile, Homeland: Film, Media, and the Politics of Place*, ed. Hamid Naficy (New York: Routledge, 1999), 19–21.

51. Ibid.

52. For a recent rehearsal of Mexican exile sons and nomadic father/cultures, see another (late) modernist: Richard Rodriguez, *Days of Obligation: An Argument with My Mexican Father* (New York: Penguin, 1993).

53. José E. Limón, *Dancing with the Devil: Society and Cultural Poetics in Mexican-American South Texas* (Madison: University of Wisconsin Press, 1994).

54. José Limón to Rosa Covarrubias, undated letter, José Limón Archives, Library and Museum of the Performing Arts, New York Public Library Lincoln Center, as cited in Williams, *Covarrubias*, 188.

55. Vachon, "Limón in Mexico, Mexico in Limón."

56. I am currently at work on a book titled *Hispanic Self-Fashioning: The Making of a Mexican-American Middle Class Identity*, which argues for this proposition.

57. John Martin, *New York Times*, April 10, 1949, as quoted by John Rosenfield in the *Dallas Morning News*, October 6, 1951.

THE NICKOLAS MURAY COLLECTION OF MEXICAN ART: COLOR PLATES

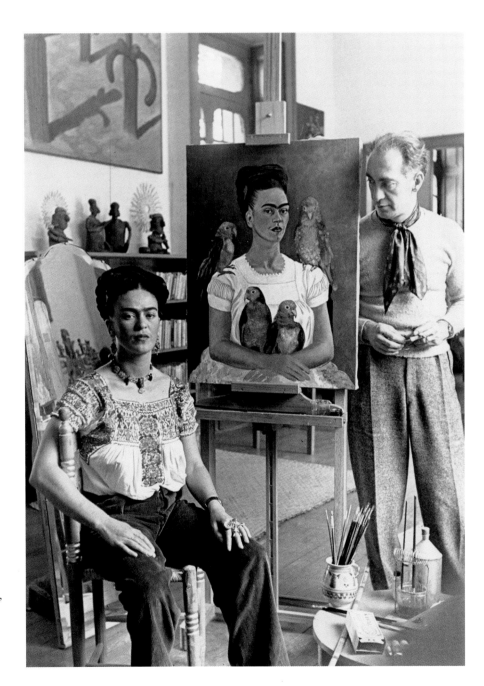

Nickolas Muray with Frida Kahlo and her unfinished painting *Me and My Parrots,* circa 1939. The painting was finished in 1941. Photograph, 39.5 x 37 cm. (15½ x 14½ in.). © Nickolas Muray Photo Archives, courtesy Mimi Muray.

FERNANDO CASTILLO

(Mexico City 1895–1940 Mexico City)

Before becoming a painter and wood engraver, Fernando Castillo worked various jobs as a shepherd, fireman, and porter. He lost a leg serving as a soldier in the Mexican Revolution. At the age of thirty-eight, Castillo took his first art classes at the Popular Painting Center in Mexico City's working-class San Pablo district. His teacher and mentor was Gabriel Fernández Ledesma. Castillo had an innate gift for drawing and threw himself enthusiastically into painting. Unfortunately, he spent the last years of his life in financial hardship, but he continued to paint when supplies were available.

1 Fernando Castillo
La Hija del Pintor
(Daughter of the Artist), undated
Oil on canvas
72.8 x 62.2 cm. (28⅞ x 24½ in.)

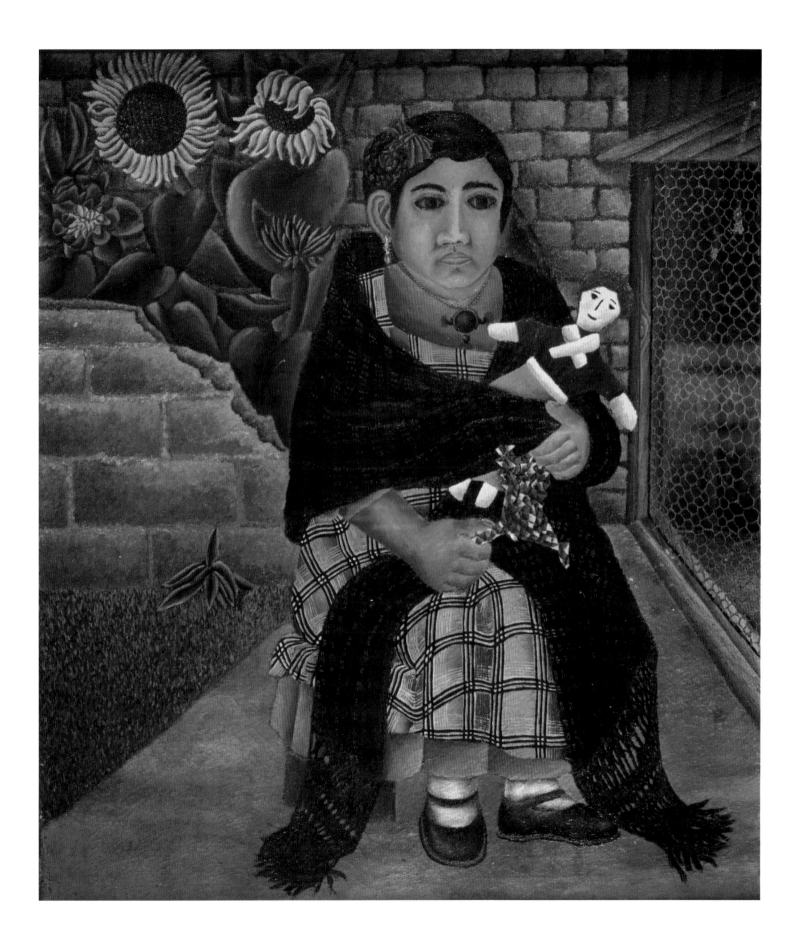

FRIDA KAHLO (Coyoacán 1907–1954 Coyoacán)

Today, Frida Kahlo is perhaps the most celebrated of all Mexican artists. Her father, Guillermo Kahlo, a Hungarian Jewish immigrant, arrived in Mexico in 1891 and became one of Mexico's foremost photographers in the first decade of the twentieth century. Her very religious mother, Matilde Calderón, was of Spanish and Mexican Indian descent.

Kahlo did not originally plan to become an artist. At the age of fifteen she entered the pre-medical program at the National Preparatory School in Mexico City. Three years later, Kahlo was seriously injured in a bus and streetcar accident that left her partially handicapped and in pain for the rest of her life. During her convalescence, she taught herself how to paint. Over time, painting became an act of cathartic ritual, with the symbolic images portraying a cycle of wonder, pain, death, and rebirth. She married Diego Rivera, the Mexican muralist, in 1929, and Kahlo's art existed in the shadow of her famous husband throughout most of her life. Mutual admiration, painful separations, divorce, and reconciliations defined her relationship with Rivera.

Kahlo's artworks, mostly self-portraits and still lifes, narrate her personal story and are filled with the imagery and bright colors of the Mexican folk art that she loved. André Breton and many other critics considered Kahlo a surrealist; she called herself a Mexican realist. While visiting New York, she and Rivera became part of the circle of Nickolas Muray's friends. In the 1930s, Kahlo and Muray had a close relationship. Kahlo completed the painting known as *Self-Portrait with Thorn Necklace and Hummingbird* in 1940, the same year she broke up with Muray and remarried Rivera. Muray photographed Kahlo extensively over the years, often in touching poses with Rivera and their friends.

2 Frida Kahlo
Untitled [Self-Portrait with Thorn Necklace and Hummingbird], 1940
Oil on canvas mounted to board
62.5 x 48 cm. (24⅗ x 18⅞ in.)
© 2003 Banco de Mexico Diego Rivera & Frida Kahlo Museums Trust. Av. Cinco de Mayo No. 2, Col. Centro, Del. Cuauhtémoc 06059, Mexico, D.F.

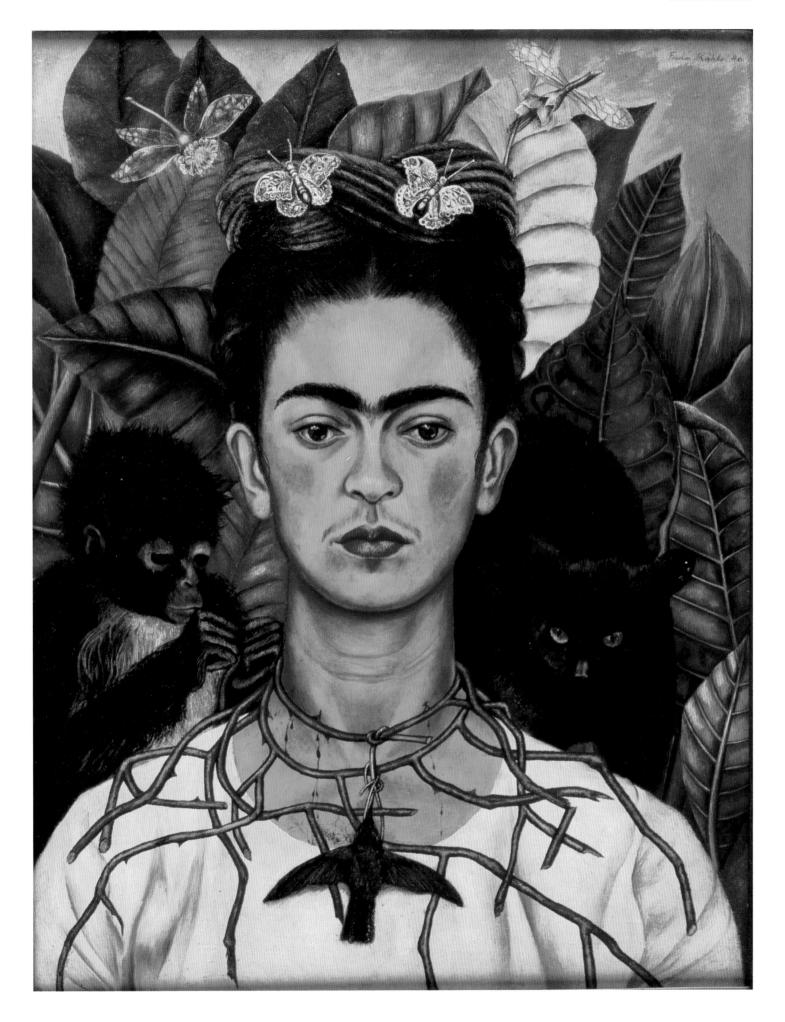

3 Frida Kahlo
Still Life, 1951
Oil on canvas
25.7 x 28.2 cm. (10⅛ x 11⅛ in.)
© 2003 Banco de Mexico Diego Rivera
& Frida Kahlo Museums Trust. Av.
Cinco de Mayo No. 2, Col. Centro,
Del. Cuauhtémoc 06059, Mexico, D.F.

4 Frida Kahlo
Diego y Yo (Diego and me), 1930
Charcoal, graphite, and ink on paper
29.5 x 21.5 cm. (11⅜ x 8 ⅞ in.)
Inscribed: "For Nick with love"
© 2003 Banco de Mexico Diego Rivera
& Frida Kahlo Museums Trust. Av.
Cinco de Mayo No. 2, Col. Centro, Del.
Cuauhtémoc 06059, Mexico, D.F.

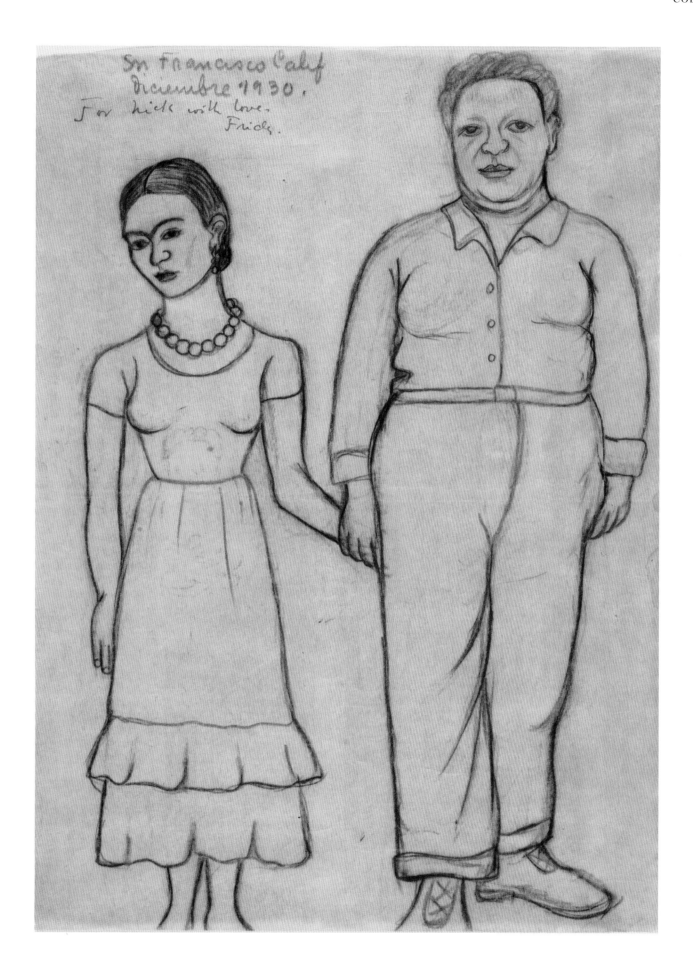

GUILLERMO MEZA (Mexico City 1917–1997 Mexico City)

Miguel Covarrubias called Guillermo Meza "one of the most impressive talents among the younger artists" in the catalogue from the 1940 Museum of Modern Art exhibition "Twenty Centuries of Mexican Art." His parents were Tlaxcalan Indians, and as a child he lived in the village of Ixtapalpa in the Valley of Mexico. Meza took up drawing and painting early in life, working in darkrooms behind his father's tailor shop. In 1937, at the age of twenty, he went to Morelia, where he worked as an assistant to the painter Santos Balmori. In 1939, Meza showed his drawings to Diego Rivera, who in turn sent a letter of support to Inés Amor at the Galería de Arte Mexicano. Amor agreed to sponsor Meza and provided the materials he needed to concentrate on his painting. Only three years later, Meza had his first one-man show at the Galería de Arte Mexicano.

Meza's signature surrealist style, which often incorporates hooded or shrouded figures, reflects his understanding of the racial complexities of Mexican society. Typical of his works from the late forties, *Baile* is infused with mystery; drapery eliminates all sense of the individual, but an intense empathy for humanity pervades the image. Of his work, Meza once said, "Above all, paintings must be social, not political, and before social, human."

5 Guillermo Meza
Baile (Dance), undated
Oil on paper
44.5 x 37.8 cm. (17½ x 14 ⅞ in.)

ROBERTO MONTENEGRO (Guadalajara 1881–1968 Mexico City)

Roberto Montenegro was primarily a painter, but he is also known as an illustrator, stage designer, graphic artist, muralist, and writer. Born in Guadalajara, he began his studies in 1905 at Mexico City's Academy of San Carlos, under Antonio Fabrés, Julio Ruelas, and Germán Gedovius. His classmates included Diego Rivera and Saturnino Herrán. Between 1906 and 1919, he studied, traveled, and exhibited throughout Europe, where he was influenced by both modern and traditional art forms. From the school of modern art, Montenegro met Picasso and Juan Gris, who encouraged him to develop his surrealist aesthetic. During his travels in Europe he developed an interest in mural paintings and went to Italy to study antique frescoes.

In 1920, Montenegro returned to Mexico City, where he took part in the revolution that instigated the production of mural painting. In fact, he was one of the first Mexican artists to receive a mural commission, eventually completing murals in the Ministry of Education building, the Benito Juárez School, and the National Teacher's School.

As a writer, art critic, and artist, Montenegro made great efforts to preserve and promote Mexican popular art. He was the first to present the popular arts in Mexico, in an exhibition that opened in 1921. In 1922, the same exhibition traveled to Los Angeles, becoming southern California's first large show of Mexican popular art. Montenegro was also in charge of the popular-art section of the 1940 exhibition "Twenty Centuries of Mexican Art" at the Museum of Modern Art in New York. Montenegro's *Adioses* shows the artist's development and interest in surrealism.

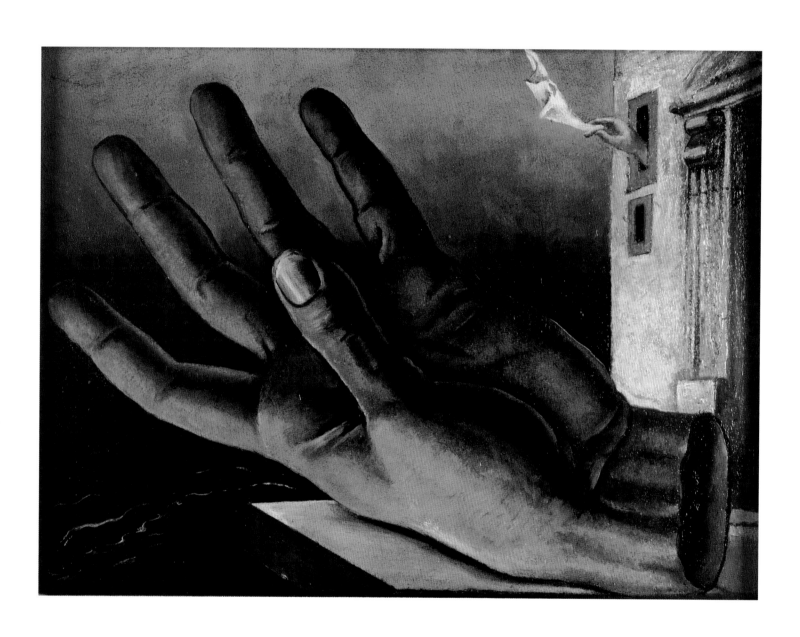

6 Roberto Montenegro
Adioses (Farewells), 1930
Oil on board
22.9 x 30.5 cm. (9 x 12 in.)

RAFAEL NAVARRO (Jalisco b. 1921)

Rafael Navarro received his first drawing lesson at the age of fourteen at the Academy of San Carlos. He was schooled in the humanities and was a student of philosophy at the Mexican National Seminary, which brought a well-rounded background to his painting. He began participating in group shows in 1950; that same year he won a scholarship for study in Paris, where he trained at the Ecole des Beaux Arts. Inés Amor gave the artist his first important one-man show at the Galería de Arte Mexicano in 1953.

Ultimately Navarro's work gained the attention and patronage of the aristocracy, high society, and literati of Europe. He has had many one-man shows in Europe, the United States, and Mexico. In Austin, Texas, his twin murals can be found at the entrance to Medical Park Tower on 38th Street.

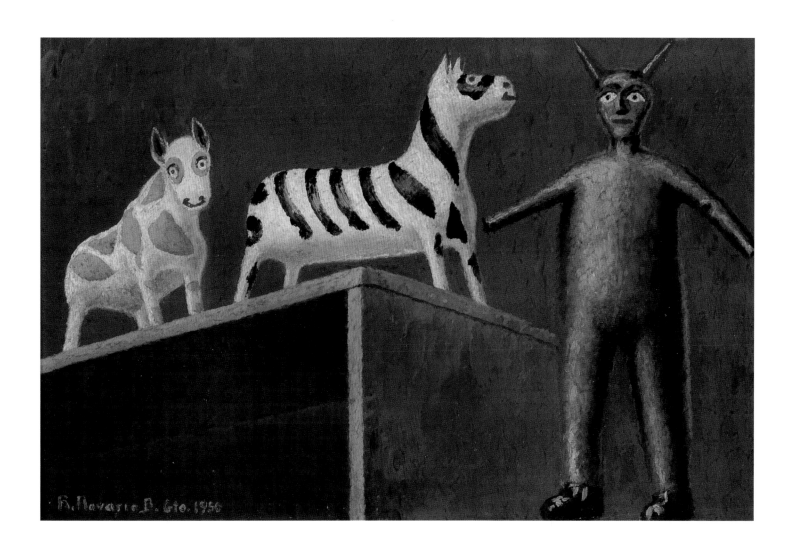

7 Rafael Navarro
Untitled [Animals], 1950
Oil on board
21.7 x 33.2 cm. (8½ x 13¹/₁₆ in.)

JUAN SORIANO (Guadalajara b. 1920)

Juan Soriano is a self-taught artist who began to paint at the age of thirteen. In 1935, he left his birthplace of Guadalajara to move to Mexico City, where at age fifteen he had his first exhibition with the League of Revolutionary Writers and Artists. He soon found that artists, in order to become recognized, were pressured to constantly promote themselves, either through dealers or art galleries.

With other directions in mind, Soriano, like Rufino Tamayo, left Mexico in search of a more relaxed surrounding. He lived in Rome sporadically throughout the 1950s and 1970s, with brief sojourns in Mexico. During this time he painted a wide variety of subjects. In 1975, Soriano took a job in Paris, where he found himself unexpectedly charmed by the city; it is now his primary residence. In Paris he began painting in semi-abstract style, combining the spirit of Mexico with the color and light of the Mediterranean.

Today, Soriano's art, especially his large cast metal sculpture and ceramics, incorporates his heritage, as well as the natural world, into abstract, imaginative, dreamlike subjects. Soriano was mentioned in the Museum of Modern Art's 1940 "Twenty Centuries of Mexican Art" exhibition as "one of the promising young talents of the younger generation." In 1987, the Mexican government bestowed upon him the National Art Prize, the most prestigious award for artistic achievement in Mexico.

8 Juan Soriano
Untitled, 1946
Gouache on paper
33.6 x 24.7 cm. (13¼ x 9¾ in.)

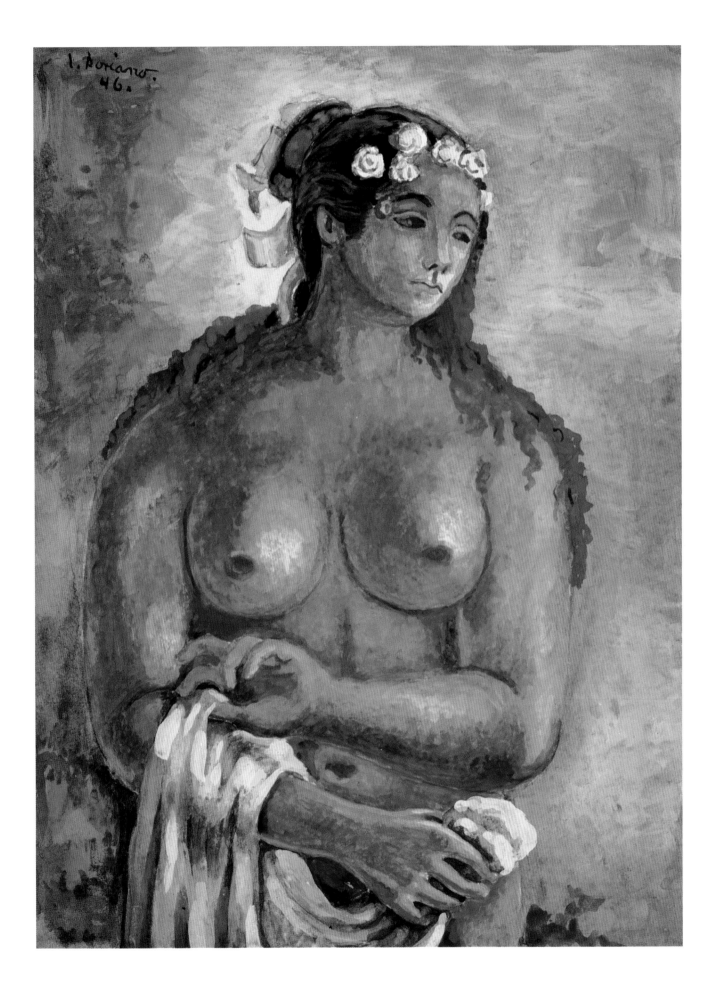

RUFINO TAMAYO (Oaxaca 1899–1991 Mexico City)

This Oaxaca-born artist is best known for his ability to combine Mexican folk imagery with European modernism in an avant-garde style. Rufino Tamayo's long and prolific career includes easel paintings as well as murals, prints, and sculpture. Tamayo was born in 1899 into a Zapotec family and was orphaned at age twelve. He then moved to Mexico City and lived with his aunt, helping her to sell produce in La Merced market. After attending the Academy of San Carlos, Tamayo studied independently, eventually becoming head of the Department of Ethnographic Drawing at the National Museum of Archaeology (1921–1926). There he encountered pre-Columbian art and became interested in cultural nationalism. He left the museum in 1926 and traveled to New York, where he had his first exhibition.

In 1928, Tamayo left New York for Mexico City to teach, paint, and exhibit. He returned to New York in 1934 and remained there with his wife until 1954. During this second stay, Tamayo taught at the Dalton School and was involved in the U.S. Works Progress Administration. He joined the Mexican delegation to the American Artists Congress in 1936. Tamayo made frequent trips abroad and was included in numerous exhibitions in Europe and America. His work from this time combined Mexican themes and subjects with cubist painting techniques.

Tamayo's exhibit at the Venice Biennale in 1950 led to international recognition and mural commissions for the National Palace of Fine Arts, in Mexico City, and the United Nations Educational, Scientific, and Cultural Organization, in Paris. Tamayo donated his collection of pre-Columbian art to the people of Oaxaca in 1974, forming the Rufino Tamayo Museum of Pre-Hispanic Mexican Art. His collection of contemporary European and American art became the Rufino Tamayo Museum of International Contemporary Art, which opened in Mexico City in 1981.

Tamayo's great creative period, according to Octavio Paz, began in New York around 1940. It was during the years in New York that he and his wife Olga became friends with the Muray family. The Tamayos appear in many of Muray's photographs from the forties and fifties.

With tongue-in-cheek references to modernist art movements, Tamayo's neo-primitive cow speaks to a primordial magic that is truly Mexican in origin. *Cow Swatting Flies* captures the relentless glow of a tropical sun, which Octavio Paz describes as "in all his pictures, whether we see it or not: night itself is for Tamayo simply a sun carbonized." The work combines Mexican imagery with cubism. The painting also shows Tamayo's use of his signature colors—red, tan, yellow, and black.

9 **Rufino Tamayo**
Untitled [Portrait of Nickolas Muray], 1954
Charcoal and white wash on plywood
102.5 x 77 cm. (40⅜ x 30⁵⁄₁₆ in.)
© Estate of Rufino Tamayo

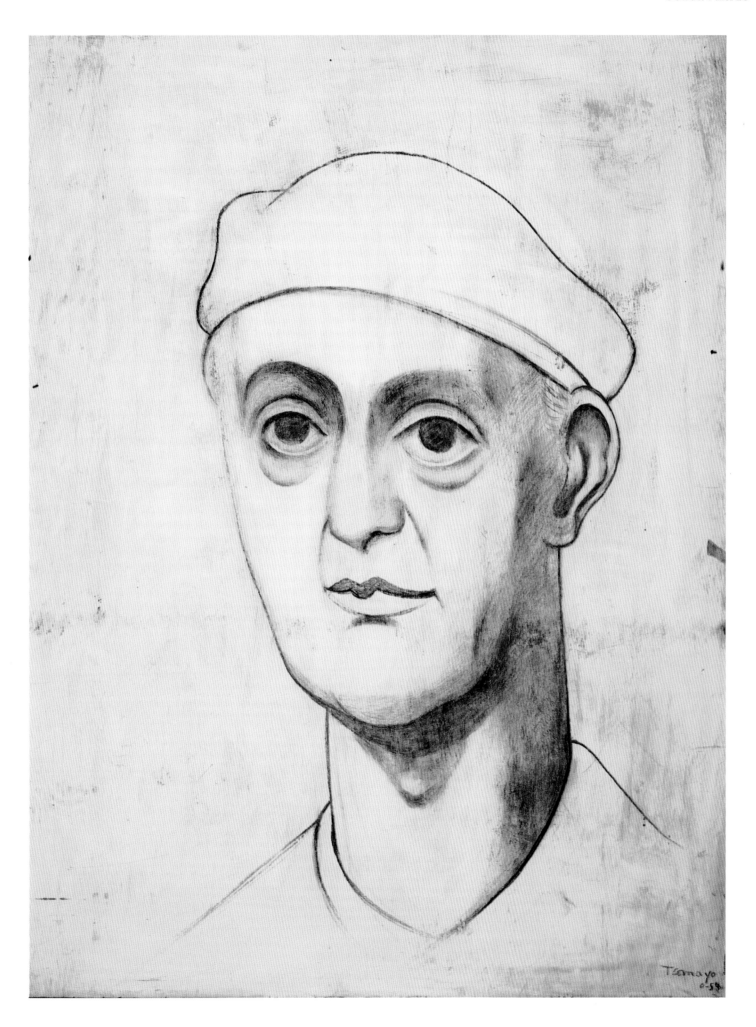

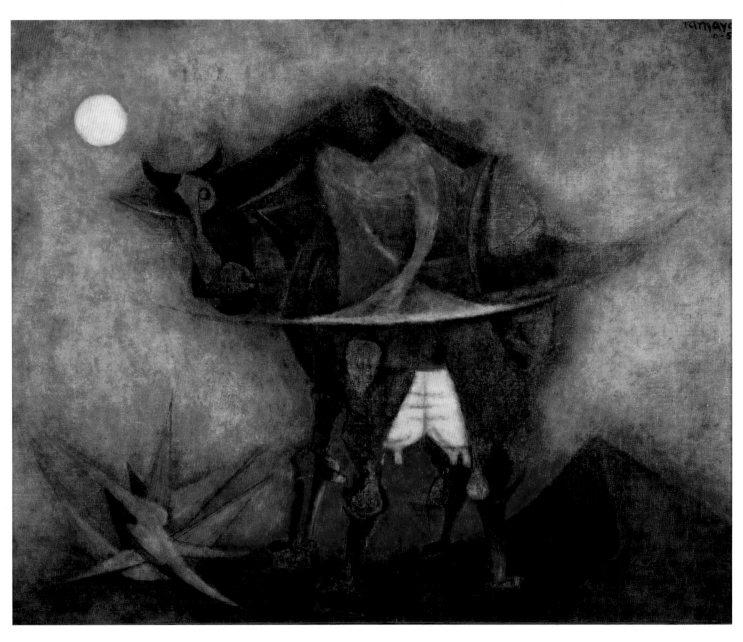

10 Rufino Tamayo
Cow Swatting Flies, 1951
Oil on canvas
79.1 x 99 cm. (31⅛ x 39 in.)

11 Rufino Tamayo
Untitled [Virgin of Guadalupe], undated
Woodcut
20.5 x 15.7 cm. (8¹⁄₁₆ x 6³⁄₁₆ in.)

12 Rufino Tamayo
Untitled [Mermaids with Lute], undated
Woodcut
15.5 x 21 cm. (6⅛ x 8¼ in.)

121

ARTWORK BY MIGUEL COVARRUBIAS

(1925–1951)

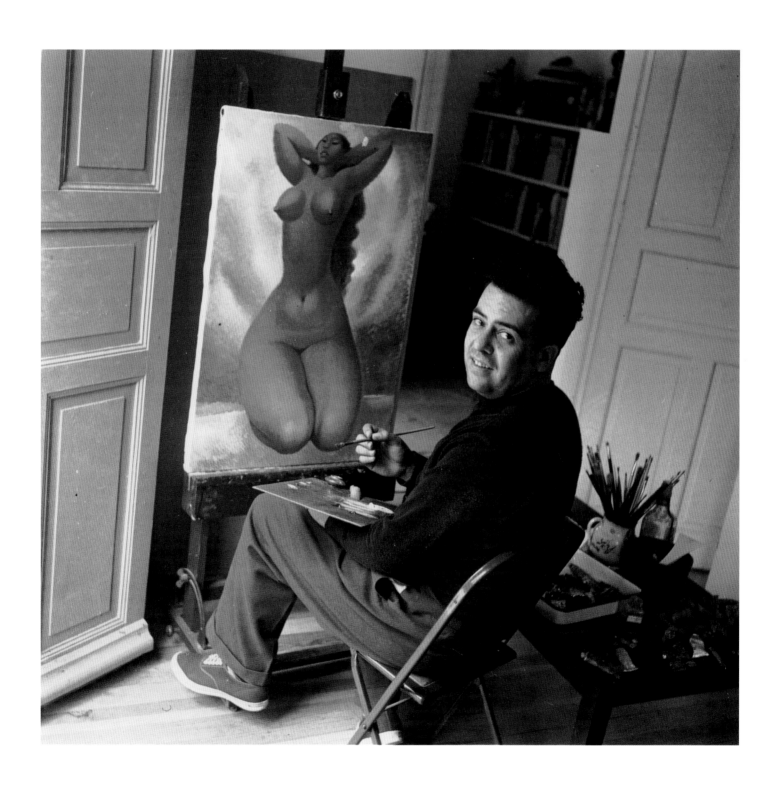

MIGUEL COVARRUBIAS (Jalapa 1904–1957 Mexico City)

After arriving in New York City in 1923 on a scholarship from the Mexican government, the talented Miguel Covarrubias established himself as a leading New York artist and caricaturist for such notable magazines as *Vanity Fair, Vogue,* and the *New Yorker.* Carl Van Vechten, influential critic, writer, and photographer, secured for Covarrubias the patronage and friendship of publisher Alfred A. Knopf and *Vanity Fair* editor Frank Crowninshield, among others. In 1932, Covarrubias created a series of drawings for *Vanity Fair* titled "Impossible Interviews," which featured the portraits of notable personalities of opposite character in impossible combinations. The great number and high renown of his subjects suggest both Covarrubias's popularity and the rarefied social and artistic circles in which he moved.

Covarrubias was also an inspired ethnologist and anthropologist whose research contributed to the knowledge of pre-Columbian artifacts and the indigenous folk arts of Native American and Balinese cultures. In 1933, Covarrubias received a Guggenheim research fellowship, which enabled him to live in Bali. He researched, wrote, and illustrated the book *Island of Bali* (1937), producing numerous paintings and drawings of Balinese life. He later wrote excellent ethnographic, art historical, and anthropological studies on the Native Americans, including *Mexico South: The Isthmus of Tehuantepec* (1946) and *The Eagle, The Jaguar and the Serpent* (1954).

Covarrubias also illustrated books for other authors. Many of these, such as John Riddell's satirical *In the Worst Possible Taste* (1932), grew directly from his success with caricature in *Vanity Fair* and the *New Yorker.* Others followed from the connections he had made in the publishing world, such as collaborations with George Macy's Limited Editions Club, for which Covarrubias illustrated a total of five books, including René Maran's *Batouala* (1932), Herman Melville's *Typee* (1935), and Bernal Díaz del Castillo's *The Discovery and Conquest of Mexico* (1942).

Covarrubias shared a close friendship with Nickolas Muray, and their long-lasting relationship is documented in Muray's photograph collections.

14
George Bernard Shaw (1856–1950)
Published in the *New Yorker* in "Profiles,"
December 25, 1926
Ink on paper
25 x 19.9 cm. (9⅞ x 7¾ in.)

15

Albert Carroll (1895–1956)
Dorothy Sands (1893–1980)
Harold Minjer (1895–1976)
in *The Apothecary*

The Neighborhood Playhouse, an off-Broadway theater on New
York's Lower East Side, staged and produced this revival of Franz
Josef Haydn's musical. It opened on March 16, 1926, and ran only
twenty-seven performances. The Playhouse focused on exploring
through folk drama the mystical, ritual, and lyrical roots of theater.
The company produced such eclectic productions as Haydn's
eighteenth-century musical, Hindu comedies, Norse fairy tales,
and Japanese Noh drama, as well as plays by Eugene O'Neill and
James Joyce and a musical revue called The Grand Street Follies.

Published in the *New Yorker,* April 10, 1926
Ink and wash on board
38 x 31.2 cm. (15 x 125/16 in.)

16

*The Horrors of Fifth Avenue Society—
At Both Ends*

Covarrubias listed the subjects in this
Greenwich Village party on the drawing's
margins as (upper row, left to right): Rich
Patron, Playwright, Poet, Cubist, Publisher,
and Actress; and (lower row, left to right):
Socialist and Editor.

Published in *Vanity Fair*, May 1925
Ink and wash on paper
24 x 33.5 cm. (9½ x 13³⁄₁₆ in.)

17

Alfred Lunt (1892–1977)
Clare Eames (1896–1930)
in *Ned McCobb's Daughter*

This play by Sidney Howard, produced by
the Theater Guild, opened on November 29,
1926. The roles of Carrie and Babe allowed
Eames and Lunt to give two of their finest,
most offbeat performances: Carrie turns in
her faithless, criminal husband and her boot-
legging brother-in-law Babe, despite
blackmail threats, to rid herself of both
good-for-nothing brothers.

Published in the *New Yorker*,
December 18, 1926
Ink and wash with gouache over pencil
on board
38.9 x 31.5 cm. (15⁵⁄₁₆ x 12¾ in.)

18

Henry Travers (1874–1965)
Lynn Fontanne (1887–1983)
in *Pygmalion*

The Theater Guild produced George
Bernard Shaw's saga of Eliza Doolittle's rise
from street-waif flower-seller in Covent
Garden to gracious lady in the smart salons.
It opened on November 15, 1926, and
despite Fontanne's (Eliza's) American accent,
the production was well-received. Travers
played Eliza's father.

Published in the *New Yorker*,
March 26, 1927
Ink and wash on paper
37 x 31.8 cm. (14⁹⁄₁₆ x 12½ in.)

19

Frank Conroy (1890–1964)
Ethel Barrymore (1879–1959)
in *The Constant Wife*

W. Somerset Maugham's comedy of marital
maneuvers opened in New York on
November 29, 1926, starring Ethel
Barrymore, the "First Lady of the American
Stage" for whom the term "glamour girl" was
coined, as Constance. Frank Conroy, who
established the Greenwich Village Theatre,
plays Bernard Kersal. The clever Constance
takes her husband's infidelity in stride and
uses it as a reason to go on a holiday with
Kersal, her former suitor. Barrymore was
well-suited for her role, and the play was
considered one of Maugham's best.

Published in the *New Yorker*,
January 1, 1927
Ink and wash with gouache on board
38.8 x 32.1 cm. (15¼ x 12⅝ in.)

20

The Idol Rich: The Pugilist

At times, *Vanity Fair* would give Covarrubias a full page to explore America's celebrity culture. Appearing under the head title "By Their Gods Ye Shall Know Them . . . Some Current American Idols," this drawing appeared with four other caricatures: "The Film Favorite," "The Home-run King," "The Water Sprite," and "Gridiron Glory: Autumn's overlord, the football hero."

Published in *Vanity Fair*, February 1927
Ink and wash on board
40.3 x 31.5 cm. (15⅞ x 12⅜ in.)

21

Leslie Howard (1893–1943)
Jeanne Eagels (1890–1929)
in *Her Cardboard Lover*

Adapted from Jacques Deval's French comedy, this play opened on
March 21, 1927, at the Empire Theater and starred Jeanne Eagels,
with Leslie Howard as Andre, her hired lover who keeps her from
being tempted to return to her husband. Eagels had hoped to recap-
ture her earlier fame with this play, but she was overshadowed by the
young Englishman Howard. The play was a success, however,
running for nineteen weeks.

Published in the *New Yorker,* May 7, 1927
Ink and wash on paper
39.4 x 31.1 cm. (15½ x 12¼ in.)

22

Helen Ford (1897–1982)
Lulu McConnell (1882–1962)
in *Peggy Ann*

This Lew Fields production opened on December 27, 1926, and was based on the book by Fields's son Herbert, with music by Richard Rodgers and Lorenz Hart. Incorporating Freudian symbolism, the musical comedy features Ford as Peggy Ann, a working-class girl who dreams of a better life, from shopping on Fifth Avenue to fending off pirates and escaping from her mother's boarding house.

Published in the *New Yorker*, April 16, 1927
Ink and wash on board
37.2 x 28 cm. (14⅝ x 11 in.)

23

William Beebe (1877–1962)

Zoologist and inventor of the bathysphere,
William Beebe was the first man to descend
to ocean depths of three thousand feet. Of
the exploring scientists, Beebe was the most
literate, writing numerous books on his
oceanic adventures.

Published in *Vanity Fair,* October 1928
Ink, wash, and gouache on paper
35.4 x 25.3 cm. (13⅞ x 10 in.)

24

Minnie Maddern Fiske (1865–1932)
Sidney Toler (1874–1947)
in *Mrs. Bumpstead-Leigh*

Harry James Smith's original production of
this comedy opened almost eighteen years
earlier to the day, starring Fiske in the title
role as an imposter who, along with her
mother and sister, claims farcical social
pretensions. The revival of the play opened
on April 1, 1929, and ran for nine weeks on
Broadway, with Toler playing the bumptious
Peter Swallow, Mrs. Bumpstead-Leigh's
former suitor, whose appearance threatens
her elevated social world.

Published in the *New Yorker,* April 27, 1929
Ink and wash on paper
30.5 x 25.4 cm. (12 x 10 in.)

25

George White (1890–1968)
Frances Williams (1863–1959)
in George White's *Scandals*

George White produced thirteen *Scandals*
between 1919 and 1936. Their topical
comedy, fast-paced dancing, and musical
arrangements made them better than the
typical music revue. White spared no
expense on his shows and, as a veteran
dancer and entertainer himself, paid a
premium for stars like singer Frances
Williams to appear in the 1929 revue.

Published in the *New Yorker,*
December 14, 1929
Ink wash and watercolor on paper
35.6 x 26.7 cm. (14 x 10½ in.)

26

Tourist Saved by Cheap Chinese Labor

This and four other caricatures by Covarrubias accompanied travel writer Charles T. Trego's "Red, White and Blue Peril," an article about "the star-spangilization of the Orient." In the early 1930s, full-page color images began appearing with increasing frequency in American magazines, thanks to color printing technology and the New York publisher Condé Nast.

Published in *Vanity Fair,* March 1931
Watercolor, gouache, and ink on paper
25.5 x 35 cm. (10 x 13¹³⁄₁₆ in.)

27

Lily Pons (1904–1976)

French-born American soprano Lily Pons was an overnight sensation after her Metropolitan Opera debut in 1931. She remained the principal soprano there until 1961. The elaborate ornamentation and embellishment of her high-ranging voice entranced audiences in Paris, London, Buenos Aires, Mexico, and the United States.

Published in the *New Yorker,* January 16, 1932
Ink on paper
37.6 x 26.8 cm. (14¾ x 10⅝ in.)

28

Brigadier General Hugh Johnson (1882–1942)

Appointed in 1933 under President Franklin D. Roosevelt's New Deal, General Hugh Johnson was head of the National Recovery Administration. Johnson was a brilliant but explosive genius who maintained a love for propaganda, a flair for epigram, and an amazing arsenal of profane expletives.

Published in the *New Yorker,* August 25, 1934
Ink and wash on board
36.8 x 29.1 cm. (14½ x 11½ in.)

29

Ogden Mills (1884–1937)

A caricature of Ogden Mills playing a black-faced Al Jolson, subtitled, "Now Open for Future Bookings."

Published in *Vanity Fair,* September 1933
Ink wash on paper
25.5 x 35.5 cm. (10 x 14 in.)

30

Alfred Lunt (1892–1977)
Lynn Fontanne (1887–1983)
Helen Westley (1875–1942)
in *Reunion in Vienna*

The Theater Guild's production of Robert E. Sherwood's comedy opened on November 16, 1931, starring the famous acting couple Lunt and Fontanne with Helen Westley, co-founder of the Greenwich Square Players and the Theater Guild. The play's twisted plot wove romance with irony.

Published in the *New Yorker*,
December 26, 1931
Ink and wash on paper
31.9 x 26.9 cm. (12⁹⁄₁₆ x 10⅝ in.)

31

Ernest Truex (1890–1973)
in *Whistling in the Dark*

Ernest Truex was six years old when he first played Hamlet. He turned professional in *Good Little Devil*, his 1914 film debut. Truex was most effective in supporting roles, but he did land some lead roles in productions such as *Whistling in the Dark*, in which he plays a young writer who concocts a story about a perfect murder. In the 1950s Truex played several "sly grandpop" roles on television shows such as *Mr. Peepers, Jamie,* and *The Ann Sothern Show*.

Published in the *New Yorker*,
February 27, 1932
Ink and wash on board
37 x 29.4 cm. (14⁹⁄₁₆ x 11⁹⁄₁₆ in.)

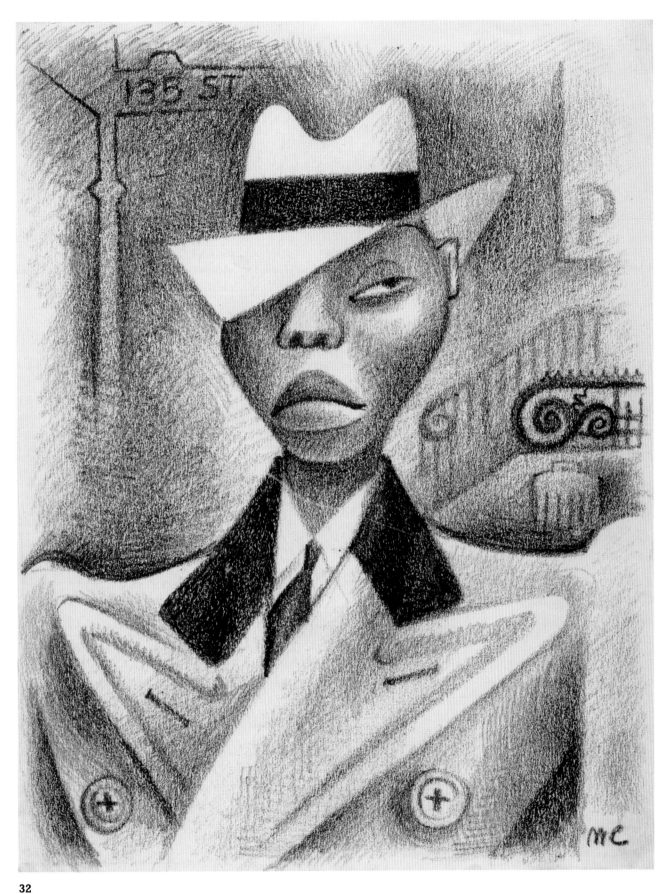

32

Harlem Dandy

In 1925, *Vanity Fair* began publishing Covarrubias's studies of black cabaret entertainers. The artist's early interest in Harlem's groundbreaking cultural scene brought him a number of commissions for significant book illustrations, including Alain Locke's *The New Negro* (1925), W. C. Handy's *Blues: An Anthology* (1926), and Langston Hughes's first book of verse, *The Weary Blues* (1926). Covarrubias's

own book *Negro Drawings,* a compilation of new and previously published drawings, appeared in 1927.

Undated
Litho crayon on paper
27.7 x 21.3 cm. (10⅞ x 8⅜ in.)

33
Untitled [Nine dancing figures], undated
Ink on paper
28.1 x 21.7 cm. (11⅛ x 8½ in.)

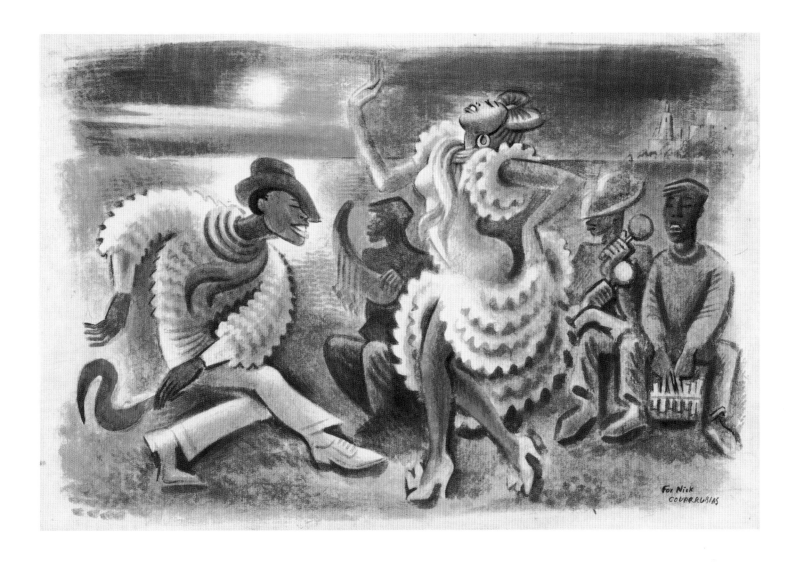

34
Untitled [Afro-Cuban dancers and
percussionists], undated
Gouache on paper
26.1 x 28.4 cm. (10¼ x 11³⁄₁₆ in.)

35

James J. Walker (1881–1946)

"Jimmie" Walker was the fun-loving, flamboyant mayor of New York City during the Jazz Age (1925–1932). The initial years of his mayoralty were a prosperous time for the city, with improvements in sanitation, hospitals, and subways. He was a popular figure known for his charm, wit, and particularly for his enthusiastic participation in New York City high life, which did little to impair his popularity. After the stock market crash of 1929, however, the state legislature charged Walker with corruption; he resigned in 1932.

Published on the cover of *Vanity Fair*, April 1932
Gouache on board
40.7 x 28 cm. (16 x 11 in.)
Inscribed: "To Nick the Nut"

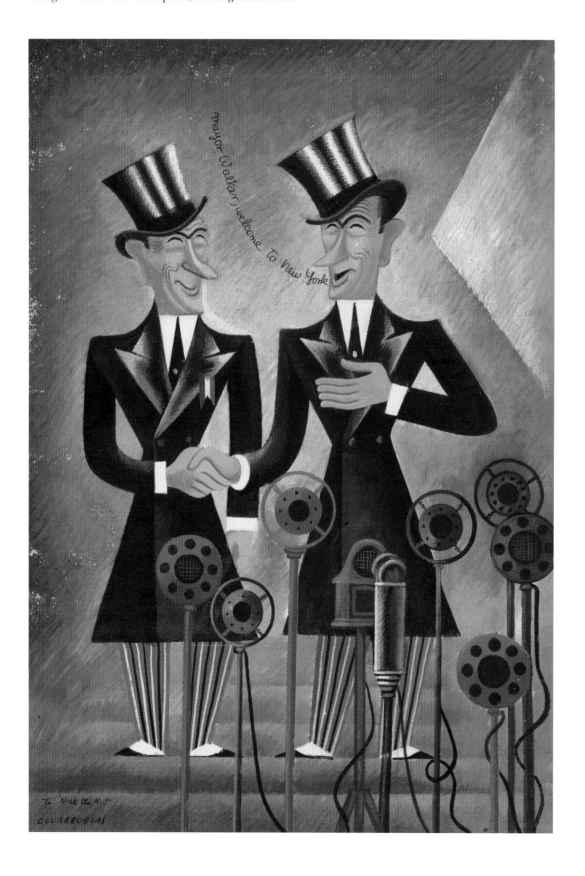

36

Helen Wills (1905–1998)

Wills gained international attention through tennis, winning thirty-one major titles during her career. She was a gold medalist in both singles and doubles at the 1924 Olympics and was named the Associated Press Athlete of the Year in 1935. Dubbed "Little Miss Poker Face," Wills helped emancipate women's tennis from the era of long skirts, petticoats, and stockings.

Published on the cover of *Vanity Fair,*
August 1932
Gouache and ink on paper
40.5 x 29 cm. (15⅞ x 11⅜ in.)

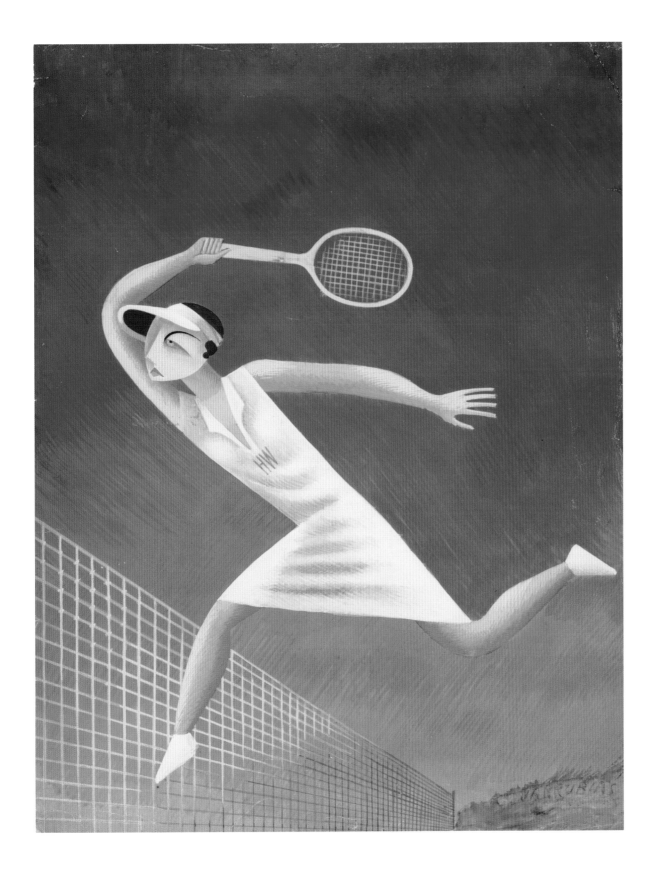

Impossible Interviews

Writing under the pen name John Riddell, humorist Corey Ford (1902–1969) collaborated with Covarrubias on the books *Meaning No Offense* (1926) and *In the Worst Possible Taste* (1932). Their celebrated *Vanity Fair* series, "Impossible Inter-views," featured notable personalities of opposite character in impossible settings. The series ran in *Vanity Fair* for four years, continuing in *Vogue* when the magazines merged in 1936.

37

Impossible Interview No. 4, Huey Long vs. Benito Mussolini (1893–1935; 1883–1945)

This interview brought together Italian dictator Benito Mussolini and Huey Long, who as the governor of Louisiana maintained dictatorial control over state government. Dressed in nightshirt and fascist uniform, Long and Mussolini strike similar poses while attempting to close an impossible deal.

GOVERNOR LONG: "I'm the Mussolini of Baton Rouge. I reckon you're the Mussolini of Rome, Italy." SIGNOR MUSSOLINI: "I am il Duce!" GOVERNOR LONG: "You said something, Big Boy, but I don't know what. Well, anyway, I'm glad to see you're wearing a black shirt, just like they said you were. Now, here's a great big idea! You ought to make your gang wear night-shirts, like the Klan does. Then you can get the monopoly on selling 'em to your people and I'll get the monopoly on selling 'em to you. It'll help the cotton planters and won't hurt you and me. How about it?" SIGNOR MUSSOLINI (brutally, and in Italian): "Italy can look after herself." GOVERNOR LONG: "Well, let's see if we can't trade something else, then." SIGNOR MUSSOLINI: "How about wines?" GOVERNOR LONG (eagerly): "That's it! Pot-likker's what you need. Just you make pot-likker the national drink of Italy and you will get a cut on the dago red racket in New Orleans and I will get a cut on the pot-likker in Milan. How about it?" SIGNOR MUSSOLINI: "Nothing doing." GOVERNOR LONG: "Nuthin' doin? And you call yourself the boss of forty million Italians?"—Original caption from *Impossible Interviews*

Published in *Vanity Fair,* March 1932
Gouache on paper
33.9 x 27.7 cm. (13⁵⁄₁₆ x 10⅞ in.)

COVARRUBIAS

38

Impossible Interview No. 10, Senator Smith W. Brookhart vs. Marlene Dietrich (1869–1944; 1901–1992)

A system of voluntary censorship in Hollywood had been in place until the early 1930s, but when movie attendance fell, sex was reintroduced to the public through such seductive stars as Marlene Dietrich. Among Hollywood's detractors was Iowa Senator Smith Wildman Brookhart (Republican), who called for a Senate investigation of the movie industry. A prohibitionist, Brookhart was described by *Time* magazine as "a vociferous champion of radical farm measures." He lost his Senate reelection bid in 1932 and was henceforth referred to as "Mr. Ex."

BROOKHART: "Bah! These movies are worse than Wall Street and the Liquor racket. They are ruining American morals—" DIETRICH: "Why, Mr. Senator, here I've been in Hollywood all this time and I've never seen any of this sin you talk about in Congress." BROOKHART: "You don't know where to look for it! Hollywood is a den of debauchery! The wages of cinema!"

DIETRICH: "We work too hard out here. We don't have any time to look for sin. It takes a bold reformer like you, Mr. Senator, to discover all the drinking and wild parties that are going on. How do you always find out about other people's business?" BROOKHART (proudly): "I make it my business. (Whispering) Now would you mind showing me about this place, even if it is getting dark? You look as if you'd be good company." DIETRICH: "Sure. Come along, Mr. Senator." BROOKHART: "Sssh, somebody might recognize me. Maybe you'd better not call me 'Mr. Senator.' (He lowers his voice) Just call me—Mr. Ex!"—Original caption from *Impossible Interviews*

Published in *Vanity Fair,* September 1932
Gouache and ink on paper
38.8 x 32.7 cm. (15⁵⁄₁₆ x 12⅞ in.)

39

Impossible Interview No. 11, Al Capone vs. Chief Justice Charles Evans Hughes (1899–1947; 1862–1948)

Al Capone, a.k.a. "Scarface" and "Public Enemy Number One," went to jail in 1931, not for gang-related crimes but for income tax evasion. In this ironic caricature, Covarrubias and Ford present the gangland boss with Charles Evan Hughes, Chief Justice of the Supreme Court, who opposed the adoption in 1913 of the Sixteenth Amendment to the Constitution, which instituted the federal income tax. For years, Capone's multimillion-dollar bootlegging organization projected its influence over politicians as well as municipal and state courts.

Hughes: "I—ah—hope that this—ah—little rest will do your constitution some good." Capone: "Well, you don't think a dirty trick like this will do America's Constitution any good, do you—sending a big shot like me to the pen? Why, any guy can make a little mistake in his income tax figures." Hughes (frigidly): "The Supreme Court sat in your case, Mr.—ah—Capone, and I can assure you that due process of law was not denied you." Capone: "Now I'll tell one. Laws? Laws are for rich guys and lobbyists who take Congressmen for a ride. You wouldn't say that Prohibition was a good law, would you, Judge?" Hughes: "So long as it is on the statute books the Supreme Court must see that it is obeyed." Capone: "Okay, chief. Every man to his racket . . . Say, that's an idea! How much does it cost to buy up the Supreme Court?" Hughes (patiently): "The Supreme Court is not for sale." Capone: "Some guys don't get paid with money. Take me, for instance. What do I care for cash? Power. That's my racket." Hughes (thoughtfully): "You talk more like the chief of a Government than a convict." Capone: "Well, ain't my gang the real Government of the U.S.A?"—Original caption from *Impossible Interviews*

Published in *Vanity Fair,* October 1932
Gouache on paper
35.3 x 28.8 cm. (13⅞ x 11⁵⁄₁₆ in.)

40

Impossible Interview No. 12, Clark Gable vs. Edward, Prince of Wales (1901–1960; 1894–1972)

With a nod and a handshake, the dashing movie star Clark Gable meets the ever-so-refined Edward, Prince of Wales. Their humorous discourse spirals ever downward as they contemplate the consequences of their sexual appeal to womankind and their popularity to their respective nations.

THE PRINCE OF WALES: "So you are the chap who has usurped my role as the heartbreaker of the world?"
GABLE: "Box office hearsay, Your Royal Highness."
WALES: "Your modesty is engaging, my dear fellow, but I do not begrudge you your position: it is not an enviable one. If there is one thing more tiresome than being loved too much by one woman, it is being loved too little by regiments of them. But, in my case, I use my charms in order to pay dividends for the Empire. Yours, I take it, is no such patriotic motive?" GABLE: "Well, I flatter myself that I have brought the feminine heartbeats of the world back to America, but unfortunately I see no practical way of turning them into dividends for the Administration. The most I can hope is that however indirectly my all-American appeal will make itself felt in the next census of the population." WALES: "Noblesse oblige, old fellow. But I have been warned that such popularity as you and I have enjoyed is short-lived. Personally I can go in for other things. When the ladies are no longer sold on me, I sell the men on the British Empire. But what will you do?"
GABLE: "I don't know, but I shall hang on by my ears as long as I am Gable."—Original caption from *Impossible Interviews*

Published in *Vanity Fair,* November 1932
Gouache and ink on paper
32.7 x 27.5 cm. (12⅞ x 10¹³⁄₁₆ in.)

41

Jim Londos (ca. 1897–1975)

A.k.a. "The Golden Greek," Londos was the world heavyweight wrestling champion for more than fifteen years; he lost only a handful of matches during his career. His athletic ability and good looks made him a top draw during the Great Depression. Covarrubias and Ford created an "Impossible Interview" match between Londos and President Herbert Hoover, whose failure to turn the economy around during the Depression years made him hopelessly unelectable.

Published in the *New Yorker*, March 5, 1932
Ink and wash on paper
36.8 x 28.8 cm. (14½ x 11⅜ in.)

New Jobs for Old Meanies

Vanity Fair featured a group of six Covarrubias caricatures in its October 1933 issue, under the heading "New Jobs for Old Meanies." Covarrubias's satirical sketches cleverly depicted a different kind of solution for national job growth. The caption read:

Under the NRA [National Recovery Administration] it looks as if everybody works but felons, whose profession is being threatened by the Department of Justice and who will now be forced to begin again. Hence this vocational chart for crooks, the beautiful feature of which is that it hides no talent under no bushel, see? Past experience, and these guys have had plenty of it, is put to good use. You may be reluctant to do business with faces like these, but on the other hand, you wouldn't want them roaming the streets and barking requests for a cuppa cawfee.
—Original caption from *New Jobs for Old Meanies*

42

Rico the Rat Turns Peruvian Bond Expert
Published in *Vanity Fair*, October 1933
Ink and wash on paper
37 x 27.2 cm. (14⅝ x 10¹¹⁄₁₆ in.)

43

Once a Kidnapper, Always a Nursemaid
Published in *Vanity Fair*, October 1933
Ink and wash on paper
37.3 x 27 cm. (14¹¹⁄₁₆ x 10⅝ in.)

44

Ray Bolger (1904–1987)
Bert Lahr (1895–1967)
Frances Williams (1903–1959)
Luella Gear (1899–1980)
in *Life Begins at 8:40*

A parody of *Life Begins at 40*, this
Shubert Brothers revue began as an
edition of the Ziegfeld Follies at the New
York Winter Garden Theater. It opened
on August 27, 1934, starring a popular
cast of comics (Lahr and Gear), singers
(Williams), and ad-lib dancers (Bolger).
The revue ran for well over two hundred
performances.

Published in the *New Yorker,*
October 13, 1934
Ink and wash on paper
26.7 x 25.4 cm. (10½ x 10 in.)

45

Maria Burke (1894–1988)
Guy Robertson (1892–date unknown)
Marion Claire (1904–date unknown)
in *The Great Waltz*

Hassard Short's extravagant staging of the
operetta *The Great Waltz* opened on
September 22, 1934, at the Center
Theater in Rockefeller Plaza. Based on
the lives, music, and conflicts between
the two Johann Strausses, father and son,
the show cost an estimated $250,000 and
boasted a cast of 180, 500 costumes, and
90 stage hands to manipulate machinery
for the elaborate set changes. At the
height of the Great Depression, *The
Great Waltz* was the biggest spectacle on
Broadway. Guy Robertson played the
young Strauss, Maria Burke the schem-
ing Countess Olga, and Marion Claire
Therese, young Strauss's love.

Published in the *New Yorker,*
November 24, 1934
Watercolor, ink, and gouache on paper
33.4 x 27.6 cm. (13 x 10⅞ in.)

46

Alfred Lunt (1892–1977)
Lynn Fontanne (1887–1983)
in *Idiot's Delight*

Robert E. Sherwood's comedy
about a couple who find each
other amid the rise of fascism
and the outbreak of war opened
on March 24, 1936; the play
went on to win the Pulitzer Prize.
Lunt and Fontanne, one of the
most successful acting partner-
ships of the twentieth century,
play an American and a Russian
stranded in the Italian Alps.

Published in the *New Yorker*,
April 11, 1936
Ink and wash on board
37.8 x 27.7 cm.
(14⅞ x 10⅞ in.)

47

F.D.R.—Everybody up now! Sing!

President Franklin Delano Roosevelt (1882–1945) was sworn in as the 32nd President of the United States in 1933. He ushered in the New Deal and went on to complete three terms in office; he died early in his fourth term in 1945. His policies helped pull America out of the Great Depression. Appearing under the heading "Potomac Singers," this drawing appeared on the same page with other political personalities of the time.

Lastly, Choirmaster Roosevelt, hoping to create unison out of discord, lifts his voice in a chorale whose theme deals with smiles, troubles and kit-bags . . . Roosevelt's selected song was "Pack up Your Troubles."
—Original caption from *Vanity Fair*

Published in *Vanity Fair*, September 1933
Ink and wash on paper
35.5 x 25.5 cm. (14 x 10 in.)

48

Walter Damrosch (1862–1950)

Son of the conductor Leopold Damrosch, Walter Damrosch was an important figure in New York's musical life and a proponent of American composers, most notably George Gershwin and Aaron Copland. This carica-ture appeared in time for the first public performance of Damrosch's opera *A Man without a Country*.

Published in the *New Yorker*, May 8, 1937
Ink and wash on paper
27.9 x 24.1 cm. (11 x 9½ in.)

49

Joseph Medill Patterson (1879–1946)

Joseph Medill Patterson founded and edited the New York *Daily News*, an American tabloid first published in 1919. In 1938, Patterson and the paper were profiled together in the *New Yorker*: "Both are earthy, lusty, and on occasion designedly vulgar; both hate the rich and love the New Deal; both are intensely patriotic and almost pathologically afraid of Japan. Patterson is mischievous and proudly lowbrow. So is the *News.* Patterson is distrustful of reformers, and impatient with restraints upon the enjoyment of life. So is the *News.*"

Published in the *New Yorker*, August 13, 1938 Ink and wash on paper 29 x 22.6 cm. (11⅜ x 8⅞ in.)

50

Dexter Fellows (1871–1937)

Veteran showman Dexter Fellows published his autobiography, *This Way to the Big Show*, in 1936. It chronicled more than forty years of his life as dean of the circus press agents. The book cover exclaimed: "'Pawnee Bill' and Colonel Cody sent him ahead to apprise the towns and cities of the land of marvels in store; he knew Sitting Bull, May Lillie, Johnny Baker and Annie Oakley. He is as necessary to Ringling Brothers and Barnum & Bailey as the big top, pink lemonade, or the elephants."

Published in the *New Yorker*, April 10, 1937 Ink on paper 26.5 x 25.7 cm. (10⅜ x 10 in.)

51

Hideki Tojo (1884–1948)

A Japanese general and statesman who
became prime minister in 1941, Tojo's acces-
sion marked the final triumph of a Japanese
military faction that advocated war with the
United States and Great Britain. Tojo held
extreme right-wing views and was a
supporter of Nazi Germany. He advocated an
aggressive foreign policy and ordered the
attack on Pearl Harbor.

Undated
Ink on board
31.2 x 22.6 cm. (12⁵⁄₁₆ x 8⁷⁄₈ in.)

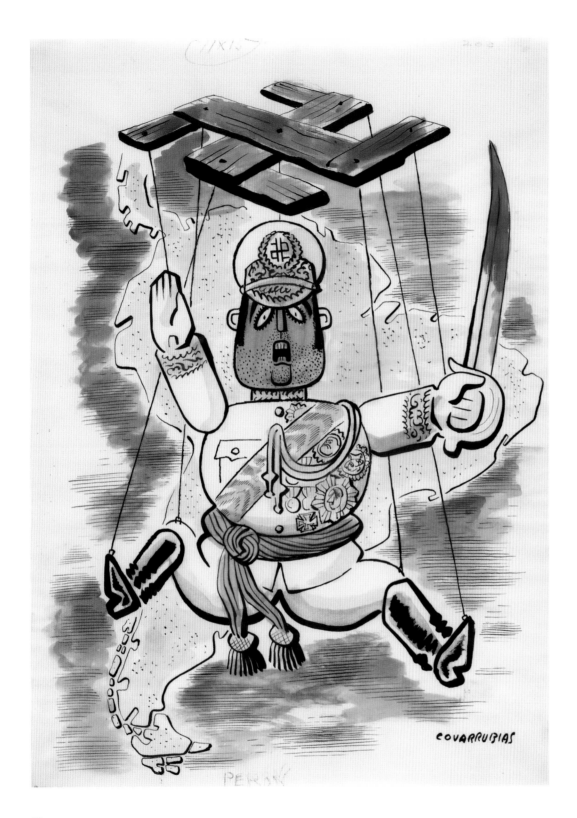

52

Juan Perón (1895–1974)

Juan Domingo Perón was an Argentine soldier and president of Argentina in 1946–1955 and 1973–1974. After seizing power in 1943, military leaders including Colonel Perón favored Japan and Fascist Germany until the end of World War II.

Undated
Watercolor and ink on paper
40.5 x 29 cm. (15⅞ x 11⅜ in.)

53

Part-time Panther in Daloa

Illustration for an African murder-mystery
that appeared with a highly stylized panther
mask, also by Covarrubias.

Published in *Vanity Fair,* May 1935
Ink and wash on paper
25.3 x 36.2 cm. (10 x 14⁵⁄₁₆ in.)

MIGUEL COVARRUBIAS:

Book Illustration and Associated Artwork (1932–1949)

54

Untitled [Female nude sitting in water]
Published on the cover of *Island of Bali*,
1937
Ink on paper
27.9 x 21.5 cm. (11 x 8½ in.)

In the Worst Possible Taste

Miguel Covarrubias contributed fourteen illustrations to Corey Ford's wildly satirical novel, *In the Worst Possible Taste,* a compilation of fictitious letters from John Riddell (Ford's pen name) to the period's best-selling authors, artists, and popular personalities. Leaving no stone unturned, the humorous captions that accompany Covarrubias's caricatures of the correspondents enliven the book's satirical punch.

55

Edna Ferber (1885–1968)

Seated on the front of her Covered Wagon and cracking her blacksnake whip over the trusty steeds which have already carried her several times across the continent, from New York to Hollywood, our pioneering Edna ("Sue Big") Ferber sets out once more to explore the famous Bad Lands between Fact and Fiction: the empire of the Psuedo-Historians, the Panorama-Painters and the Scope-Seekers of literature. "If the truth were really known, my friends" (Edna had said all this before, and doubtless would again) "it is the sunbonnet and not the sombrero that started this racket."

—Original caption from *In the Worst Possible Taste*

Published in John Riddell's *In the Worst Possible Taste,* 1932
Ink and wash on paper
36.8 x 26.7 cm. (14½ x 10½ in.)

56

Rockwell Kent (1882–1971)

Surrounded by one of his familiar black-and-white landscapes—complete with geometric icebergs, angular nudes and a slide-rule sunset, its rays numbered carefully from 10 to $10,000.00— Rockwell stands created at last in his own image. Before him lies his Art, the Art of creating too-muchness out of Nothing. Behind him several basalt-buttocked Eskimo girls leap from crag to cubic crag in terror, as Rockwell raises his arms aloft in joy at the sight of this virgin territory. "Greenland," he exclaims, "so wild and beautiful!"

—Original caption from *In the Worst Possible Taste*

Published in John Riddell's *In the Worst Possible Taste*, 1932
Ink and wash on board
38.7 x 27.4 cm.
(15³⁄₁₆ x 10¹³⁄₁₆ in.)

57

William Faulkner (1897–1962)

Clad in his rompers and carrying his little tin pail and shovel, in case he desires to dig in the dirt, Bill halts nervously in the loft of the old barn and grips his corncob pipe, glancing about him furtively at the dark and sinister shadows, full of their vague but suggestive meanings. It was in this forbidden corn-crib, at one time or another, that most of "Sanctuary" was laid.

—Original caption from *In the Worst Possible Taste*

Published in John Riddell's *In the Worst Possible Taste*, 1932
Ink and wash on paper
35.6 x 28 cm. (14 x 11 in.)

58

Floyd Gibbons (1887–1939)

Amid shot and shell, our irrepressible Floyd ("Hello, Everybody!") Gibbons sticks bravely at his typewriter and his microphone, sending over the latest ringside reports on the Sino-Japanese War. The toes of a deceased Oriental are turned up before him; in the distance a bomb has just exploded and blown several more victims into the air; a Japanese machine-gun has even sent a bullet through the upper half of Floyd's own head. Fortunately none of these mishaps seems to have made the slightest difference to our intrepid correspondent. "What a fight!" he cables back eagerly, at two bits a word, "some murder! Boy oh boy oh boy . . ."

—Original caption from *In the Worst Possible Taste*

Published in John Riddell's *In the Worst Possible Taste,* 1932
Ink and wash on paper
38.7 x 26.9 cm. (15³⁄₁₆ x 10⅝ in.)

59

For eight days and eight nights . . .

The illustration depicts a funeral ceremony. "Thus for eight days and eight nights, weeping and wailing women kept vigil about the body"

Published in René Maran's *Batouala,* 1932
Ink and gouache on board
46.1 x 35.6 cm. (18 x 14 in.)

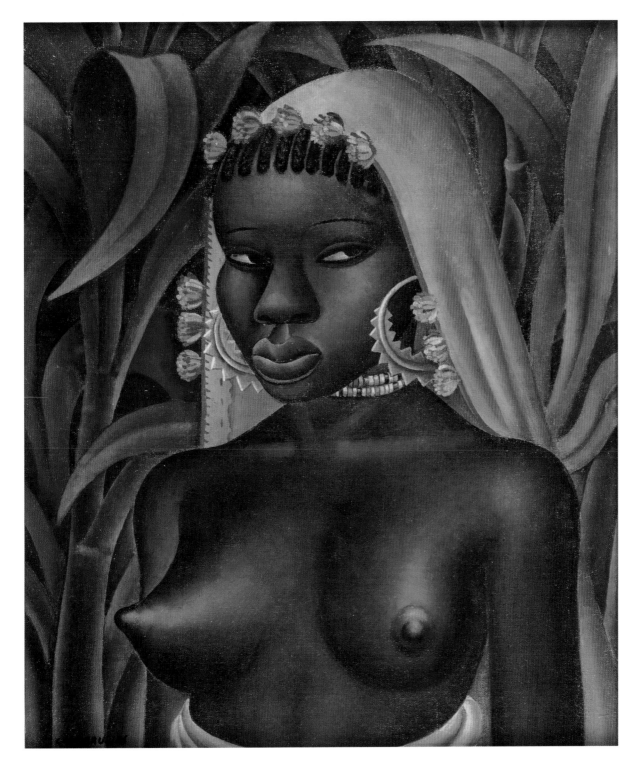

60

Untitled, ca. 1932
Oil on canvas
43.2 x 35.5 cm.
(17 x 14 in.)

61
Untitled [Standing African female], undated
Ink on paper
26.8 x 20.9 cm. (10⅝ x 8³⁄₁₆ in.)

62
Untitled [Bird with Snake]
Published in René Maran's *Batouala*, 1932
Ink on paper
18.2 x 23.6 cm. (7³⁄₁₆ x 9⁵⁄₁₆ in.)

63

Tiki in the Jungle
Published in Herman Melville's *Typee*, 1935
Black ink and colored ink wash on paper
27.4 x 22.6 cm. (10¹³⁄₁₆ x 8⅞ in.)

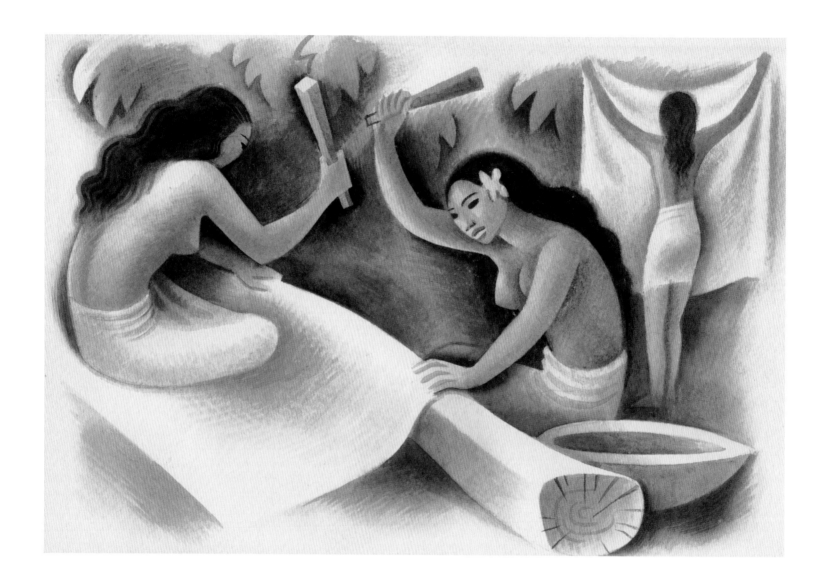

64

Making Tapa
Published in Herman Melville's *Typee*, 1935
Watercolor on paper
20.7 x 29.8 cm. (8 x 11¹¹⁄₁₆ in.)

65

Untitled [Balinese Landscape], ca. 1934
Oil on canvas
45.7 x 59.3 cm. (18 x 23⁵⁄₁₆ in.)

66

Movements of the Baris

Performed by young Balinese men and accompanied by music, the Baris is a ritualized war dance that combines elaborate costumes with flowers and weapons. The dance requires years of training, as every part of the body—from the toes to the face and tips of the fingers—is in constant motion. These eight drawings are grouped as they appear in the book *Island of Bali*.

Published in *Island of Bali,* 1937
Ink and wash on paper
Each image: 31.8 x 24.1 cm. (12½ x 9½ in.)

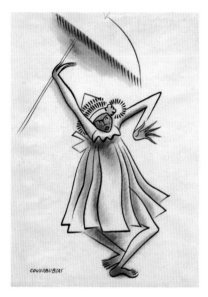 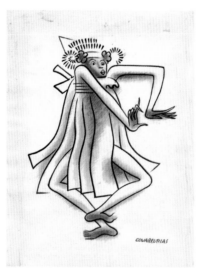

67

The Abuang

Covarrubias describes the abuang as "a decadent version of the ancient mating dance found in the village of Tenganan," and adds that it is performed once a year by unmarried girls and boys.

Published in *Island of Bali,* 1937
Watercolor on paper
27.8 x 21.5 cm. (11 x 8½ in.)

68
Untitled [Female Balinese
dancer with headdress],
ca. 1937
Ink on paper
27.8 x 21.8 cm. (11 x 8⅝ in.)

69
Untitled [Seated Balinese woman], ca. 1937
Ink on paper
27.7 x 21.4 cm. (10⅞ x 8⅜ in.)

70
Untitled [Seated Balinese woman], ca. 1937
Ink on paper
27.8 x 21.5 cm. (10⅞ x 8½ in.)

71

Untitled [Profile of a young Balinese]

This drawing appears in *Island of Bali*'s chapter titled "The Family," between the subheadings "Adolescence" and "The Balinese love life." It serves to illustrate the Balinese physical ideal of human facial features.

Published in *Island of Bali*, ca. 1937
Ink on paper
28 x 21.6 cm. (11 x 8½ in.)

72

Untitled [Portrait of man wearing hibiscus], ca. 1937
Gouache on paper
35.5 x 25.5 cm. (14 x 10 in.)

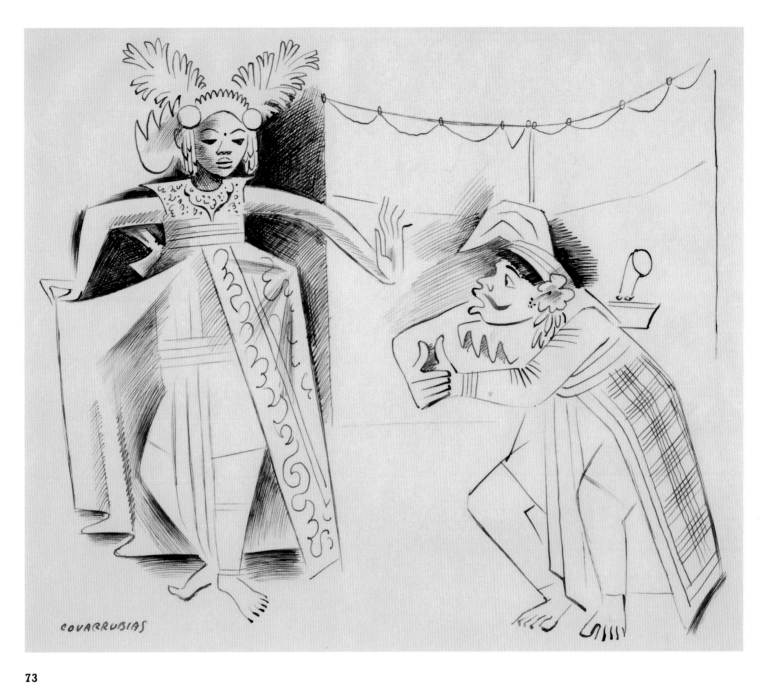

73

The Ardja

Covarrubias dedicated an entire chapter in *Island of Bali* to "The Drama," which includes detailed descriptions of Balinese theater, classical dance, and the musical instruments of a typical village orchestra. In this depiction of the romantic Balinese opera *The Ardja*, the prince is giving instructions to his prime minister, the *Patih*.

Published in *Island of Bali,* ca. 1937
Ink on paper
21.4 x 28 cm. (8⅜ x 11 in.)

74

Fabric Designs
[Bali prints by Miguel Covarrubias], ca. 1937

Covarrubias's research helped inspire a Balinese vogue among fashionable New Yorkers, as seen in Franklin Simon's Fifth Avenue window display.

Unknown photographer, 1937
Photograph
20.3 x 25.4 cm. (8 x 10 in.)
Prints and Photographs Division, Library of Congress

75
Untitled [Study, Balinese nude],
ca. 1937
Ink on paper
28.1 x 21.5 cm. (11 x 8½ in.)

76
Untitled [Balinese man drinking
from a charatan], ca. 1937
Ink on paper
27.9 x 20.9 cm. (11 x 8³⁄₁₆ in.)

77

Untitled [Three Balinese women with basket
of grain, bananas, and bottles], ca. 1937
Ink on paper
36.9 x 25.5 cm. (14½ x 10 in.)

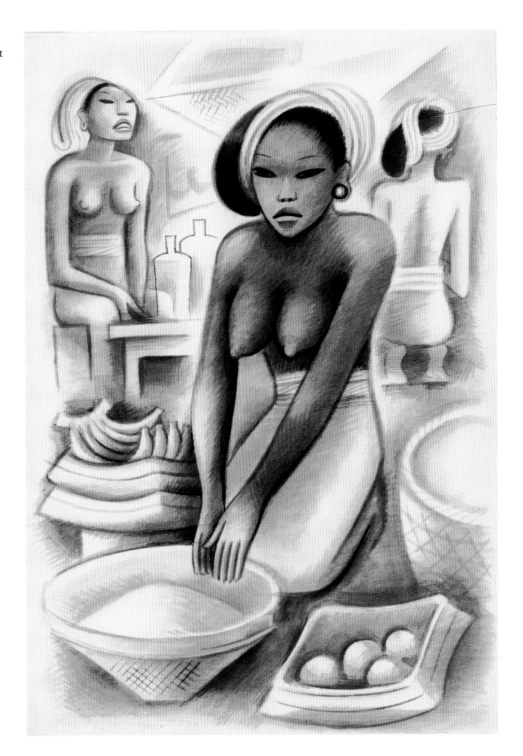

78
Untitled [Nude study], ca. 1937
Ink and crayon on paper
20.5 x 12.7 cm. (8 x 5 in.)

79
Untitled [Reclining female nude], ca. 1937
Ink on paper
20.9 x 27.7 cm. (8³⁄₁₆ x 10⅞ in.)

80
Untitled [Seated female nude],
ca. 1937
Ink and wash on paper
27.7 x 20.8 cm. (10⅞ x 8 in.)

81
Untitled [Spanish soldier and Aztec warrior
in battle]
Published in Bernal Díaz del Castillo's *The
Discovery and Conquest of Mexico,* 1942
Watercolor and ink on paper
27.8 x 21.5 cm. (11 x 8½ in.)

82
Untitled [Montezuma's tax gatherer
with slave]
Published in Bernal Díaz del Castillo's *The
Discovery and Conquest of Mexico,* 1942
Watercolor and ink on paper
27.8 x 21.5 cm. (11 x 8½ in.)

83
Untitled [Two Spanish soldiers—one with
raised branding iron—restraining half-nude
kneeling woman]
Unpublished drawing for Bernal Díaz del
Castillo's *The Discovery and Conquest of
Mexico,* 1942
Watercolor and ink on paper
21.5 x 27.7 cm. (8½ x 11 in.)

84
Untitled [Market scene]
Published in Bernal Díaz del
Castillo's *The Discovery and
Conquest of Mexico*, 1942
Ink on paper
21.5 x 27.8 cm. (8½ x 11 in.)

85
Untitled [Group of Aztec men holding
Spanish soldier for sacrifice]
Published in Bernal Díaz del Castillo's *The
Discovery and Conquest of Mexico*, 1942
Ink and crayon on paper
27.3 x 20.8 cm. (10¾ x 8 in.)

86
Untitled [Tehuana], undated
Gouache on paper
38.1 x 25.2 cm. (15 x 10 in.)

87
Untitled [Four Mexican women at market],
undated
Watercolor on paper
27.2 x 20.7 cm. (10¹¹⁄₁₆ x 8³⁄₁₆ in.)

88
Untitled [Set design for Carlos Chávez's
ballet, *Los cuatro soles* (The Four Suns)],
1951
Gouache on paper
22.6 x 27 cm. (8⅞ x 10⅝ in.)

89
Untitled, undated
Watercolor and gouache on paper
17.4 x 14 cm. (6⅞ x 5½ in.)

APPENDIX

Artworks by Miguel Covarrubias from the Nickolas Muray Collection
not appearing in this book:

Untitled [Three mariachi musicians],
undated
Felt-tip marker on paper
25.7 x 27.8 cm. (10⅛ x 10¹⁵⁄₁₆ in.)

Untitled [Squatting Balinese man with hat],
ca. 1937
Watercolor on paper
27.8 x 20.9 cm. (10¹⁵⁄₁₆ x 8¼ in.)

Untitled [Seated female Balinese nude,
hands holding breasts], ca. 1937
Ink on paper
26.9 x 20.8 cm. (10⅝ x 8³⁄₁₆ in.)

Joan Lowell in *The Cradle of the Duped*,
ca. 1929
Published in *Vanity Fair*, June 1929
Ink wash on paper
35.4 x 25.4 cm. (13¹⁵⁄₁₆ x 10 in.)

Untitled [Group of Aztec men holding
Spanish soldier for sacrifice], ca. 1942
Illustration for Bernal Díaz del Castillo's
The Discovery and Conquest of Mexico,
1942
Ink and crayon on paper
20.8 x 27.3 cm. (8³⁄₁₆ x 10¾ in.)

Untitled [Beach scene with various figures],
undated
Ink and wash on paper
21.6 x 28 cm. (8½ x 11 in.)

Untitled [Young Balinese woman with
earrings], ca. 1937
Ink on paper
27.8 x 21.5 cm. (10¹⁵⁄₁₆ x 8⁷⁄₁₆ in.)

"Picture Frames a la Baroque" [Framed
portrait of President Franklin Delano
Roosevelt], ca. 1934
Illustration for *Vanity Fair*,
February 1934
Ink and watercolor on paper
27.3 x 23.2 cm. (10¾ x 9⅛ in.)

IN MEMORIAM

HEIDI HAEUSER

**Award-winning book designer
at the University of Texas Press, 1995–2004**

Her work and her life were models of superb design